PILLARS
OF FIRE

PILLARS OF FIRE

THE BATTLE OF MESSINES RIDGE JUNE 1917

IAN PASSINGHAM

FOREWORD BY PETER SIMKINS

First published 1998
This edition published 2012

by Spellmount, an imprint of
The History Press
The Mill, Brimscombe Port
Stroud, Gloucestershire, GL5 2QG
www.thehistorypress.co.uk

British Library Cataloguing in Publication Data.
A catalogue record for this book is available from the British Library.

ISBN 978 0 7524 7664 3

Typesetting and origination by The History Press
Printed in Great Britain

Contents

To Sally, Joe and Ellie,
for their support, patience and encouragement over the years;

In loving memory of my father and mother,
who remain a inspiration;

and
to the men who fought at Messines
and deserve perpetual recognition
for their skill, courage, sacrifice and achievement.

List of Photographs and Plates

Maps/Diagrams

Acknowledgements

My first association with the remarkable story of the Battle of Messines came whilst on a battlefield tour in 1996 when Professor Peter Simkins was the guest speaker and I was amazed to discover that no book existed that covered the successful assault by the BEF's Second Army in June 1917 in a singular way. I was encouraged to fill the gap and did so, with the excellent help of the then Sutton Publishing in November 1998, which was followed by the paperback edition in 2000. Now The History Press has agreed to republish *Pillars of Fire* to mark the 95th Anniversary of the battle and I am delighted to have the opportunity to make it available for a new generation of historians and also to those whose relations may have fought at Messines and wish to augment their family histories and learn more about a remarkable achievement of one of their kith and kin in a war that remains so often clouded by failure, rather than ultimate victory. The process of turning ideas into the printed word is a fascinating and complex one and therefore help, contributions, opinions and good advice, whether small or large, are always most welcome. I have realised over the passage of time that research and authorship of military history, in this case, cannot be achieved in splendid isolation.

Therefore, the extensive list of acknowledgements provided in the original edition of *Pillars of Fire* remains extant and is reproduced below; but others should be acknowledged here. First and foremost, Jo de Vries, Senior Commissioning Editor Military History at The History Press, has been instrumental in bringing this book, as well as that on the German Army on the Western Front, *All the Kaiser's Men*, into the public domain once more. The History Press has kept faith with my previous work and has more recently commissioned another book, based on medical support to a frontline Australian infantry battalion on the Western Front in 1917 and 1918, to be published in 2013. While every effort has been made to contact and acknowledge copyright holders of the references and illustrative material used in this publication, if any copyright holders inadvertently have been omitted they should contact The History Press directly.

Over the past decade or so I have had outstanding assistance from the Imperial War Museum Library and Archive, Department of Printed Books, Photographic, Map and Sound Archives and particular assistance from Mary Wilkinson, Simon Robbins, Stephen Walton, Angela Wootton, Chris Hunt, Colin Bruce and Peter Hart. The same goes for the National Archive (formerly PRO), plus the Bundesarchiv and the German Historical Institute, as well as other sources of the German perspective for the book. Peter Liddle and Matthew Richardson gave me free access and considerable

assistance in trawling through the Liddle Collection at the Brotherton Library, University of Leeds and the staff of both the Royal Engineers Library & Museum and The Royal Regiment of Artillery Institution at Woolwich were most helpful in guiding me through the extensive primary and secondary source material held there.

My visit to the Australian War Memorial, Canberra, was pivotal in my research. The help from all the staff and resources provided there was outstanding. My particular thanks must go to Peter Stanley for his eager encouragement of my journey 'down under' in the first place; Ian Smith, Head of the Research Department and every one of his staff; Tim Roberts and the Photographic Archive; Peter Londey; Ashley Ekins and Peter Burness. I am most grateful to Dr Robin Prior, the Australian Defence Force Academy (ADFA), the University of New South Wales, for his interest and comments on my views. The AWM gave me access to the extraordinary collection of diaries, letters and memoirs which have also helped me to paint a more vivid picture of the period by those who were there to experience it.

Other individual contributions were extensive: veterans, especially Walter Humphrys, and the narratives of many others, including Sapper John McCreesh, Kiwi 'Sapper' Edward Leslie (Les) Hughes and Ky Walker were all brought back to the fray so vividly by their families who I was immensely privileged to meet. Other considerable help was offered and gratefully received from Jacques Ryckebosch, Albert Ghekiere, Alexander Barrie, Philip Robinson, Peter Barton, Peter Oldham, Dr Bill Philpott, Giles Allen and Cyril Coombes, as well as the many Holts' travellers and members of the Western Front Association (WFA) who have shared a comment or two with me and helped to keep me on the right track; and to Freddie Cohen for providing some excellent photographs that were donated from the private Plumer family collection.

I shall be forever indebted to Holts Battlefields and History Tours for giving me the opportunity to travel on the 'Australians on the Western Front' trip in September 1996 that led to *Pillars of Fire* with the encouragement, faith and stoicism of the former Managing Director, Isobel Swan, who 'challenged' me to fill the gap in the historiography of military history at a bar in a certain hotel in Ypres (The Ariane) all those years ago!

To John Lee, Stephen Young and Joy Thomas I pass on my heartfelt acknowledgement of their assiduous work in reading and adding clarity to my original draft. Above all, I send my special thanks to Marie Joly for taking my rough sketches and often dubious ideas on graphics and creating such professional maps covering Messines and Third Ypres in particular.

Finally, Professor Peter Simkins agreed to write the foreword for the original publication and has kindly done so for this latest edition, for which I am even more grateful. It has been my immense privilege to have worked with and enjoyed his company on further historical tours and at conferences, seminars and other functions at the University of Birmingham, the Western Front Association (WFA) and British Commission for Military History (BCMH), amongst others, over the years.

Glossary and Introductory Notes

AA&QMG	Assistant Adjutant & Quartermaster General.
A Branch	Adjutant General's Branch of the General Staff: responsible for administration, discipline and awards.
ADMS	Assistant Director of Medical Services.
ADS	Advanced Dressing Station – most forward medical treatment posts behind the Regimental Aid Post (RAP).
AHQ	Army Headquarters.
AMC	Army Medical Corps: later to become Royal Army Medical Corps (RAMC).
Anzac	Australian and New Zealand Army Corps (used as term for all Australian and NZ troops).
AP	(Medical) Aid Post.
APM	Assistant Provost (Military Police) Marshal.
Area Shoot	Term used for artillery/mortar saturation bombardment of a targeted enemy area.
Army Troops	Supporting units (e.g. transport, services, logistics units in general) attached to divisional order of battle from army resources for miscellaneous duties.
Arty	Artillery.
ASC	Army Service Corps (Logistics support units), later to become Royal Army Service Corps (RASC).
Aus	Australian.
Aussie	Australian.
BAB	'Bab code' British telephone code-book post-1916.
Banjo	Australian slang for a spade.
Barrage	Artillery bombardment (different types shown in glossary).
Battery	Artillery sub-unit, level equivalent to an infantry company. Commanded by a Major.
Battle bowler	British slang for the steel helmet.
Battle Order	Reduced infantry order of dress and equipment, worn for action. Also known as 'fighting order', it disposed of the main back-pack and consisted of steel helmet, gas-mask, haversack for emergency

	rations and spare ammunition, webbing-belt, water bottle(s) and ammunition pouches. This facilitated freedom and speed of movement in battle.
Bde/bde	Brigade – infantry bde – fighting unit of four infantry battalions, plus supporting artillery, engineer and other support units – approximately 5,000 men. Commanded by a Brigadier/Brigadier-General.
BEF	British Expeditionary Force (original term was used for the British force sent to France and Belgium in 1914, although the term was used throughout the war to describe the total British and Empire forces deployed in the conflict).
BGGS	Brigadier-General, General Staff.
Bn/bn	Battalion (infantry, approximately 650–800 men in 1917, comprising four rifle companies, support (heavy weapons) company and HQ company). Commanded by a Lieutenant-Colonel.
BGHA	Brig-Gen Heavy Artillery.
BGRA	Brig-Gen Royal Artillery. Commander of the Corps artillery units.
BGRE	Brig-Gen Royal Engineers. Commander of the Corps engineer ('Sapper') units.
'Black Hand Gang'	Expression used for a trench-raiding party.
Blighty	Common expression used for Britain (or the mother-country for some Empire troops) – 'Getting a Blighty one' meant being wounded seriously enough to be evacuated home: those who did were often a source of envy for their mates who had come through a battle unscathed.
'Blue Caps'	Nickname for the Royal Dublin Fusiliers (dating back to the Indian Mutiny).
Boche	French term for German and adopted by most Allied troops. (Sometimes seen as Bosche.)
Bomb	British term for hand-grenade.
Bombardier	RA rank equivalent to corporal.
Bomber	Infantry soldier tasked as grenade-man for attacks against enemy positions.
Bomb-proof	Well-defended position, position or dug-out which is well protected against enemy artillery or mortar bombardments. Also used colloquially to describe a lucky or clever soldier or officer.
Bomb-stop	Barricade built within a trench as an obstacle to enemy attackers.
Bonk/Bonking	To shell/shelling the enemy.

Bonzer/Bonza/bosker	Australian slang for good, or very good.
Box barrage	Artillery barrage targeted on a small ('box') area, often to protect troops carrying out a limited attack, such as a trench raid.
Bracket	Artillery method of finding the correct range to a target. Guns would 'bracket' and fire on a target area, observed by an artillery (gunner) forward observation officer (FOO). The FOO would then correct the range and direction of the guns via telephone reports to the artillery gun-line until the shells were landing 'on target'.
Brass/The Brass	Generally derogatory term used by the troops and more junior officers for senior officers and the General Staff officers.
Brig/Brig-Gen	Brigadier/Brigadier-General.
Bully Beef	Canned corned beef; as the hors d'oeuvre to 'Plum and Apple' jam, the staple diet of most of the BEF!
Bung	Processed cheese issued to the men: also known as 'cheese possessed'. Known as 'bung' for its uncanny ability to reduce the need to visit the latrines.
Bunker	German protective position, normally reinforced concrete, designed to protect HQs, medical units and shelter for forward troop concentrations etc.
Cable	Telephone land-line, generally buried to protect it against artillery fire.
Cage/PW Cage	Prisoner of War (PW) cage – a fenced and guarded PW camp close to the front line.
Camouflet	Counter-mining explosives-chamber used for destroying or disrupting the use of enemy mine-tunnels.
CB fire	Counter-Battery fire: artillery bombardment to neutralise or destroy enemy artillery batteries.
CCS	Casualty Clearing Station – main medical site behind the front-lines. Site would be tented or hutted camp.
CEF	Canadian Expeditionary Force.
CHA	Commander Heavy Artillery (of a corps).
C-in-C	Commander-in-Chief.
CO	Commanding Officer (normally of a battalion-sized unit), usually Lt-Col rank.
Company/Coy	Company. Infantry company: a tactical sub-unit of four platoons, plus company HQ. Approximately 150 men in 1917. Commanded by an OC (Officer Commanding), a Major or Captain.
'Cord' road	Corduroy trackway laid over uneven, broken or

	muddy ground, built from cords of wood laid at right angles to the direction of the path.
Corps	Formation usually consisting of three or four infantry divisions, with artillery, engineers, tanks, cavalry and other supporting and logistic units as part of the order of battle (ORBAT). Commanded by a Lieutenant-General (Lt-Gen) as General Officer Commanding (GOC).
CRE	Commander Royal Engineers.
Creeping barrage	Artillery bombardment (designed to protect advancing infantry while neutralising enemy defenders) which extends its range at timed intervals. Introduced to BEF in September 1916, as an improvement to the 'lifting barrage'.
Crump	Shell-burst.
CSM	Company Sergeant Major.
CT	Communication Trench: narrow trench dug at an angle to a defensive trench to permit concealed entry to the trench.
Curtain fire	Artillery barrage, like creeping barrage, designed to provide a 'curtain' of artillery fire between advancing troops and the enemy.
DAG	Deputy Adjutant General.
DAQMG	Deputy Adjutant & Quartermaster General.
DCM	Distinguished Conduct Medal.
DGMS	Director General Medical Services.
Digger	Australian (though also used at the time to describe New Zealanders; the generic term referred to the early gold miners in both countries).
Dinkum	Australian slang for good news, or an excellent comrade (as an example, 'a dinkum' was a Gallipoli veteran).
Direct Fire	Small-arms, machine-gun, tank and gun fire which is observed by the firer and therefore aimed directly at the target. (Compare indirect fire.)
Div	**Division: Allied**: tactical formation of three infantry **brigades**, with artillery, engineers, and other supporting arms and services under command. Approximately 15,000–20,000 men, depending on its role. Commanded by a Major-General as GOC.
Division	**German**: tactical formation of two or three infantry **regiments**, with artillery, engineers, and other supporting arms and services under command. Approximately 12,000–17,000 men, depending on its role. Commanded by a Colonel or Major-General.

DOW	Died of Wounds.
DQMG	Deputy Quartermaster General.
Dreckfresser	'Mud eater': German slang for an infantryman.
Drumfire	Artillery barrage fired by each gun in succession, rather than a salvo (simultaneous firing of the guns). So called because of the drum-roll sound of its effect.
DSO	Distinguished Service Order.
Duckboard	Wooden paletted plank used to cover trench floors or cross muddy ground.
Dug-out	Shelter made in the wall of a trench, ranging from a small alcove ('funk-hole') to large underground rooms (normally HQs, medical aid posts, etc).
Egg grenade	Small German egg-shaped hand-grenade.
E-in-C	Engineer-in-Chief: Chief Sapper, based at GHQ.
Eingreif-	German independent counter-attack unit (Regimental or Divisional level), specifically trained for counter-attack tactics.
'Erk'	Fitter/mechanic in Royal Flying Corps or RAF, (abbreviation of 'air mechanic').
Feldwebel	German rank, equivalent to company sergeant major (CSM).
Festung	German term for fortress.
Fire trench	Front line trench.
Five-nine	British term for the German 5.9-inch shell.
Flight	Smallest RFC sub-unit, consisting of five or six aircraft.
FOO	Forward Observation Officer – artillery/mortar spotter of indirect fire.
Funk-hole	Individual dug-out.
Gefreiter	German rank, equivalent to lance-corporal.
GHQ	General Headquarters, BEF.
GOC	General Officer Commanding.
Gruppe	German Corps, its principal resource being infantry divisions, artillery and engineer units, plus supporting logistic and administrative units.
GS	General Service.
GSO	General Staff Officer.
Gunner	Officer or soldier serving in the Royal Artillery (RA).
HAG	Heavy Artillery Group.
Hard tack	British army biscuits (iron rations).
HE	High Explosive.
HQ/Hqrs	Headquarters.
Hun	Allied slang for Germans.

'I' Branch	Intelligence branch of HQs at battalion-level and above.
Identity ('ID') Disc	Also known as 'Dog-tag'. Name-tag bearing the name, initials, service number, unit and religion of an individual. Made of metal, or more commonly a form of compressed fibre. From 1916/1917, British servicemen wore two: One to remain on the body to ensure proper identification for reburial and the second, removed and passed through the reporting chain as proof of death.
Indirect Fire	Artillery, mortar and machine-gun fire which is not observed by the firers, but predicted or observed and adjusted by forward observation officers (FOOs).
Interdiction	Long-range artillery fire and bombing from the air to destroy or neutralise enemy lines of communication, supply dumps and troop concentration areas; designed to isolate the main battlefield from reinforcement and resupply.
Iron ration	Emergency rations carried by men in battle order: normally bully beef, biscuits (hard tack), tea, sugar, extra water bottle and a 'brew kit' to allow for boiling of water.
Jerry	German.
Jump	To jump off was to begin an attack. Jumping-off positions, or jumping-off lines were the equivalent of the start-line (SL), or in more current military terms, the line-of-departure (LoD).
Kamerad	German for comrade or friend. Used as a gesture of surrender.
'K' ammunition	German armour-piercing bullets with steel core, (German: *Kern-Munition*). An effective anti-tank bullet against the earlier types of British tank, but ineffective against the Mk IV type used at Messines and subsequent battles.
KIA	Killed in Action.
'Kite' balloon	Observation balloon, so called as it was attached to a cable to control it from the ground.
Kiwi	New Zealander.
Maj-Gen	Major-General.
MG	Machine gun.
MGRA	Maj-Gen Royal Artillery. Commanding artillery at Army HQ.
MIA	Missing in Action.
Minenwerfer	Also called 'Moaning Minnie': German trench mortar.
MM	Military Medal.

MO/RMO	Medical Officer/Regimental Medical Officer. Term normally refers to a doctor attached to a battalion or regiment (rather than a doctor at a hospital).
Mop-up	To neutralise or destroy pockets of enemy resistance.
MT	Motor Transport.
NCO	Non-Commissioned Officer. Any rank from lance-corporal (L/Cpl) to Warrant Officer Class I, normally a Regimental Sergeant Major (RSM). (Commissioned officers hold the ranks from Second-Lieutenant (2/Lt) to the most senior officer ranks, the highest being Field Marshal.)
No Man's Land	Territory between the respective front lines.
NZ	New Zealand.
OC	Officer Commanding (normally of a company-sized unit): Captain or Major rank.
OHL	*Oberste Heeresleitung* – German General HQ.
OP/'O. Pip'	Observation Post ('O. Pip').
ORBAT	Order of Battle.
Oz/Ossie	Australian.
PBI	'Poor Bloody Infantry': British slang to describe the eternal condition of life as an infantry officer or soldier.
Phonetic Alphabet	Introduced to avoid confusion in communications – certain letters of the alphabet were given distinctive pronunciations: A-Ack, B-Beer, D-Don, M-Emma, P-Pip, S-Esses, V-Vic; hence 'O. Pip', 'Toc. H', etc.
Pillbox	Reinforced concrete machine-gun or field-gun post.
Platoon	Infantry sub-unit comprising four sections and platoon HQ in 1917. Section is the smallest fighting group, approximately 8–10 men, commanded by a corporal. Platoon commanded by Lieutenant/Second-Lieutenant (Lt/2/Lt), assisted by a Platoon Sergeant.
'Possy' or 'Possies'	Australian slang for a defensive or other battle position(s).
'Push'	Common expression for a major offensive.
RA	Royal Artillery.
RE	Royal Engineers.
Recce	Abbreviated term for reconnaissance.
Redoubt	Strongly fortified position in a trench system, with a labyrinth of tunnels and alternative defensive positions within it.
Regiment	**Allied** – Cavalry, RE unit, level equivalent to infantry battalion.

Regiment	**German** – Unit of three battalions, roughly equivalent to a British Brigade.
Register	Confirming fall of artillery or mortar rounds by firing 'trial' shots to observe and adjust them on to their target.
RFA	Royal Field Artillery.
RFC	Royal Flying Corps.
RGA	Royal Garrison Artillery.
RNAS	Royal Naval Air Service.
Rocade	Light trench railway which ran parallel to the front line.
RSM	Regimental Sergeant Major. The most senior NCO in a unit such as an infantry battalion, RA regiment, etc.
Russian sap	Narrow trench dug as if a mine shaft, allowing attacking infantry to cross under part of no man's land without being detected by the enemy.
Salient	Bulge in front line which protrudes (often precariously) into enemy territory. The 'Ypres Salient' is the most enduring example of the First World War.
Sap	Narrow trench dug at an angle from an existing trench for a number of tasks in trench routine. It could be for a listening/observation or machine-gun post, as a communication sap between trenches, or as a covered approach to a main dug-out.
Sapper	Military engineer. Generic term for 'combat' and 'support' engineers in field companies and the 'Tunnellers'.
SB	Stretcher Bearer ('SB' normally shown on SB's armband with Red Cross to signify medical personnel).
SFA/San Fairy Ann	Sweet Fanny Adams – nothing! General expression of resignation to fate: San fairy Ann, a British version of the French expression: *Ça ne fait rien*: it doesn't matter.
Shrapnel	Steel balls thrown out by an exploding shell. Shrapnel is a more commonly used term to describe shell splinters. These are the razor-sharp shards of metal which fly out on a shell's detonation and which cause devastating damage to their victims.
Sicherheitsbesatzung-	German front line and main defensive garrison.
SIW	Self-inflicted wound.
SOS	Emergency protective artillery barrage on one of a number of pre-registered target areas. Normally ordered by the FOO attached to the threatened

	front line unit using a target number by telephone, or *in extremis*, by a series of coloured flares.
Stosstruppen	Local counter-attack troops of a sub-unit within a German division defending a front line.
Strafe	Bombardment or hail of fire, most commonly associated with the actions of the RFC/RAF fighter pilots in the last eighteen months of the war.
Stunt	Generally, a soldier's term for an attack.
Sturmtruppen	German infiltration and specialist attack troops, their tactics developed in the latter part of 1917, and later used en masse for the German offensive (*Kaiserschlacht*) of 1918.
Subaltern	Officer with the rank of Lieutenant or Second-Lieutenant.
Suicide Club	Bombers (grenade-men in a raiding party, or in a major attack).
Tapes	Lines of tape, white or green, laid out to denote the jumping-off line prior to an attack.
Toc H	Talbot House, Poperinghe, near Ypres. An Everyman's Club founded in 1915 on the suggestion of Colonel Reginald Talbot, whose brother Gilbert had been killed in the Ypres Salient. The Reverend 'Tubby' Clayton became its first warden. It was a haven for thousands of troops thereafter, its ethos encapsulated by the sign by the front door which, in effect, reads: 'Abandon rank all ye who enter here'. It remains open as a 'working museum' to this day.
Tour	Period of front line service of a unit, routinely 4–7 days.
Trench-foot	Fungal infection suffered by the troops as a result of repeated exposure to wet and cold conditions. Often became gangrenous if not treated quickly.
Unteroffizier	German rank for NCO equivalent to senior corporal or Sergeant in BEF.
Very	Very light – flare fired from the Very pistol (named after the inventor).
WO	Warrant Officer or War Office.
Woodbine(s)	Australian nickname for British soldier, on account of the universally-smoked issued Woodbine cigarettes.
Woolly Bear	British term for the burst of a German shell, due to the amount and shape of the black smoke thrown out.
Zero	zero day – the day on which an attack or more general offensive began.
	zero hour – the exact time at which the attack/offensive would begin.

Introductory Notes

I have attempted to ensure that all abbreviations are used in full initially within the text. They appear in the glossary also.

The spelling of Flemish names varies, but for the purposes of this book, Mesen, the appropriate Flemish name, is replaced by Messines. Wytschaete (popularly known throughout the war as 'Whitesheets') is also used rather than Wijtschate which is seen on many more current maps. Bois de Ploegsteert/Ploegsteert Wood and Ploegsteert village are noted in the text as shown, or as 'Plugstreet' as it is still popularly known today. Many maps and books or pamphlets will show St Elooi, although St Eloi is preferred in the text of this book. The Flemish name for Ypres is Ieper, although Ypres is used throughout this text.

All German personalities, terms and units are shown throughout the text in italics to distinguish them from British personalities, terms and units.

The term '*Soldatendämmerung*' alludes to Richard Wagner's 'Ring Cycle' (Der Ring des Nibelungen), specifically to the '*Götterdämmerung*' ('The Twilight of the Gods'), indicating their imminent destruction.

The study has used the British, German, Australian and New Zealand Official Histories, *Flandern 1917*, and Alexander Barrie's excellent *War Underground* as its main secondary sources, with the kind permission of the Imperial War Museum (IWM), Bundesarchiv, Australian War Memorial (AWM) and Alexander Barrie respectively. Naturally, many other primary and secondary sources were used, as the text and bibliography reflect.

Foreword

by

Peter Simkins

For the British and Dominion divisions serving on the Western Front under Field-Marshal Sir Douglas Haig, 1917 was a year of transition and mixed fortunes. In the collective folk-memory of Britain, Australia, Canada and New Zealand, the story of the fighting in France and Belgium that year is still largely dominated by images of the lunar landscape of the Ypres Salient and of the mud of Passchendaele, in which hope itself seemed to have drowned. There can also be little doubt that Haig's forces – compelled by the French Army mutinies to bear the main burden of Allied offensive operations on the Western Front – were showing distinct signs of strain at the end of 1917. The war correspondent Philip Gibbs wrote that, for the first time, 'the British Army lost its spirit of optimism, and there was a sense of deadly depression among the many officers and men with whom I came in touch'.

Such gloomy observations notwithstanding, the fact remains that the British Expeditionary Force (BEF) did *not* crack under the terrible pressure and was the only army on the Western Front capable of undertaking *sustained* offensive operations until the closing weeks of the year. The Etaples mutiny in September, which occurred at an infantry base camp and was prompted by a harsh training regime, did not represent a major collapse of morale in *front-line* units. Indeed, for those willing or able to take the long view, there had been some heartening achievements during 1917. These included the brilliant assault on Vimy Ridge by the Canadian Corps, and an advance of 3½ miles by the British XVII Corps near Arras on 9 April; the storming of Messines Ridge in June; the methodical and powerful blows struck by Plumer's Second Army at Ypres between 20 September and 4 October; and the penetration of the Hindenburg Line, facilitated by the massed deployment of tanks, at Cambrai on 20 November.

There is now growing agreement among historians that these successes are evidence of a discernible 'learning process' in the BEF during 1917 – a process of improvement which, however bloody, ultimately placed it at the technological and tactical cutting edge of the Allied armies on the Western Front by the final months of the war. Artillery provided the key to its successes. Creeping barrages – protective screens of shells moving in front of the advancing infantry – became a standard feature of attacks. Greater

accuracy was ensured by better ammunition, by taking more account of meteorological conditions, and by making allowances for the individual characteristics, such as barrel wear, of each gun. German gun positions were more efficiently pinpointed by sound-ranging, flash-spotting and aerial photography. All these techniques made it possible to eliminate the need for lengthy preliminary bombardments and so restore surprise to the battlefield.

With the reorganization of the platoon, the infantry now attacked in more flexible formations, which encouraged initiative and manoeuvre, and they carried extra firepower in the form of rifle grenades and Lewis guns. Trench mortars and heavy machine-guns, often firing barrages, offered additional close support. Tanks, though prone to breakdowns and vulnerable to German artillery, helped the infantry to assault enemy trenches, overcome machine-gun nests and, sometimes, to advance beyond the range of their own artillery, while aircraft were also beginning to be used increasingly in a ground-attack role.

Given that many historians would judge the outstanding assault on Messines Ridge in June 1917 to be one of the most important indicators of the BEF's 'learning process', it is perhaps all the more remarkable that so few detailed analyses of the battle have been published, particularly in recent years. Of course, one would not deny that the Messines attack is inextricably linked with the Third Battle of Ypres, to which it was the essential prelude and with which it is frequently bracketed by historians. Nevertheless, Messines has long merited a separate study and this lively, fascinating and timely account by Ian Passingham – himself a former infantry officer – will therefore do much to fill an obvious gap in the historiography of the First World War. Not the least of the author's own achievements in this – his first – book is that he has paid due attention to what was happening on the German side of no-man's-land, an aspect of First World War battles all too often ignored, avoided or, at best, sketchily covered by British writers, apart from Jack Sheldon. For these and other reasons, Ian Passingham's contribution to the existing corpus of works on the Western Front in the First World War remains most welcome.

Peter Simkins
March 2012

Preface

In the public domain, the First World War casts a dark shadow over our history. It is a shadow which has generated all-encompassing myths about incompetent leadership, careless attitudes towards human life and the dreadful conditions which 'our boys' were forced to endure. All of these things did happen, and much of the First World War *was* characterised by siege warfare and stalemate which was broken only by often apparently futile and costly offensives. Also, the more objective narrative does not suit the idea that virtually every campaign was fought through clinging, sucking, porridge-like mud where British soldiers and their animals were dragged to their deaths as they struggled to advance a yard or two closer to the enemy front line. Certainly, these things did happen. There is no attempt here to suggest that they did not, or that when they did, the futility of war was apparent to even the most hardened soldier in any army. Nevertheless, that is not the whole story.

The problem with such sweeping perceptions of the First World War in particular is that in the past the importance of Allied successes has been qualified by subsequent failures and the view that the German army on the Western Front was able to *inflict* insufferable casualties without *suffering* similar or greater casualties. The German situation 'across the wire' as I prefer to call it, has been generally neglected. Stray shells or machine-gun bullets have never respected either rank or the colour of a uniform; clinging, sucking mud was just as effective in gripping a floundering jackboot as it was a hob-nailed one.

Naturally, the passage of time becomes the mother of myth. Some facts are irrefutable, others debatable and many ignored, in order to suit the story told. Unfortunately, the consequence has been that the tragedy, or 'pity of war', is what many writers and historians have chosen to dwell on. The real pity is that this has largely coloured the more widespread perception of the tragedy and grim reality of this war. On balance, this is because the tragedy is more simple to discern than the ultimate triumph of the Allies on the Western Front against the main enemy – Germany.

Myths have been sustained by brushing aside or playing down the successes. After all, success does not suit the image of butchering and bungling generals and their staffs, donkeys to a man, directing major campaigns from maps in comfortable châteaux miles behind the fighting troops. It does not conform to the belief that senior officers had no idea of the reality of life in the front line. The 'roll of honour' of senior officers killed in action simply does not bear this out. Indeed, one brigade

commander and a divisional commander within Second Army were killed by enemy action during and shortly after the battle for Messines.

Most of us have heard of the Somme, 'Wipers' and Passchendaele, but the full picture of the battles fought on the Somme and throughout the Ypres Salient in the final two years of the war is only vaguely known in the public domain. As we approach the twenty-first century and the inexorable 'fading away' of the veterans who are still with us 80 years on from the year of victory and armistice in 1918, it is most important to honour the soldiers' achievements, as well as the great sacrifices made. Not to do so renders a great disservice to the memory of those who fought and died to secure ultimate victory in 1918.

The battle for the Messines–Wytschaete Ridge in June 1917 was a clear victory and one which has stood the test of time. Yet the name and place, together with the General who masterminded this and other successes between 1916 and 1918, 'Plumer of Messines', are simply not recognised today as they deserve to be.

The final eighteen months of the war saw extraordinary peaks and troughs in the fortunes of the Allies. However, by August and September 1918, the BEF was a well-led, well-resourced and mobile all-arms formation. This is all the more impressive as many of its troops were young (only 18 in 1918) and inexperienced, and the German army fought tenaciously until November and the armistice.

The seeds of the BEF's maturity in 1918 were firmly sown in June 1917 at Messines. It was a victory which gave Haig a golden opportunity to pursue a shaken, demoralised enemy by conducting a Third Ypres campaign while the excellent weather of June and July remained in his favour, but one which he inexplicably missed. The planning, preparation and conduct of the Battle of Messines belied many of the popular myths which surround the First World War. Its legacy was profound and therefore it should stand as a singularly important story.

Ian Passingham
April 2012

© Ian Passingham/Geocad April 1998

GREAT BRITAIN (UK)

English Channel

Dover

Calais
Boulogne
Montreuil

Le Havre

Rouen

Nieuport

Ypres
Messines
Armentières

Mons
Lille

Vimy
Arras
Bullecourt
Albert

Bourlon
Bapaume
Péronne
Somme

Cambrai
St Quentin

Amiens

Beauvais

Soissons
Chemin

Reims

PARIS

Seine

Aisne

Marne

Seine

BRUSSELS

BELGIUM

Liege

Cologne

Coblenz

Rhine

Moselle

LUX.

Luxembourg

GERMANY

Metz

Nancy

Strasbourg

Belfort

VOSGES Mts

Meuse

Verdun
St Mihiel

Châtillon-Sur-Seine

FRONT LINE

F R A N C E

KEY DATES TO END OF 1917:

1st YPRES	21st Oct - 22nd Nov 1914
2nd YPRES	22nd Apr - 24th May 1915
3rd YPRES	31st Jul - 6th Nov 1917

0 50 100 150 200 kms (Approx)

0 50 100 150 Miles (Approx)

Map 1: The Western Front

Prelude

An army which thinks only *in defensive terms is doomed. It yields initiative and advantage in time and space to an enemy – even an enemy inferior in numbers. It loses the sense of the hunter, the opportunist.*
 Gen Sir David Fraser, And We Shall Shock Them *(1983).*

The offensive is the most effective means of making war; it alone is decisive.
 General Erich von Ludendorff, My War Memories *(1919).*

Out with the Old?

Winter 1916

The third and hardest winter of the war. It froze the feet and souls of the men on both sides of the wire: sentinels of their respective front lines, existing in a surreal, troglodyte world. The winter of 1916/17 was the coldest for more than 30 years. Perhaps it was nature's verdict on the conflict which had been fought on and under the soil of France and Flanders since December 1914: it was bleak, iron-hard and enduring. As the season took hold it seemed as though it, like the war, would be endless.

Private Leslie Jungwirth (10th Machine Gun Coy), with 3rd Australian Division, wrote home:

> It has been snowing all day. Our clothes are wet and we have had no chance to get dry. I've felt so miserable. . . . I am in my dug-out trying to sleep but it is impossible, my limbs are aching with cold. . . . The cold: It started to freeze about 12 January and kept freezing. The temperature was down to 10 below zero [Celsius]. A number of men got frozen feet and hands.[1]

The year 1916 had been marked by a grim harvest of human suffering for the Allied and German armies alike. Verdun and the Somme were indelible scars on the memory of those who had fought there and survived. It was the end of another year of mourning for the millions of lovers, fathers, mothers, wives and children at home struggling to cope with their losses.

By the end of the year the Germans in the west had exhausted their offensive capability. Despite the charnel houses of Verdun and the Somme, the Allies had actually achieved more than they had dared to hope, after the disastrous first day of the Somme offensive. It had been the most sustained offensive effort to date and had forced the German soldier from positions which had been considered impregnable. *General Erich von Falkenhayn*, German Supreme Commander at the beginning of the Somme campaign, ordered that: 'The first principle in position warfare must be to yield not one foot of ground; and if it

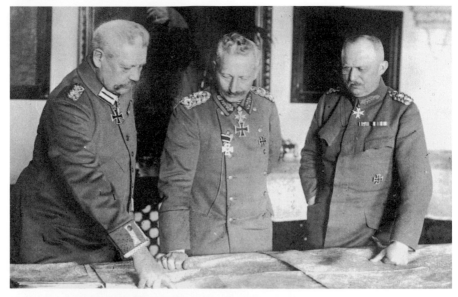

Gen Erich von Ludendorff and FM Paul von Hindenburg with the Kaiser.

is to be lost to retake it by immediate counter-attack, even to the use of the last man'.[2] This doctrine gravely depleted German manpower and many of its most experienced and hardened men. German troops saw Verdun, and particularly the Somme, as the killing fields of the 'Old Guard'. These were the men who had survived the first two years, but whose graves now littered the battlefield.

At the end of August, *Falkenhayn*'s career had become another casualty of the Somme campaign. His profligate use of his troops in the defence of the Somme could not continue. He was replaced by *General Erich von Ludendorff* and *Field Marshal Paul von Hindenburg*. Their mission was to create a radically new defensive doctrine. They were to supervise the secret construction of a new defensive line as the bedrock of future operations on the Western Front, the *Siegfried Stellung*, or Hindenburg line. They were also under pressure to increase their forces, despite the losses of 1916.

The Central Powers had had a bad year. At Verdun, General Robert Nivelle had inspired the reclamation of the territory lost in the German offensives of the spring and summer through a series of French counterstrokes, and had become a hero in France. Gorizia had been taken on the Italian Front. In the east, General Brusilov had destroyed three Austrian armies. Only the Rumanian campaign had offered a crumb of comfort as the solitary success.[3]

As winter wore on, the opposing armies sank into a fitful hibernation while the political and military wheels rolled out new plans for 1917. In 1916 there had developed a new reality to the war on the Western Front: 'attrition', or more graphically in German *Materialschlacht* – a technological war. At the

so-called 'sharp end', the innocence of 'Kitchener's Army' and the millions who had answered their respective nations' call was gone forever. It had been replaced by an implacable, hardbitten determination to do one's duty – and survive. Equally hard lessons had been learned on both sides.

To the commanders on the ground, the COs, junior officers, NCOs and men, nothing much had changed in their daily routine. They lived as best as they could in the front lines. Daily shelling and sniping constantly reminded them that each day might be their last. Comradeship and a common sharing of the often bestial conditions in which the men fought sustained them. They were determined not to let their mates down. Above all, they maintained a stoic acceptance of their situation and a cynical humour at least helped them to make light of their lot – to a point. The 'BEF' and *'Wipers Times'* and Regimental magazines reflected it:

> The World wasn't made in a day,
> and Eve didn't ride on a bus:
> But most of the world's in a sandbag
> and the rest of it's plastered on us![4]

Solace was sought through writing, poetry, keeping diaries (although the latter was officially frowned upon). The soldiers' humour was not confined to the enemy and the General Staff:

Notice

We regret to announce that an insidious disease is affecting the Division, and the result is a hurricane of poetry. Subalterns have been seen with a notebook in one hand, and bombs [grenades] in the other absently walking near the wire in deep communication with the muse and equally deep oblivion of the buzzing of machine guns. . . . Even Quartermasters with 'books, note, one', and 'pencil, copying', breaking into song while arguing the point re 'boots, gum, thigh'. The Editor would be obliged if a few poets would break into prose: as a paper 'cannot live by poems alone'.[5]

Thousands of men were about to join the conflict. They were eager enough to do their bit, but any naïve notions that each may have had of glory and crushing 'Harry Hun' were already consigned to the painful history of the past two and a bit years. Maj-Gen Sir John Monash's 3rd Australian Division were off to France and Flanders after gruelling training on Salisbury Plain. Thousands of soldiers, about to join their units for

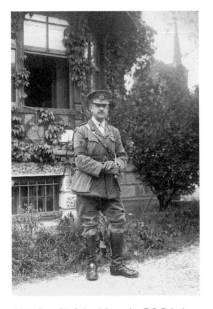

Maj-Gen Sir John Monash, GOC 3rd Australian Division at Messines. He was to become Commander of the Australian Corps in 1918.

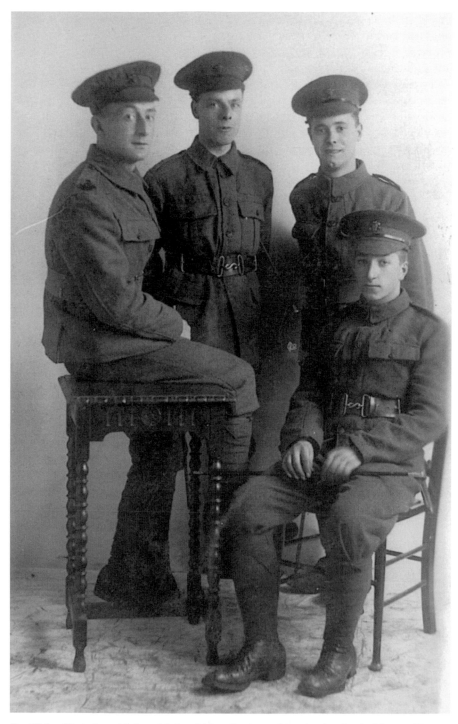

Pte Walter Humphrys (sitting, right) and his colleagues prior to leaving for the Western Front.

the first time, were preparing to cross the Channel also. Among them was 19-year-old Pte Walter Humphrys, who was now old enough to join his battalion, 15th London (Civil Service Rifles) Battalion, of 47th (2nd London) Division. In weeks he would be with his battalion opposite Hill 60 near Ypres. In June he would go 'over the top' at Messines in the Ypres Salient.[6]

'The Salient' – Grasping the Sickle's Handle

The Ypres Salient has been variously described as a skull, a geographical question Mark[7] or more graphically, a giant sickle, '. . . with its cutting edge turned against the British holding the Salient.'[8] (See map 2) Since the winter of 1914 the Ypres Salient had been an almost immovable bulge in the Allied front line. 'Salient' is a term which describes a bulge in a front line which juts out into enemy territory. The town of Ypres lies in Flanders, which means 'the flooded land'. The land was, and remains today, flat and criss-crossed by drainage ditches. Prior to the First World War, these drainage ditches had kept the seasonal flooding in this region at bay. During the first and second Ypres campaigns in 1914 and 1915, much of this drainage system (together with Ypres itself) was destroyed by continual artillery fire.

Thereafter, when it rained much of the battlefield and rear areas were turned into a shell-cratered lunar-like landscape of watery mud. Soldiers in the British and German front lines were forced to live in perpetually inundated trenches, where drainage became virtually impossible. Trench foot and nephritis/'Trench fever' and scores of other illnesses became as common as the effects of the bullet and the bomb. The troops who had served here considered it to be a regular Hell on earth – a place of continued shelling, trench raids and other activities which reduced each man's odds of coming out unscathed.

It had been the scene of some of the most savage and bitter fighting in the latter part of 1914 (First Ypres), and the first use of gas by the enemy on 22 April 1915, which heralded a German offensive designed to snuff out the British resistance around Ypres (Second Ypres). Though the 1915 offensive failed, the salient continued to be overlooked by the German army which held and exploited the high ground. This gave it a dominating and terrifying command over the salient as a whole. The British forces occupying the front-line trenches here were under constant observation and danger from three sides. Even without a grand offensive here, thousands of men had become casualties: victims of German snipers, machine-guns and, above all, the artillery. The unpleasantness of it all was graphically illustrated by place names such as: 'Hellfire', 'Shrapnel' and 'Suicide Corner'; 'Sniper's House'; 'Dead Cow', 'Stinking' and 'Hell Farm'.

Capt Oliver Woodward, of 1st Australian Tunnelling Company summed up the troops' view of his part of it:

> On leaving Ypres by way of the Lille Gate there is seen about two miles distant a low ridge of hills, the highest point of which is slightly over 100 feet above the level of the city. This ridge forms the northern section of what [is] known as 'The Messines Ridge'. Virtually due

Pillars of Fire

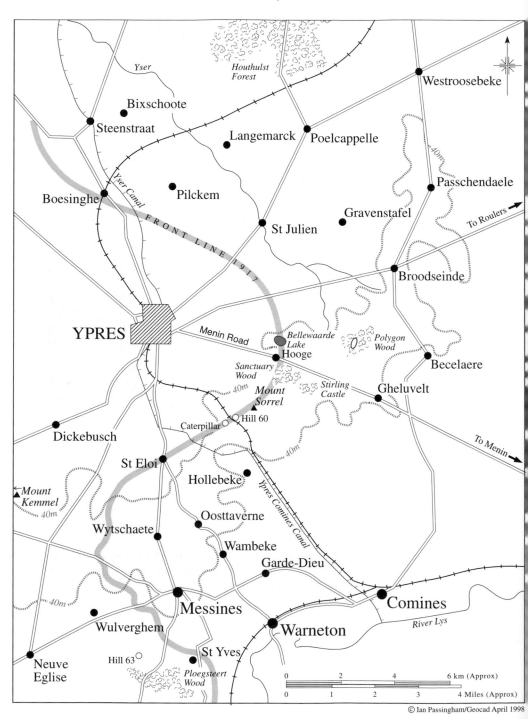

Map 2: The Ypres Salient (1917).

Capt Oliver Woodward and fellow officers of 1st Australian Tunnelling Company, June 1917.

east of Lille Gate, the Ypres–Menin railway passes through this ridge . . . just to the north of the railway cutting here is the highest point 'Hill 60'. Hill 60 was just high enough to dominate the countryside lying to the west and the east. Thus it became a . . . point of great importance to both the British and German forces.[9]

The enemy had the luxury of staring into the salient from their own seats in the circle of this macabre theatre of war. They forced the pace of the drama which unfolded here, obliging the 'players', principally the BEF, to act out the German script.

But Field Marshal Sir Douglas Haig, the British Commander-in-Chief (C-in-C) since December 1915, was planning to change this scenario. The sickle would be seized by the 'handle' in the south and the 'blade' would then be turned against the German garrison to sweep them away. But the southern line of the salient was dominated by the Messines–Wytschaete Ridge, running from St Eloi in the north to St Yves and Ploegsteert ('Plugstreet') Wood in the south. (See map 2) The ridge was already associated with extraordinary events, including the gallant but doomed defence of Messines by the London

FM Sir Douglas Haig, Commander-in-Chief (C-in-C) BEF from December 1915.

Scottish and the 6th Dragoon Guards (Carabiniers) throughout Hallowe'en night 1914, the 'Christmas Truce' and the 'other' war which raged underground from Hill 60 to Ploegsteert Wood and St Yves. This special conflict below the surface of Flanders was to play a starring role in the drama to follow.

To Take a 'Bow'

The ridge would have to be captured if any serious attempt was to be made in the northern part of the salient. It was a vital task, but an extraordinarily difficult one to accomplish. After all, the Germans had been there for over two years and had improved this sector known to them as the '*Wytschaete-Bogen*'. Messines, Wytschaete and the rest of the defensive positions here had been strongly fortified and the defence arranged in depth to prevent any breakthrough. The German defence was shaped like an archer's bow formed by the front line, with the draw-string or chord, known as the *Sehnen Stellung*, as the principal depth position, centred on the village of Oosttaverne. This second main defensive line would have to be taken in order to secure the main Messines–Wytschaete Ridge. It was dubbed the 'Oosttaverne Line' by the British. It would fall to one man uniquely qualified to crack this German nut.

General Plumer – Personal Roads to Messines

By 1917 it was said that Gen Sir Herbert Plumer, Commander of Second Army and the 'warden of the Ypres Salient' for two years, knew every puddle in the salient. One of the most prominent war correspondents of the day wrote of him: 'In appearance he was almost a caricature of an old time British General, with his ruddy, pippin-cheeked face, white hair and a fierce little white moustache, and blue, watery eyes, and a little pot-belly and short legs.'[10] Plumer looked every inch the caricature of the affable yet elderly and out-of-touch General who had apparently orchestrated routine slaughter on the Western Front. Yet this image could not have been further from its mark. His resolute defence of the Ypres Salient had dissuaded any further German offensives since May 1915. His appearance may well have been

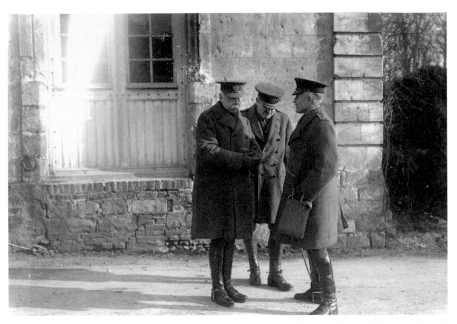

Gen Sir Herbert Plumer (left), Commander Second Army, with Gen Horne (First Army) and Gen Sir Edmund ('Bull') Allenby (Third Army), Army Commanders' Conference concerning plans for 1917, held on 14 February 1917.

David Low's inspiration for 'Colonel Blimp', but those under his command respected his thoroughness and his emphasis on the importance of detailed planning, training and rehearsals for battle, and leadership.

He was an infantryman who had seen action before this war in South Africa and during the many colonial wars characteristic of the latter part of the Queen Victoria's reign. Born in the year of the Indian Mutiny (1857), he was educated at Sandhurst and commissioned into the York and Lancaster Regiment at the age of 19. His first major actions were in the Sudan in 1884. He was the battalion Adjutant as a Captain (Capt) at the battles of El Teb and Tamai. In 1893, now a Major, he served in what was to become Rhodesia (Zimbabwe) where he raised and commanded a corps of mounted rifles and with it assisted in putting down the Matabele rebellion.

By the summer of 1899, he was in South Africa as a Special Service officer, serving under Col Baden-Powell. When the Anglo-Boer war broke out, Plumer was trusted to continue offensive operations while Baden-Powell was diverted by the relief of Mafeking. His outstanding performance throughout the South African War earned him the highest praise and promotion to Colonel and then Major-General (Maj-Gen) by 1902. Lord Kitchener's dispatches of 23 June 1902 underlined this contribution: 'Throughout the campaign, Plumer has invariably displayed military qualifications of a very high order. Few officers have rendered better service.'[11]

In 1902, Plumer was one of the youngest senior officers in the British Army. Between 1903 and 1914, he commanded a brigade and a division, as well as being appointed to Northern District Command and Quartermaster-General, a member of the Army Board. He was promoted to Lieutenant-General (Lt-Gen), and called upon to command V Corps at Ypres in January 1915. At that time, V Corps was part of Second Army, commanded by General Sir Horace Smith-Dorrien, and whom Plumer succeeded in May 1915.

His conduct of the defence of the Ypres Salient, first at St Eloi, then in support of the Canadian action which prevented a German breakthrough after their first use of gas, at Hooge and the Bluff, all convinced his German opposite numbers that there would be little point in attempting a major offensive here between 1915 and 1917.

However, in February 1916 the Germans launched a determined attack in the area of the Bluff, just north of the Ypres–Comines canal. Although they were repulsed, FM Haig criticised Plumer's conduct of the action. In a frank discussion with the C-in-C, Plumer offered to resign. Haig, realising Plumer's many qualities and his potential as a sound army commander, turned down the offer.

With this exception, the effect of Plumer's resolute and consistent operational performance on the ordinary soldiers was described by Lt Brian Frayling, Royal Engineers (RE), an officer with 171 Tunnelling Company which was to play an important role in the events to come:

> Junior officers and other ranks were not supposed to have opinions about very senior officers, but we all knew when we were under General Plumer's Army Command, there was a clear-cut plan and maximum efficiency. Any references to a certain other Army Command [Fifth] were universally unprintable. Everything under General Plumer was successful, under the other a flop.[12]

Plumer was tough, yet sensitive to the conditions in which he was expecting his men to fight and win. He was one of the senior commanders on both sides of the wire who were more thoroughbred than the 'Donkeys' or 'Butchers and Bunglers' observations which have clouded the perception of subsequent generations.

The Promise of Spring – New Hope and Grand Plans for 1917

In 1916, plans had been devised to force the German defenders off the dominating bow-shaped ridges overlooking Ypres from Pilckem in the north to Messines in the south. However, the German offensive at Verdun led to a drastic reappraisal of the priorities for the Allies in 1916 and the Ypres offensive was shelved in favour of the Somme campaign.

The year 1917 had to be different. Surely the sacrifice could not continue on the scale of the outgoing year? To the Allied Chiefs, there was some optimism as the old year closed that Germany was perhaps fatally weakened. It was reasoned that there had to be a plan to match this which would bring

Germany to its knees. The philosophy was that the remaining Central Powers would not resist beyond a German collapse. Following the Chantilly Conference in November 1916, Général Georges Joffre was replaced by Général Robert Georges Nivelle as the French Commander-in-Chief.

Nivelle, the eternal optimist, was convinced that he had a realistic plan to destroy the German army in spring 1917 with a major offensive against the Chemin des Dames in Champagne, where the enemy's position ran north of and parallel to the River Aisne. The Allied plan was to conduct a combined advance on a massive scale, as soon as the weather allowed it, in the early spring and therefore leave the whole of the summer and early autumn to shatter German resistance across all fronts. The concept was simple: carry out a relentless series of hammer blows at different points of German defences on the Western Front, then pile on the pressure elsewhere. Russia and Italy would take the field and press forward or tie the enemy down so that the German army in the west could be defeated. It was a grand idea, with equally grand and almost fatal flaws.

In order for the Allies to advance in such a sweeping manner, there had first to be found a new way to crack the German defensive wall: denting it, or breaking it on a narrow front would not be good enough. It had to be cracked so that it would then disintegrate like a bursting dam. The historical lessons of successful siege warfare still had to be relearned. This was fundamentally an Engineer's war, yet the Sappers' role had been limited. The principles of war needed revision also. Concentration of force was the very essence of a successful assault, but only if it were possible to overwhelm and mystify the enemy by the use of surprise; 1916 had shown that this combination had been largely forgotten.

On 5 December 1916, David Lloyd-George succeeded Herbert Asquith as British Prime Minister. Lloyd-George's view on the war was simple: it must be won and there could be no compromise. He had made this plain in September when interviewed by an American journalist. He firmly rejected US President Woodrow Wilson's ideas on a possible peace settlement by stating that 'there will be no quitters among the Allies', and furthermore that 'The fight must be to the finish – to a knock-out'.[13]

Besides, Germany had disqualified itself from any peace negotiations by cynically asserting that its possession of most of Belgium and much of France was a negotiable asset. Germany, the main enemy, would have to be bludgeoned into a non-negotiable armistice. Lloyd-George's basis for enforcing a suitable conclusion to the war was crystal clear, but his ideas on where to win it were often ambivalent. After the Somme and Verdun, he was not eager to pursue the war by major costly offensives on the Western Front. He saw the Balkans, or the Italian front as apparently seductive alternatives. Then he was himself seduced by the confident, charming and heroic figure of the new French C-in-C, Général Robert Nivelle.

Nivelle had begun the year with a sensational claim which captivated the British PM: his planned offensive across the Aisne. It was a plan heralded

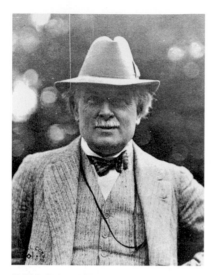

British Prime Minister Lloyd George, who had succeeded Herbert Asquith in December 1916.

as being both operationally sound and technically brilliant. It would help to end the war. It was to take place on the Western Front, which Lloyd-George had apparently rejected. Yet he was hooked. Haig's BEF would be subordinated to Nivelle's overall command and carry out a diversionary operation against the Arras/Vimy Ridge and Bullecourt sectors. This would commit the British First, Third and Fifth Armies from Easter Monday, 9 April, along a 14-mile front. This was in order to draw the majority of the German reserves into the battle and thus make the way clear for Nivelle. His master stroke would be launched with three Army groups across the Aisne a week later. Nivelle was so confident of his success that the plans became almost an issue of public debate. The Germans were most grateful when the full plans fell into their hands in advance.[14]

Haig was wary of Nivelle's exaggerated confidence and proposed an alternative strategy, that of switching the main effort from the Arras area to Flanders and a link-up to the coast, if there was no breakthrough at Arras. Nivelle responded by saying that the success of his main offensive in Champagne would commit the remaining German reserves. Therefore, the 'British would be able to break through wherever and whenever they wished'. Both commanders did agree that 1917 might herald a return to a war of manoeuvre rather than the enduring stalemate. The German plans for 1917 were to rather spoil their ideas.

Haig's vision for the knock-out blow, as Lloyd-George had described it, was firmly focused on Flanders. (See map 3) Haig was convinced that Flanders had a number of advantages as a potentially decisive area of operations. First, in anticipation of possible operations in the Ypres Salient in 1916, Gen Plumer had devised detailed plans and planning options which could be dusted off and utilised for a campaign in 1917. Railways and roads had been improved and developed in a typically thorough manner so that the movement of hundreds of thousands of troops with their weapons and equipment for a major campaign would be facilitated. (See map 4) Most importantly, the 'war underground' had continued and the British miners and tunnellers were winning it. Secondly, the lines of communication and resupply from Britain were short and manpower and materiel could be brought in rapidly. Thirdly, the front line in the north ended at the Belgian coast and provided an open flank which could be exploited by the Royal Navy.

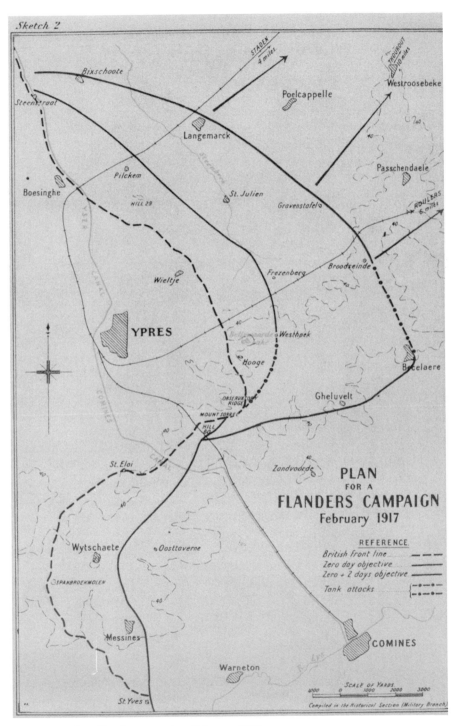

Map 3: Plan for a Flanders campaign, February 1917.

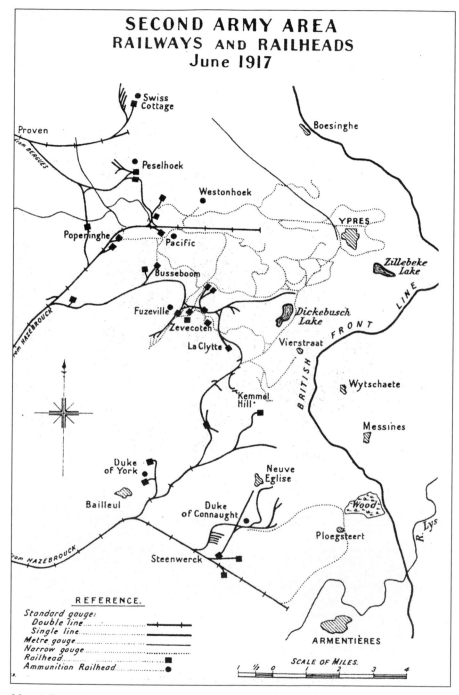

Map 4: Second Army Area railways and railheads, June 1917.

Fourthly, the Royal Navy had advocated a scheme for clearing the Belgian coast to retrieve the ports of Zeebrugge and Ostend since 1915. Germany had used these ports as bases from which to carry out submarine raids on British shipping in the Straits of Dover and the North Sea. By the winter of 1916, the Allied shipping losses as a result of such raids were so great that it seemed vital to tackle the problem decisively. The British Cabinet's War Committee concluded on 23 November 1916 that 'there is no measure to which the Committee attach greater importance than the expulsion of the enemy from the Belgian coast'.[15]

Fifthly, Haig knew the ground of the Ypres Salient well. It was here that he had commanded a corps of the original BEF in 1914. His knowledge of the part of it since held by the German *Fourth Army* was no doubt still fresh enough in his mind. He knew that he could count on Gen Plumer and the Second Army staff. They knew their area of operations intimately, and in particular knew what was and what was not possible against the enemy within it. Nevertheless, the C-in-C regarded Plumer, only a year or two older than himself, as 'the old man'. He thought this infantryman was a plodding infantry sort, a perception perhaps coloured by the Bluff incident in February 1916, rather than a thrusting, have-at-you type typical of a cavalry commander, and of a type most obviously represented by Gen Sir Hubert Gough.

Gen Gough was, at 47 years, the youngest of Haig's senior commanders. He had commanded the 16th Lancers in South Africa, 3rd Cavalry Brigade

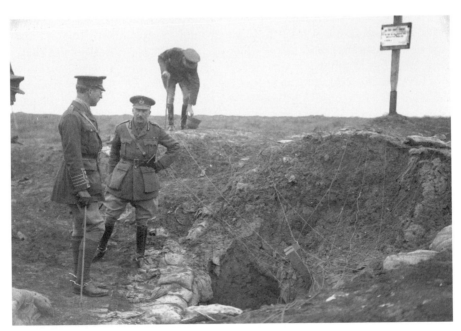

Gen Sir Hubert Gough (facing camera), Commander Fifth Army.

at the outbreak of the war and then I Corps in July 1915. During the Somme offensive, he had been appointed Commander Fifth Army. As an individual he was popular with some, despised by many, and his reputation was not helped by Fifth Army staff and his Chief-of-Staff, Maj-Gen N. Malcolm. Their methods were a stark contrast to that of Second Army. Gough's standing among the Anzac troops in particular was not good as a result of his performance at Pozières in 1916. It was to suffer a further blow after Bullecourt. However, he was favoured by Haig, at least until the third Ypres campaign, for his thrusting attitude. This gave Haig confidence that Gough would be the right man to execute the sweeping campaign which he was planning.[16]

Finally, there was the French factor. Haig was eager to prove that the BEF was capable of taking on and beating the main enemy in the main theatre of operations on its own terms. He was still riled at the criticism it had received prior to the Somme campaign from French military commanders for not pulling its weight while the French Army was slowly bleeding to death at Verdun. Flanders was one sector which belonged almost exclusively to the British and Empire forces.

British Alternatives for the Grand Plan

Although Gen Sir Henry Rawlinson (Commander Fourth Army) had been the original author of a Flanders breakout plan in February 1916, GHQ revised and improved it by the summer of the same year. The revised version envisaged six phases and was to include a diversionary attack towards Neuve Chapelle. The concept of operations envisaged three principal stages: one – take the high ground of the salient; two – break out north-eastwards; and three – link up with forces landed on the coast, supported by sea power.

Therefore, the concept was to oust the German *Fourth Army* first from the Messines–Wytschaete Ridge south of Ypres, secure the Gheluvelt Plateau and then progressively extend over the high ground of the salient north-eastwards, through Passchendaele and beyond. The breakout stage would be realised when the German third main defence line was penetrated. The link-up with the forces moving inland from a simultaneous amphibious operation would fatally disjoint and outflank the German defence. GHQ planned on this entire operation being wrapped up within three weeks of continuous operations by a force of sixty divisions. With this overall concept of operations squared away, Second Army had prepared for a Flanders offensive in the summer of 1916. Verdun forced Haig's hand and he was obliged to turn his sights away from the Ypres Salient in favour of the Somme.

Plumer and his Chief-of-Staff Maj-Gen 'Tim' Harington continued to work on the plan for Flanders, with considerably reduced manpower, throughout the remainder of 1916. Infantry were re-tasked to keep the mining effort going, under Sapper supervision; planning revisions continued and Flanders remained firmly on Haig's priority list. Soon after the Somme

campaign drew to its bloody conclusion on both sides of the wire, Haig discussed the Flanders plan with Plumer. On 17 November 1916, Haig asked him to suggest any changes to it as it stood, or to propose a new plan, based on the use of up to thirty-five divisions, less reserves.

Also, a special planning team had been established some six months earlier at GHQ, Haig's headquarters, to prepare a plan based on the 'breakout and link-up' concept of operations. There was a slightly unpleasant taste to this alternative planning team idea, as its principal authors, Lt-Col C.N. MacMullen and Maj the Viscount Gort were told frankly not to consult with Gen Plumer and Second Army staff. The reason for this secrecy was ostensibly to encourage the GHQ team to come up with a few original ideas of their own. Haig's motivation was more likely that it would give him alternatives if Plumer's actual 'modus operandi' did not conform with his own.

Plumer's resubmitted and updated plan for 1917, presented to Haig on 30 January, perhaps predictably fell short of Haig's expectations. It was sound and almost certainly workable, but was 'altogether too cautious' for the C-in-C. He asked Rawlinson for a second opinion; Rawlinson disappointed Haig by fundamentally agreeing with Plumer's assessment. Both Army commanders agreed that there would be too little room around Ypres for the concentration of the necessary assault divisions and artillery for simultaneous attacks north and south with a simultaneous advance due east to link them. A dissatisfied Haig then turned to the special planning team, adding one or two of his own ideas to throw in the planning melting pot.

With the GHQ version complete, Gort and MacMullen were instructed to present it to Plumer and Rawlinson for comment, but without incorporating any suggested amendments in the plan. The only concession made from the Army commanders' views was Plumer's agreement that he could take the Messines–Wytschaete Ridge on the first day of the offensive with twelve instead of seventeen divisions. Haig added that they should plan for the opportunity of taking the slopes around the Gheluvelt Plateau, as well, as recommended by Plumer. Thereafter, the GHQ operational order became the official plan. Plumer believed that the opportunity to exploit success and push on to the Gheluvelt area was realistic, providing that the Messines–Wytschaete Ridge operation met its objectives. By March, Second Army staff were already planning to exploit such an opportunity.

The Road to Messines – Early Moves:
Alberich, *Arras and* l'affaire Nivelle

There was one small problem with the Allied master plan for victory in the west in 1917: The German High Command. Without the benefit of attending their enemy's strategic conferences, *Ludendorff* and *Hindenburg* had been rather busy making their own plans. In mid-March, under the codename *Alberich* (the Nibelung dwarf in Richard Wagner's 'Ring Cycle'), the Germans rather spoiled the party. They made their own rather dramatic

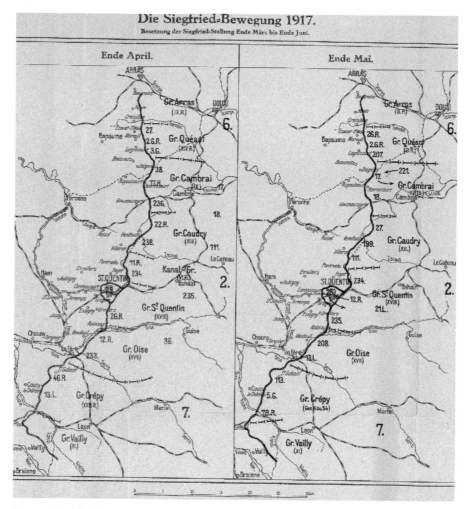

Map 5: *Siegfried Stellung* – the Hindenburg Line – April and May 1917.

gesture by withdrawing to a more solid, flexible system of fortified defences known as the *Siegfried Stellung* or 'Hindenburg line'. (See map 5)

In order to reduce the minimum number of divisions obliged to hold the front line on the Western Front, Hindenburg and Ludendorff had accepted the need for a strategic withdrawal to a more defensible line, giving up as much as thirty miles in places.[17] Though this rather negated much of the planning for the grand offensive along the Chemin des Dames, Nivelle was not to be deterred. The original plan was retained, as Nivelle continued to champion its cause. Despite severe reservations by both British and French politicians and senior military staff, nothing was done to modify or stop it. The BEF attack around Arras/Vimy Ridge was to go ahead as planned.

On Easter Monday, 9 April, under the command of Generals Edmund 'Bull' Allenby and Sir Julian Byng, the British offensive against the Arras front commenced. There were spectacular gains across much of the front. VI Corps, with the British 12th and 15th Divisions making the main assault in its sector, swept all before it and captured German field-gun batteries in the open before they could withdraw. XVII Corps on the left made one of the most outstanding advances of the war, penetrating the German defences over three-and-a-half miles. The Canadian Corps captured the previously unassailable Vimy Ridge. This achievement was largely due to an innovative attacking style against the highly organised German defences. It augured well for what was to come at Messines. The sappers had played an important part. The Canadian troops attacked beneath, rather than over, no man's land through a series of parallel and intricately constructed tunnels, before emerging close to the German front line in force. Surprise was total and a major factor in the Canadian achievement.

The first days of the Arras offensive looked promising for the Allied plan, but disappointment overturned this optimism as the German resistance stiffened and British reserves dwindled. It became evident that no serious thought had been put to the possibility of exploiting an initial success. At Bullecourt, the British and Australian divisions were forced to attack without the planned support of tanks. The attack failed largely as a result of poor planning at Army level. A second attempt would be made in May. Both battles led to considerable resentment among the troops toward Gen Gough's Fifth Army HQ. Overall, the result was another stalemate. Haig might well have suspended operations at this stage, but the offensive was continued to maintain pressure on the Germans in the north to assist the imminent Nivelle campaign.

The Nivelle offensive was launched on 16 April, petered out on 5 May and, as anticipated, was a disaster. In less than a month, the French suffered 187,000 casualties, of which 120,000 occurred within the first four days. Nivelle was hounded out of office by his immediate subordinates in a dramatic demonstration of no-confidence. He was swiftly replaced by Général Henri-Philippe Pétain, but not before the French Armed Forces had begun to suffer their most acute crisis of the war. The losses on the Chemin des Dames had been so avoidably enormous that widespread mutiny occurred.

The implications of this desperate situation were both immediate and far-reaching. First, for months afterwards the best that the French army as a whole could do was to *contain* the German army, while Pétain restored its shattered confidence (which he would do with great skill). Second, the BEF would have to take on the full burden of the war on the Western Front until the autumn of 1917 at the earliest. 'The promise of spring' had been a false one and the grand plans were in danger of resulting in disaster.

Something had to be done – and above all there had to be a clear and rapid response in the form of a victory for the Allies. It was vital, too, for the millions at the 'home front' who were growing as cynical as the troops

about the chances of any discernible success. The Allied leaders agreed to hold crisis talks and review strategy at the beginning of May. The Allied conference of 4/5 May in Paris assessed the failure of the Nivelle débâcle and its consequences. The consensus was that the Allied offensive planned for the Ypres Salient should continue, along with wider operations including the attack on the Belgian coast.

In the longer term, there was the positive news of America's entry into the war, on 6 April, but the immediate military situation would not be helped by this: it would be many months before an American force of any significance could take the field. On the other hand, the shipping losses had continued, which precluded the Balkans military option preferred earlier in the year by Lloyd-George. He had decided against any material assistance to Italy by this stage also. The Western Front it had to be.

David Lloyd-George, the British Prime Minister, summed up the justification underlying this decision: 'The Enemy must not be left in peace for one moment . . . we must go on hitting and hitting with all our strength until the Germans ended, as they always do, by cracking.'[18]

Decision Time

Haig believed that the time had finally come to focus on Flanders: the German army should be defeated here, being forced to collapse on the Western Front by the year's end. The Arras initiative was to be continued only until the focus could be shifted towards Flanders.

On 7 May, Haig brought his Army commanders together. He began by telling them that any uncertainties concerning the summer were at an end. The French offensives had achieved only limited success, but were exhausted. Therefore, the new year's declaration of planned Anglo-French cooperation was over. The principal aim would be to wear down the enemy's resistance. The main blow would fall on the Ypres sector: the Arras offensive would be continued to wear down and divert the enemy only until preparations could be made for Messines.

Haig concluded by declaring that there were to be simultaneous offensives as soon as possible by French, Russian and Italian forces to support the Allied effort to grind the enemy down on all the principal fronts. Messines was to be the preliminary operation for a more general offensive and breakout around Flanders, as Haig had advocated almost two years before. Plumer was asked by Haig when he would be ready to carry out the attack, to which he replied 'In one month from now'.[19]

Thus the date was finally fixed for the battle – Thursday 7 June.

Notes

1 Australian War Memorial (AWM) PR89/63 Private Papers of Pte L.M. Jungwirth, 10th Machine Gun Coy, Australian Imperial Force (AIF).
2 The background to Falkenhayn's doctrine and quote on its execution in the Somme

battles is described in both Ober Kommando des Heeres (OKH): *Der Weltkrieg 1914–1918; Band 10 (1916)*, hereafter also termed *German Official History (GOH)*, p. 355; and Edmonds, J.E. *Military Operations in France and Belgium, 1916, Vol II*, p. 27. (Also referred to by the author here as *British Official History (BOH)*.)

3 Edmonds, *BOH*, 1916, vol. II.
4 *Wipers Times* 1917.
5 Ibid.
6 Pte Walter Humphrys, private recollections.
7 Wolff, Leon, *In Flanders Fields* (London, Penguin, 1958), p. 117.
8 Swinton, Maj-Gen Sir Ernest KBE, CB (ed.), *Twenty Years After: The Battlefields of 1914–1918, Then and Now* (London, George Newnes Ltd, 1938), vol. II, pp. 931–2.
9 AWM Private Records Section: MSS 717 Capt Oliver H. Woodward, 1st Australian Tunnelling Company; Oi/c Firing Party, Hill 60, Messines June 1917: (AWM File 419/118/18); *The Firing of the Hill 60 Mines by the First Australian Tunnelling Company* (donated to the AWM by the author, 10 February 1931.)
10 Gibbs, Philip, *From Bapaume to Passchendaele, 1917* (London, William Heinemann, 1918).
11 Extract from Campaign Dispatches of Lord Kitchener, 23 August 1902, cited in *The Times History of the [First World] War* (London, 1920); see also Powell, Geoffrey, *Plumer, the Soldiers' General* (London, Leo Cooper, 1992).
12 Frayling, Bryan CBE, 'Tunnellers': Article in *RE Journal*, August 1988, p. 174.
13 Wrigley, Chris, *Lloyd George* (London, Historical Association Series, Blackwell, 1992) pp. 80–1.
14 The story of the German acquisition of the plans involved a French SNCO, captured on 3 March 1917. More details found in Edmonds, *BOH*, 1917, vol. I, ch. XIX and Wolff, *In Flanders Fields*, p. 83.
15 Edmonds, *BOH*, 1917, vol. II, p. 8.
16 See Farrar-Hockley, Gen Sir Anthony, *Goughie: the Life of General Sir Hubert Gough* (London, Hart-Davis/MacGibbon, 1975).
17 *GOH, Band 11:* (1917), pp. 55–70, 73–9.
18 David Lloyd-George, quoted in: Edmonds, *BOH*, 1917, vol. II, p. 23.
19 Edmonds, *BOH*, 1917, vol. II, pp. 24–5.

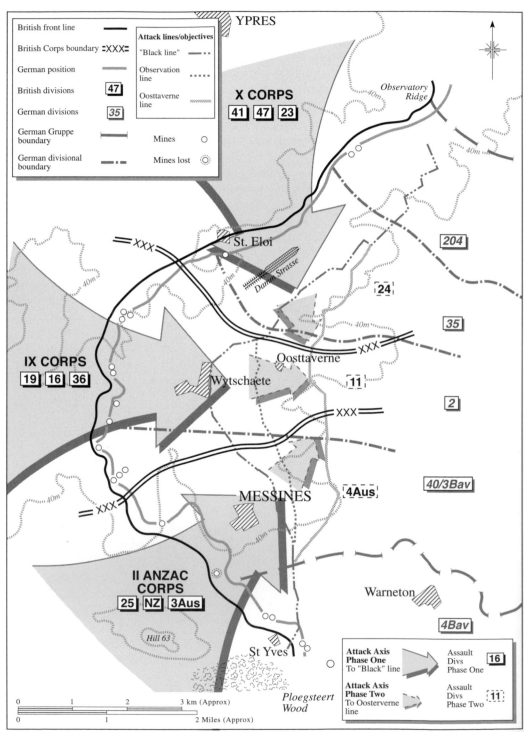

YPRES

X CORPS
41 47 23

Observatory Ridge

204

St. Eloi

Damm Strasse

24

35

Oosttaverne

11

2

IX CORPS
19 16 36

Wytschaete

MESSINES

4Aus

40/3Bav

II ANZAC CORPS
25 NZ 3Aus

Warneton

4Bav

Hill 63

St Yves

Ploegsteert Wood

Legend:
- British front line
- British Corps boundary ⊐XXX⊏
- German position
- British divisions 47
- German divisions 35
- German Gruppe boundary
- German divisional boundary

Attack lines/objectives
- "Black line"
- Observation line
- Oosttaverne line
- Mines ○
- Mines lost ◎

Attack Axis Phase One To "Black" line — Assault Divs Phase One 16
Attack Axis Phase Two To Oosterverne line — Assault Divs Phase Two 11

0 1 2 3 km (Approx)
0 1 2 Miles (Approx)

© Ian Passingham/Geocad April 1998

Map 6: Messines, June 1917. Outline plan for 7 June.

An Orchestra of War

*A perfected modern battle plan is like nothing so much as a score for an orchestral composition,
where the various arms and units are the instruments, and the tasks they perform are their
respective musical phrases. Every individual unit must make its entry precisely at the proper
moment, and play its phrase in the general harmony.*

Maj-Gen Sir John Monash (Commander 3rd Australian Division, Messines 1917 and later
Commander, the Australian Army Corps 1918)[1]

The Stage is Set

Plumer's confident answer to Haig was qualified by the fact that there was
still a great deal to do. Preparations had been going on for a good month
already. Formations and units warned off for the possibility of the assault on
the Messines–Wytschaete Ridge now knew that the plan would go ahead.
The tunnellers had been scrabbling away here for some time already and
many of the infantry divisions that would attack were already holding the
line in this area. The rest had to be brought into Second Army area and
prepared for battle. The arrangements were elaborate and each unit had first
to be brought up to full strength in manpower, weapons and equipment.
Then, Second Army and corps HQ staffs coordinated the necessary training
and rehearsals, passage of operational and administrative orders and a
programme of rest for each unit before the battle. It was often hectic stuff,
but it instilled a general confidence throughout. (See map 6)

Pte Jungwirth (10th Machine Gun Coy, 3rd Australian Division) had
been keen to move away from the 'Nursery' where 3rd Australian Division
had been since arriving in France. The 'Nursery' was a sector of the front
line near Armentières, a few miles south of Messines, where new units were
introduced to the realities of the Western Front. Jungwirth wrote:

> . . . [On 2 May] Fritz raided at 4 a.m. and got in our trenches. We lost 7 killed and about 60
> wounded. None of his men got back. A few taken prisoner, the rest killed. From this day on,
> things got very lively and there were plenty of air fights, but our chaps had Fritz well under.
> The Germans held [the Messines Ridge]. We knew we were going to take that ground from
> then soon. . . . Some of the bloodiest fighting [had taken] place here. But we felt confident
> that we would take it.[2]

Even to the veterans of previous offensives, the preparations were
impressive. To the troops of 3rd Australian Division, about to embark on
their first, it was both awesome and awe-inspiring:

The thousands of guns and heaps of shells gave us confidence. To see the preparations behind our lines was wonderful. No one that had not actually seen it could imagine the magnitude of it. Railways were laid from main lines, new roads made, hundreds of light Rlys [railways] branching from the heavy lines. Motor trains ran right up to the trenches. Men, guns and ammunition could be rushed to any part at anytime . . . 60,000 shells a day were sent across to [Fritz] and . . . millions of machine gun bullets. . . . His men were afraid to go for their rations and went hungry for days.[3]

The Dream Team

Plumer was an excellent communicator and he ensured that both he and his Chief of Staff consulted widely on operational and administrative issues. Both visited subordinate HQs regularly and the troops knew the General affectionately as 'Daddy Plumer', or 'Old Plum and Apple'. Lt-Col Philip Neame, who had won a VC at Neuve Chapelle, saw Plumer as '. . . one of the best Army Commanders. . . . He was so personally in touch. He would be up and see the troops and talk to them in the way they understood, and he'd talk to any junior officer . . . – he would be interested in what was going on and interested in the person. And there is no doubt his judgement of the war was very fine'.[4] Pte Frank Dunham, a Stretcher Bearer (SB) with the 1/7th London (City of London) Battalion of 47th (2nd London) Division, was moving up the line towards Messines at the end of May when: 'En route, we came upon General Plumer . . . standing just off the roadside to take our salute, and a few days later our CO read out to us a message he had received from the General, complimenting us on our good bearing. Probably every battalion received the selfsame message; nevertheless, these little "pats on the back" were good tonics for the "Tommy".'[5]

Despite the more common touch with the soldiers and junior officers,

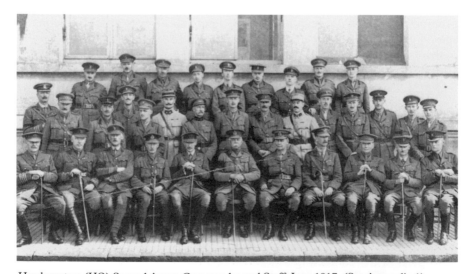

Headquarters (HQ) Second Army: Commander and Staff, June 1917. (See Appendix 1)

Plumer demanded from them the same high standards and attention to detail that he expected from all under his command. He was hard-nosed enough to accept that even successful actions against a determined enemy in the white heat of this war would result in relatively high casualties. He mitigated against this by meticulous planning, training, rehearsals and the issuing of orders down to the lowest common, but most important, denominator: the private soldier, trooper, gunner and sapper. Plumer had established an excellent reputation already: 'Plumer . . . was, in some ways, the most talented of all [of FM Haig's Commanders]. . . . Even before Haig became C-in-C, one divisional commander declared: "Popular opinion pointed to Haig as the 'pretendant', though Plumer would probably have had the army's vote". This was long before he had won his important victories.'[6]

Most importantly, Plumer's relationship with his Chief of Staff, Maj-Gen Charles 'Tim' Harington, and Second Army staff, and their relationship, in turn, with the troops which they served was a model of efficiency and cooperation. The correspondent Philip Gibbs wrote, 'There was a thoroughness of method, a minute attention to detail, a care for the comfort and spirit of the men, throughout the Second Army staff which did at least inspire the troops with the belief that whatever they did in the fighting . . . would be supported with every possible help that organisation could provide'.[7] Harington told Gibbs at the end of 1917 that 'It was my ambition to make cordial relations between battalion officers and the Staff. . . . The Second Army staff has been able to show the fighting soldiers that the success of a battle depends greatly on efficient staff work, and has inspired them with confidence in the preparations and organization behind the lines'.[8]

Harington's own philosophy was simple: that all staffs exist to help units, and not make difficulties for them. This position perfectly suited the maxim that: '. . . the best means of organizing an army . . . is to: 1 – Give the command to a man of tried bravery and experience, bold in the fight and of unshaken firmness in danger; 2 – Assign as his Chief of Staff a man of high ability, of open and faithful character, between whom and the commander there may be perfect harmony'.[9]

It was a doctrine which not only inspired confidence in the Commander and his staff by the fighting units, but also promoted the belief that this was a winning team; a belief which was to prove to be unequivocally justified. Their guiding principles were what Plumer termed as the Three Ts – Trust, Training and Thoroughness.[10]

The difference between this harmonious situation and that which existed between Gough's Fifth Army staff and the troops under their direction could not have been more different. Lt-Col Philip Neame underlined the reservations of the troops: 'The only serious criticisms or complaints that I heard were against Gough's Fifth Army. It got to the stage where everyone hated the idea of going to Gough's Fifth Army.'[11]

Typical of the contrast in attitudes was that of the men in 4th Australian Division, warned off for Messines so soon after their experience at

Bullecourt. Unlike 3rd Australian Division, for which Messines was its debut in a major offensive, 4th Australian Division had gained wide experience on the Western Front already. It was heavily involved at Pozières during the Somme offensive in 1916 together with 1st and 2nd Australian Divisions, where the combined casualties of these divisions from 23 July to 3 September had amounted to 23,000, of which were over 7,000 killed. Yet they had inflicted similar casualties on an increasingly desperate German defence against all the odds.

Then, in April 1917 4th Division fought at Bullecourt. The plan was to use Fifth Army to assault the formidable Hindenburg line near the village as a diversionary operation separate from the main offensive around Arras. The 4th Australian Division was to assault the German line to the right of the village, then sweep right to left along the Hindenburg line, creating the conditions for 62nd British Division to then assault and capture the village itself. The final phase of the battle would exploit the success of this plan by allowing a link-up between the two divisions and a deep penetration into the German depth positions. The actual result was nothing short of a fiasco. The preliminary artillery barrage failed to cut much of the massive fields of barbed-wire in front of the German positions, so Fifth Army HQ decided to use the tanks which were to support the attack to flatten the wire. Gen Gough was persuaded by a relatively junior Staff officer in Fifth Army HQ that this could be achieved safely for the tanks only if the planned creeping artillery barrage planned to assist the infantry assault was cancelled. Then, most of the tanks failed to arrive and the 4th Australian Division was ordered to attack without the support of tanks or artillery. Once again, poor planning and execution of the attack plan left the Division exposed to determined German resistance, but 4th Australian Division managed to enter the German second defensive line before being forced back by sheer weight of fire by the enemy and because of conversely ineffectual artillery and other fire support of their own. As a result, the division suffered 3,000 casualties.

The common denominator in 4th Australian Division's experiences at Pozières and Bullecourt was Gen Sir Hubert Gough and his Army staff. The confidence of the officers and men of the Australian divisions commanded by Gough was seriously undermined, a fact which was both inevitable and enduring. When 4th Australian Division was given its orders to prepare for Messines, its morale was lifted by the knowledge that it was to be relieved at least of the responsibility to continue its association with Fifth Army. The Aussies felt that they would be better served by Second Army HQ as their new masters, though their recent experience had hardly made them relish the prospect of another major battle within two months of Bullecourt. For many of the Australian troops it was still a grim prospect.

The division had become hardened to the realities of the war and had adopted an uncompromising attitude in dealing with the enemy, as Messines would show. Their disillusionment with the news of being involved in this forthcoming battle could have affected their morale badly. That it was not,

was the direct result of both the move out of Fifth to Second Army and the fact that 4th Australian Division had one of the most able and experienced divisional commanders within the BEF: Maj-Gen William Holmes. He became a citizen soldier at the age of 10, commissioned in 1886 and, by 1903, had become CO of his parent unit, 1st Infantry Regiment of the New South Wales colonial forces, which he had joined as a bugler. He served with distinction in South Africa against the Boer and saw action at Colenso, Pretoria and Diamond Hill. His courage during these actions was reflected by his award of the DSO, Mentions in Dispatches and promotion to Lieutenant-Colonel. From 1912, he commanded the Australian 6th Brigade and at the outbreak of the war was appointed as commander of the Australian Naval and Military Expedition Force, which captured German New Guinea, before he was selected to command 5th Infantry Brigade from March 1915 for the Gallipoli campaign. He commanded the brigade with excellent and inspirational skill throughout the ill-fated campaign until the evacuation. He remained in command during the brigade's training for and actions on the Western Front, most notably on the Somme in 1916. With this track record, he was a natural and wise choice for the command of 4th Australian Division. His trust in his men and his example as a highly experienced field soldier and commander were the perfect combination of leadership which 4th Division so sorely needed at this time.

A Commonwealth of Nations and Nationals

In fact, one highly significant factor in the planning for Messines was that compared to the opening of previous offensives on the Western Front, the troops assembled for this attack were a genuine commonwealth of nationalities. As well as the Australians, there were New Zealanders ('Kiwis'), already established as tough and resolute in both Gallipoli and at Flers (Somme) alongside 41st Division on the day that tanks were first used – 15 September 1916. The 41st Division was an excellent mix of Home Counties men from Surrey, Kent, Middlesex with the Hampshires, the King's Royal Rifle Corps and Royal Fusiliers. There were also the proud men from the coal and slate mines and the rugged farmland of north and south Wales. For the first time (at the express wish of Plumer himself), Southern Irishmen and Ulstermen were to fight alongside each other. This was a little over a year after the bloody fighting of the Easter Rising in Dublin, but Plumer suggested that this time they would feel a great deal better by fighting the Germans rather than each other. Both the 16th (Irish) and 36th (Ulster) Divisions had distinguished themselves on the Somme, having established a fearsome reputation and admiration from the enemy. Now they had an opportunity to prove that they could do the same together. The character of each division was not in doubt and personalities within each division gave hefty testament to their ability to turn on the charm as well as the aggression from the top downwards.

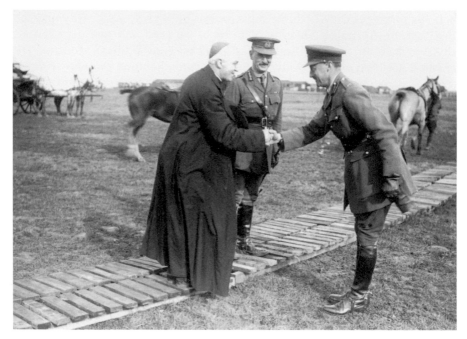

Maj-Gen W.B. 'Willie' Hickie (centre), GOC 16th (Irish) Division, with Cardinal Bourne and
Brig F.W. Ramsey (48th Brigade).

Maj-Gen William ('Willie') Bernard Hickie, GOC 16th (Irish) Division,
was typical of the personality. Born into an Irish Catholic family, partly of
Spanish descent, he was an energetic 52 in 1917, having already completed
31 years in the Army. He had seen operational service in Egypt, India
and South Africa during the Anglo-Boer war. His military reputation
was established by the outbreak of the First World War and he was given
command of 16th Irish Division when it was deployed for front line
service, in preference to Sir Lawrence Parsons, the first GOC and who
had been responsible for its formation and training. Lt-Col Hammond, a
senior staff officer with 16th Irish Division from its inception, was asked
by Sir Lawrence to sum Willie Hickie up. After suggesting that he would
be eminently qualified for senior command when it came along, Hammond
also noted that he was: 'a fine looking man, full of charm and with a bit of a
reputation with the ladies. [He is] . . . a very clever fellow, and he is a really
good sort, though a great talker and a bit of a windbag'![12] It was a reputation
which suited the man and those under his command, a common thread
which was to bind the Irishmen together for the forthcoming offensive.

The remaining divisions came from almost every enclave of the cities,
towns and countryside of England: men from the north, north-west and
north-east, London, the Midlands, and others from the southern or home

counties. Most of the divisions were already part of Second Army, or knew this part of the salient well.

The 23rd Division recruited from the north Midlands and the north and north-east of England, including two battalions of General Plumer's former regiment, the Yorks and Lancs, and included the Northumberland Fusiliers, Green Howards, Sherwood Foresters, King's Own Yorkshire Light Infantry (KOYLI), the West Yorkshire Regiment and Durham Light Infantry (DLI).

By this time 47th (2nd London) Division was in the line near Hill 60, having been there for some months. The division still retained a very parochial reputation, so its units were known as, for example, the Post Office Rifles, the Poplar and Stepney Rifles, London Irish Rifles and the Civil Service Rifles Battalions of the London Regiment. By 1917 its territorial force – 'Saturday night soldiers' – had really come of age and were to play a prominent part in the battle.

Training and Tactics

Second Army's preparations for the battle were characteristic not only of detailed planning, but also of the most up-to-date training, based on lessons learned from previous campaigns such as the Somme as well as the more recent offensives around Arras and the Chemin des Dames.

The Somme had demonstrated the tactically decisive advantage of platoon weapons such as the Lewis 'light' machine-gun, the rifle-grenade and the Stokes light mortar. These weapons improved the infantry's chances of fighting their way forward without the advantage of an artillery barrage if it had moved too far ahead of the assaulting troops. Such weapons were becoming more plentiful for infantry platoons and companies. Experience was to lead to their more skilful and effective use.

The winter of 1916/1917 had seen the publication of two vitally important army-issued pamphlets which distilled and sought to apply the tactical lessons learned in 1916 in particular. The first was SS 135: *Instructions for the Training of Infantry Divisions for Offensive Action* (December 1916); the second was SS 143: *Instructions for the Training of Infantry Platoons for Offensive Action* (February 1917). Both were absorbed and translated in practical terms in typically assiduous fashion by Second Army staff. They would be applied for the Messines battle. SS 135 acknowledged the importance of the creeping barrage and the primary role of artillery to fire the infantry onto the enemy objective, supported by mortars and Vickers machine-gun barrages. Thereafter, enemy resistance would be broken by a combination of snipers, Stokes mortars, Lewis guns, rifle-grenades and smoke barrages, ultimately followed by the infantry assault using riflemen and 'bombers' (grenade-men) to mop up any enduring enemy pockets of resistance. SS 143 developed this framework by providing the detailed instructions for the structure and tactics of the infantry platoon. The use of waves of infantrymen going over the top in extended line was a tactic that was to be gradually phased out.

From these crude beginnings, the infantry platoon was to become a self-sufficient, specialist group, based on a small platoon HQ and four sections (approximately seven to ten men per section). Each section was to have a particular task: the first being the 'bomber' or grenade-specialist section, the second providing the Lewis gun section, the third providing the 'assault' section (normally with a sniper and a 'scout'), and finally, the rifle-grenade section, which would have four specialists assisted by their protection party of a further four or five men.[13]

The New Zealand Division, under Maj-Gen Sir Andrew Russell's personal direction, took steps to apply the new tactics zealously. Russell, like Plumer, was a meticulous and thoughtful commander in preparing his men for battle. Not only were the new tactics and plan for Messines rigorously rehearsed, but also each commander, from brigade to section level, had gone forward before the battle to see the ground over which they were to attack. Every man knew his task and that of the units on each flank.

Most importantly, Plumer and Harington were disciples of other innovative methods which had been advocated by Pétain. In Second Army, staff and regimental officers were already being sent to French tactics schools to familiarise themselves with the evolving tactical and operational doctrine. Despite the long-held myth that senior officers and their staffs were incapable of learning lessons from the mistakes of previous battles, it had become clear during the Somme offensive that the Allies were developing alternative methods which were severely testing German defensive resolve. In a less than a year, lessons had been learned and applied. Examples were the use of surprise, the creeping barrage, improvements of artillery munitions such as the '106 instantaneous fuse' (more effective in cutting wire), the development of 'fire and manoeuvre' infantry tactics, the use of tanks, closer ground–air cooperation, the application of the increasing accuracy and range of the Allied artillery and the use of sound-ranging and 'flash-spotting' methods to pinpoint enemy artillery.

Messines was to show that these developments were becoming integral in evolving tactical methods to defeat strong German defences and would reflect the growing Allied consensus encapsulated by the principle of 'bite and hold' operations. Despite the relative inactivity of the French forces at this time as a result of the fallout from the Nivelle offensive, Pétain was already planning for a revival of French offensive spirit. This would be reflected by two remarkable successes in August and September at Verdun and on the Chemin des Dames. In both cases, much of the foundation for each of the victories would be laid by the example and lessons learned from Messines, a fact acknowledged by Pétain in his operational directives for 1917.

At the tactical level then, all the troops were given detailed orders of their tasks and their role in the battle as a whole. Similar detailed training had been applied successfully also at Arras/Vimy in the spring. The use of carefully prepared, accurate scale-models was manifest throughout the army, ranging from the Second Army model of the whole battlefield area at Scherpenberg down to platoon-level models of company, platoon

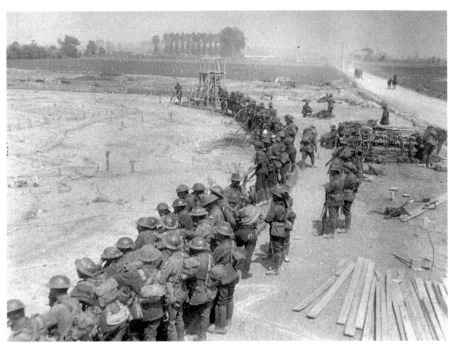

Troops from 3rd Australian and 25th Divisions study the scale model of the battlefield, 6 June.

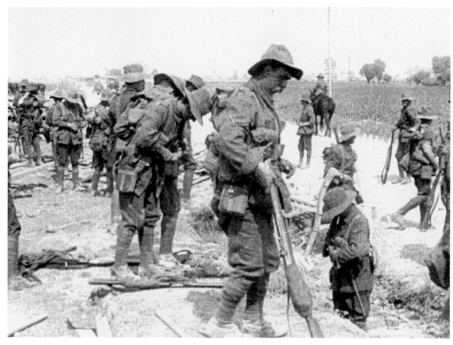

Troops of 3rd Australian Division leaving the scale model area.

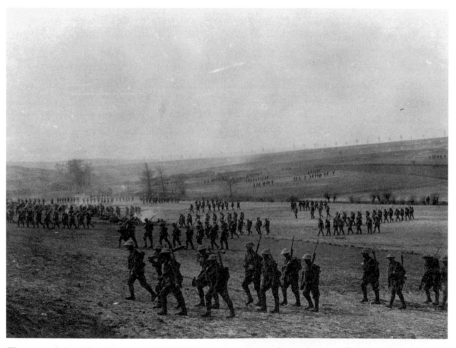

Troops of the New Zealand (NZ) Division conduct rehearsals near Scherpenberg for the forthcoming battle, 2 June 1917.

and even section objectives. Equally, training and rehearsals returned to first principles, such as individual shooting skills and fitness. This rapidly graduated to collective tactical training at platoon, company and battalion level to inculcate the wider tasks and responsibilities of units for the battle. In addition to the models, large areas were laid out behind the lines to rehearse each battalion, brigade and corps for its particular role. This they did several times. Each battlefield rehearsal area was laid out to scale and enemy positions, including pillboxes, machine gun posts and headquarters, denoted by various markers such as location boards, flags and different-coloured tapes. At the end of each rehearsal, there would be training conferences to carry out a critique from which suggested improvements were welcomed. Where relevant, adjustments were made to the plan.

The training throughout May was hard, relentless and exhausting. Nevertheless, when the time came, the troops were ready and more confident on the outcome of this battle than of any other in which they had fought before. Pte Victor Fagence, a Lewis gunner with the 11th Royal West Kents (122nd Brigade of 41st Division), described the preparations:

> We did sort of open warfare . . . attacking [mock] trenches that had been temporarily built by an opposing company or battalion. . . . We would be doing the same sort of thing that we would be doing in actual combat. . . . It was all explained to us and models were shown, models to scale showing our front line, No Man's Land, the enemy front line . . . and how far our objective would be. . . . It was all pretty good really.[14]

Plumer's view was that his troops should train hard and consequently fight more easily. It suited his philosophy that the Army must be built from the bottom-up, the foundation of the three Ts.

Thorough planning was characteristic of all of the corps and divisional HQs, and this was passed on down the line. The scale of the detail communicated to subordinate units before battle was joined varied considerably, as it would in any large organisation. Sir John Monash considered himself fortunate to be commanding his division within Second Army. He saw it as an organisation which put into practice much of what he had been preaching during the division's formative period in the UK and at the 'Nursery'. Monash prided himself on his attention to detail. As a professional engineer outside army life, he regarded the meticulous planning for this battle as he might a civil engineering project.[15] Notwithstanding this, he realised that he had an excellent mentor. He wrote home on 19 May that: '[Gen Plumer] The Army Commander spent all yesterday afternoon with me, going patiently and minutely through the whole of my plans, and said [that] he felt sure that I had done all that was possible to ensure success'.[16]

Monash was to call this first major battle for his 3rd Division his 'Magnum Opus'. One guiding principle was that of giving to each of his brigade commanders as much information on the operation as early as possible and in as much detail as possible. Consequently, the first lengthy draft of the orders for Messines, entitled 'Magnum Opus', was produced between 9 and

14 April, two months before the event. There would be another thirty-five instructions which covered everything from the concept or design for battle down to detailed platoon-level tasking, including techniques to defeat enemy strongpoints. The administrative detail was as vital to him as the operational planning and his influence was evident concerning both.[17]

Principles of War

Second Army was well-drilled in the principles of war long before the battle. The aim was crystal clear and every man knew what he was expected to accomplish. The troops built a detailed knowledge of their tasks through orders, briefings, rehearsals and the models which were built to scale representing the ground over which the battle would be fought. Morale was high. Cooperation was the watchword at all levels of command. The administration, or logistics, of the operation were remarkable. Surprise was planned through the exploding of nineteen enormous mines beneath the German front line. Offensive spirit was to be the key once the mines were blown and the infantry assaulted the German defence.

Above all, Plumer had achieved the concentration of force so vital for success. Linked to that, he foresaw that all-arms cooperation was a battle-winning factor. This meant that the supporting arms – namely engineers, artillery, machine-guns, tanks and aircraft – were brought together to improve the chances of the infantry's ultimate tasks of closing with and killing the enemy, achieving its objectives and then consolidating and holding the ground taken.

Plumer's philosophy was encapsulated by Maj-Gen Sir John Monash:

> The true role of the Infantry was not to expend itself upon heroic physical effort. . . . But, on the contrary, to advance under the maximum possible protection of the maximum possible array of mechanical resources: guns, machine-guns, tanks, mortars and aeroplanes . . . to be relieved as far as is possible, of the obligation to fight their way forward.[18]

Arras had confirmed that the new German flexible defence methods had a number of flaws which could be exploited. Plumer's formula to achieve this was based on the principle of unleashing a locally overwhelming concentration of force on a narrow front, consolidation of objectives and the deliberate 'come-on' to the enemy's counter-attack forces. Therefore, Plumer intended to invite the main counter-attack forces into a pre-planned 'killing area' where they would be systematically destroyed by the massive use of a combination of artillery, mortars, machine-guns, infantry Lewis gun and rifle fire.

A Singular Plan

Therefore, the aim was to defeat the German garrison occupying the Messines–Wytschaete Ridge in detail. The plan was to 'pinch out' the southern part of the salient by assaulting the whole of the Messines–Wytschaete Ridge with three corps. There would be nine initial

assault infantry divisions and three reserve infantry divisions, over 150 battalions, giving a total assault force of 80,000–100,000 men.

Plumer had the artillery plan he required with the necessary guns and ammunition, as well as excellent and innovative Gunner commanders, staff and men. The Royal Engineers, or Sappers, were responsible for the explosion of the mines beneath the German front line at zero hour. The Gunners would be assisted in turn by the Royal Flying Corps (RFC). Its principal tasks were to identify German artillery positions as targets for counter-battery (CB) fire, to adjust artillery fire to support the assaulting infantry once the battle was joined, including low-level strafing attacks on German troops and defensive positions, and to disrupt enemy movement in the German rear areas.

Infantry

The three Corps allotted for the operation were (north to south):

- X 23rd, 47th (London) and 41st Divisions designated as the assault divisions, with 24th Division as the Reserve;
- IX 19th (Western), 16th (Irish), and 36th (Ulster) Divisions (assault), with 11th Division as Reserve;
- II ANZAC 25th, New Zealand and 3rd Australian Divisions designated as the assault divisions, with 4th Australian Division as Reserve.

Once the Messines Ridge was secure, the Reserve divisions would assault the final objective – the Oosttaverne Line.

In reserve for Second Army:

- XIV Corps i.e. Guards, 1st, 8th and 32nd Divisions.

Tasks

The three principal tasks for the offensive were to be: first – to capture the enemy position on the Messines–Wytschaete Ridge, including the villages of Messines and Wytschaete (see maps 7 and 8), from Observatory ridge in the north to St Yves in the south: a front of about 10 miles; second – to capture as many as possible of the enemy's guns behind the ridge; third – to secure and consolidate a final objective east of the ridge (the Oosttaverne Line) and establish a series of posts in advance. Subsequent operations to exploit a success at Messines would be planned for and carried out as ordered.[19]

The second-phase/final objective was defined as the Oosttaverne Line, which stretched like a chord across the base of the Wytschaete Salient. This conformed in the main with the German depth position: the *Sehnen Stellung* ('bow-string') of the *Wytschaete-Bogen*. There would be two main phases:

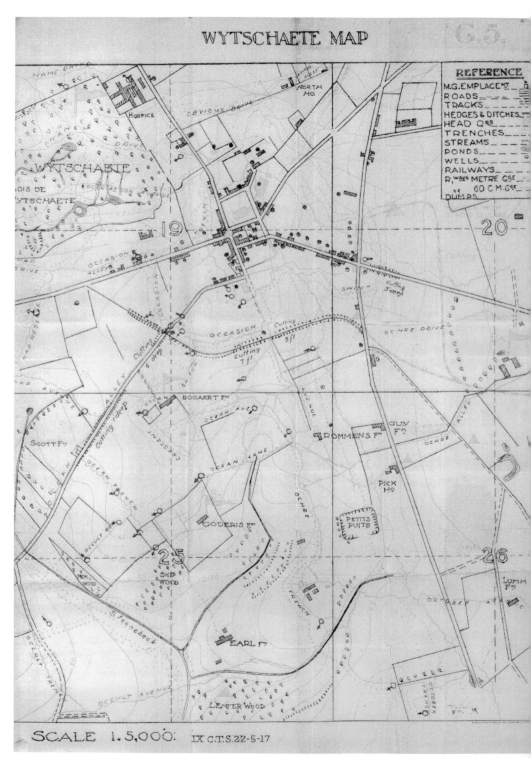

Map 7: Wytschaete: Second Army/IX Corps Intelligence estimate of enemy dispositions as at 22 May 1917.

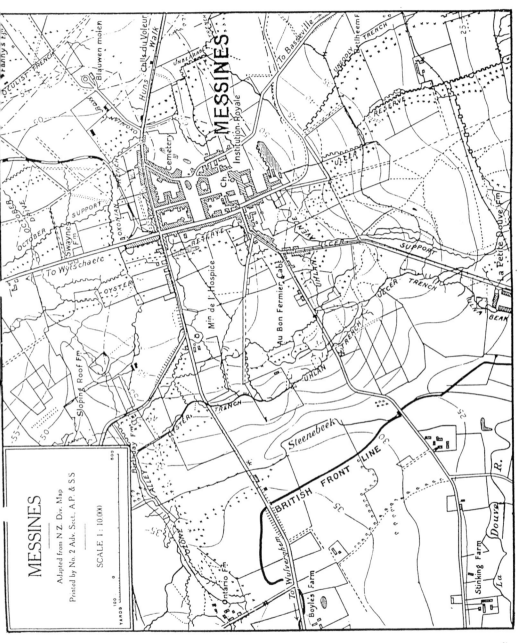

Map 8: Messines: principal defensive layout, 1917.

the capture of the Ridge ('Black' line) and then the Oosttaverne Line. The intermediate stages ('Red', 'Blue' 'Green, and 'observation'/'Black dotted' line) would allow time for consolidation of gains made and fresh troops to move on to the next stage.

Notes

1 Gen Sir John Monash KCB, *The Australian Victories in France in 1918* (Battery Press for the Imperial War Museum, originally published in 1920).
2 AWM PR89/63 Private Papers of Pte L.M. Jungwirth, 10th MG Coy AIF.
3 Ibid.
4 Private Recollections of Lt-Col (later Lt-Gen Sir) Philip Neame, VC, KBE CB DSO DL: *Western Front; Life and Operations*, Reference No. 000048/15: Imperial War Museum (IWM) Department of Sound Records (Sound Archive).
5 Pte Frank Dunham, private records.
6 Terraine, John, *The Western Front; 1914–1918* (London, Hutchinson, 1964).
7 Gibbs, Philip, *Realities of War* (London, William Heinemann, 1920), pp. 389–90.
8 Maj-Gen Sir Charles ('Tim') Harington; in conversation with Philip Gibbs following a press conference at the end of the Third Ypres ('Passchendaele') campaign. Quoted in Gibbs, *Realities*.
9 Jomini, Lt-Gen Henri Baron de, *Summary of the Art of War* (Paris, Anselin, 1838). Translation (Philadelphia, Lippincott, 1871).
10 Harington, Gen Sir Charles ('Tim'), *Plumer of Messines* (London, John Murray, 1935), p. 79.
11 Neame, *Western Front*.
12 Quoted in Dr Terence Denman, *Ireland's Unknown Soldiers: The 16th (Irish) Division in the Great War* (Black Rock, Co. Dublin, Irish Academic Press, 1992), p. 57.
13 SS135/SS143: For an excellent and detailed account of this evolution of tactics and the operational art, see Paddy Griffith's study, *Battle Tactics of the Western Front* (London/ New York, Yale University Press, 1994).
14 Private Recollections of Pte Victor Edgar Fagence, *Western Front; Life and Operations*, Reference No. 000327/08: IWM Sound Archive.
15 AWM (DRL2316 Item 79/3 (1934)), *War Letters Of General Sir John Monash* – Extracts from volume II, 14 March 1917 to 28 December 1918: Letter to his wife, dated 1 June 1917; (*War Letters*, p. 301).
16 Ibid., pp. 298–300.
17 Monash Papers (AWM DRL2316), Item [25] Personal Box No. 15: Period 1 April to 31 July 1917, including hand-written and typed draft orders and instructions.
18 Maj-Gen Sir John Monash, quoted in Pedersen, Peter, *Australia's Commanders* (University of Melbourne Press, 1989), p. 98.
19 Second Army Operational Order for Messines; quoted in Harington, *Plumer of Messines*, pp. 85–96.

Instruments of War

I Artillery

It is with Artillery that war is made.
Napoleon, 1809

Background (see Appendix 1, p. 192)

The contribution of the artillery at Messines was to be a battle-winning factor. Plumer was well aware that the art of gunnery was evolving, together with the technological capabilities of both the guns and the ammunition used. Lessons had been learned from the Somme and more recently from the Arras offensive and they were rigorously applied by the Gunners, with the full sanction of Plumer. Messines was to mark an important phase in the further evolution of the BEF's artillery methods.

Before the battle – defining the need

The concentration of guns was unprecedented. Plumer demanded and was given the number of guns of different calibres and ranges which would be necessary to do the job. The artillery plan was meticulously calculated and planned. The allocation of the guns was based by tasks on careful mathematical analysis rather than on a more vague notion that more guns would guarantee greater effect. The opening phase of the Somme offensive had proved a costly example of this assumption. This time there was to be no compromise. Painstaking staff work by the artillery planners provided Plumer with the most accurate estimates of the requirements. As little as possible was to be left to chance.

As an example of this artillery appreciation (i.e., the analysis of the artillery's role for the battle as part of the overall plan), the total of heavy guns and howitzers required for the forthcoming attack was assessed as follows:

a. The frontage for Second Army was 17,000 yards (approximately 10 miles).

b. All German guns within 9,000 yards of the frontage were to be neutralised. There were 169 guns on the flanks of the assault and these were to be targeted by 25 per cent of their number of British guns, i.e. 42.

c. The other 299 guns, closer to the centre of the German defence, were

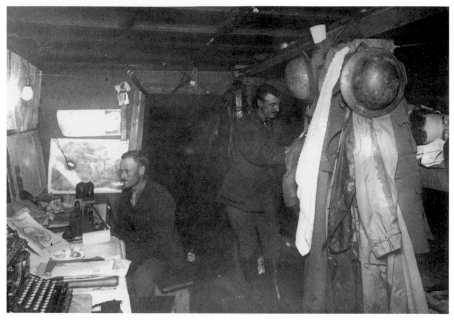

Interior of an Artillery Group HQ dugout.

to be dealt with on a one-for-one basis, i.e. a further 299. A total of 341 British guns were tasked for counter-battery (CB) fire alone.

d. For the bombardment to protect and allow the infantry to advance, it would be necessary to have one medium or heavy howitzer every 45 yards of front, or 378 guns. These were to augment the divisional artillery groups which were to lay down the protective barrages in front of the advancing infantry battalions.

e. Experience had shown that 5 per cent of the total should be 'super-heavy'.

Therefore, the total requirement for heavy guns and howitzers was:

CB	341 guns/howitzers
Bombardment	378 guns/howitzers
Super-heavy	38 guns/howitzers
Total	757 guns/howitzers.[1]

Based on this calculation, Plumer had 756 guns/howitzers assigned for the battle and it was agreed that a timed programme of such fire was to be provided throughout, together with a concentrated, complementary and simultaneous fire plan for the heavy machine guns. The 756 'heavies' consisted of the complete range of types and calibres of guns from 60-pounders to 15-inch howitzers.[2]

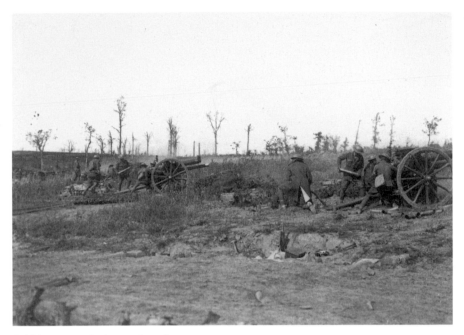

British 18-pounder battery in action.

An awesome instrument

The principle of concentration of force was best illustrated by the Gunners' role in the forthcoming offensive. The total artillery available for the battle was 2,266 guns and howitzers, with the 756 heavies organised into 40 groups. There were 64 Field Artillery Brigades, with a total of 1,158 × 18-pounders and 352 × 4.5 inch howitzers formed as the respective Divisional Artillery Groups within each of the Corps. There were also 33 Army Field Artillery Brigades, allotted on the scale of 10 to II Anzac Corps, 10 to IX Corps and 13 to X Corps. Each Corps organised its mass of heavy artillery according to its own plan.

There were 144,000 tons of ammunition dumped in the Second Army area for the battle. By zero day 7 June, this amounted to 1,000 rounds per gun per 18-pounder, 750 rounds per 4.5-inch howitzer and 500 rounds per heavy gun/howitzer. 120,000 rounds of gas shells and 60,000 rounds of smoke were also available for the 18-pounders. The light railways, which would be pushed up as far as possible to serve the guns, were crucial in keeping all calibres of artillery supplied.

Moving into range

Secrecy was of paramount importance in the concentration of guns and ammunition during the early part of May. The guns were brought into the Messines sector from Arras, Bullecourt and elsewhere. II Anzac Corps, for

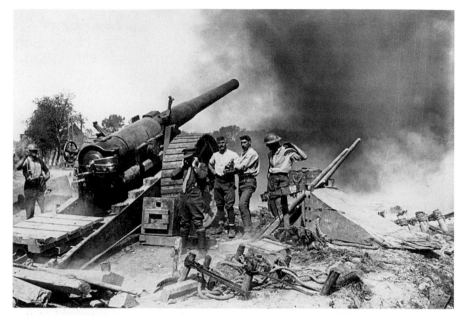

Messines preliminary bombardment: 6-inch Mk VII gun in action on 5 June.

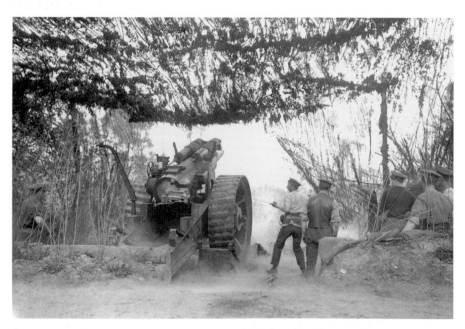

Messines preliminary bombardment: 8-inch Mk V Howitzer in action, 31 May.

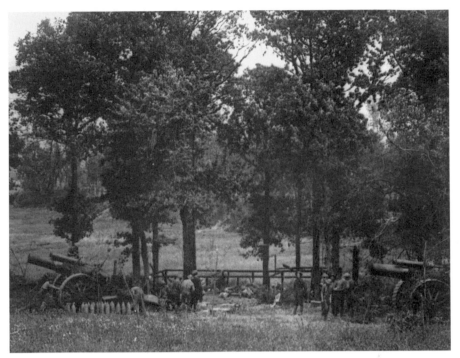

Messines preliminary bombardment: battery of guns of NZ Division in a wood, 5 June.

example, had four CB groups, each with one heavy group. In mid-May, the Corps area added thirty-seven heavy batteries and five field artillery brigades, many of which had followed 4th Australian Division from Bullecourt. It then received an additional five Army Reserve field artillery brigades.

Available to IX Corps, on the other hand, were four CB groups and five bombardment groups; of these, one was allocated to each of the three initial assault Divisions: 19th (Western), 16th (Irish) and 36th (Ulster). The remaining two groups, which included super-heavy howitzers, would then be used as flexibly as possible under the Corps Brigadier General Heavy Artillery (BGHA).

Dilemmas and solutions

The gunners had a difficult task. The ridge concealed the whole of the German second defence line and all artillery battery positions from the British Observation Posts (OPs). The RFC's role of gathering target information was pivotal. Air superiority was a prerequisite to fulfil this task. The RFC duly obliged, and 300 aircraft were allotted to the specific task of aerial reconnaissance and reporting of German gun positions in this 'unseen' zone. In addition, 2nd Kite Balloon Wing RFC flew eight captive balloons at

5,000 feet, operating from between 3,000 and 5,000 yards behind the front line. They provided an excellent intelligence-gathering service for the guns.

The nub of the problem which faced Second Army here was the need to employ accurate artillery fire not just to support the assaulting infantry, but more importantly to protect the infantry once it had achieved its objective and was consolidating those gains. This was to be achieved by destroying or neutralising any possible threat from a German counter-attack in strength.

The outline artillery fire plan for Messines was similar to that used at Vimy Ridge in April. Approximately 60 per cent of the 18-pounders would be deployed to produce the effective 'creeping barrage' ahead of the assaulting infantry, while the remaining 18-pounders and 4.5-inch howitzers were to fire standing barrages, 700 yards ahead of the creeping barrage. As the assaulting waves of infantry reached their objectives, this creeping barrage would become a protective barrage 150–300 yards ahead of them. This would shield them from the threat of direct enemy reprisals during the reorganisation and consolidation phase. A machine-gun barrage would then be established 400 yards ahead of this protective barrage, firing in the indirect role. Simultaneously, medium and heavy batteries would engage depth targets, the priorities being CB, interdiction and the destruction or neutralisation of strongpoints and enemy counter-attack force assembly areas.

Another instrument – communications and the Signal Service
Though complex, the air-to-ground communications were improving. Preparations were based on the concept of centralization of the information received, and unified reporting procedures. The communications plan was based on the Second Army Report Centre at Locre Château, four miles behind the front line. The Report Centre had cables running from it to Corps Report Centres, Corps Heavy Artillery HQs, HQRAs at each of the Divisional HQs and to the RFC, balloons, survey and radio stations. All cables were buried six feet deep and most, offered this type of protection, were to survive the battle and allow the important flow of information to continue between command HQs, the artillery and the aerial OPs.

The Signal Service was learning its trade, often at some cost. Working parties responsible for the deep burying of cables were continually harassed by shell fire. Furthermore, even the deeply buried lines would not survive continual shelling in the same area. However, these problems were solved by a combination of deception, camouflage and protection. Cable routes were recced more carefully to avoid areas of known frequent shelling, and camouflage was used to prevent the enemy from finding the 'bury', either by direct or air observation. The danger of direct observation was comparatively easily averted. Buries were carried out in the exposed areas by night only.[3]

An all-informed net
Centralised control and flexible fire planning became hallmarks of the organisation of the artillery's role for Messines. Maj-Gen G. McK. Franks,

Maj-Gen Royal Artillery (MGRA) Second Army, the gunner commander, co-ordinated all corps plans which had been drawn up by the divisional and brigade artillery staffs, and in particular the close co-ordination of the CB tasks for the heavy artillery. Brig-Gen G. Humphreys, Brig-Gen RA (BGRA), the commander of IX Corps artillery, had no doubts as to the roots of the gunners' achievements during the preparatory phase and once battle was joined: 'To my mind, the success of our CB fire was largely due to the fact that control rested in the hands of one expert, the CB staff officer and his staff, who were free to devote their whole time, energy and brains to the one end of defeating the enemy guns.'[4]

Every evening, the CB staffs at divisional and corps HQs held a conference, collating and assessing each of the reports on German gun positions from all sources: RFC, balloons, field survey companies, sound ranging sections and artillery observers (FOOs). Each corps CB area was divided into zones and each of these was in turn allocated to a heavy artillery group. Each zone was then further sub-allotted to gun batteries by map grid square, directed by the group HQ.

The artillery battle

Although the British had an overwhelming superiority in guns, German retaliation was at times fierce. German guns targeted the rear areas, dumps, roads and camps which were known British troop concentration areas. The Germans knew that this massing of British men and materiel around the Messines–Wytschaete Ridge would lead to an attack, and *Crown Prince Rupprecht* had insisted on reinforcing his own indirect firepower across the *Gruppe Wytschaete* frontage. Throughout April, 200 batteries – some 700 guns – were brought in to counter any attempted British assault.[5]

The artillery duel began on May Day and continued for the next month. At times it was an horrific experience on both sides. Throughout the month, the Gunners were in almost constant action and the strain was at times unbearable. The experience of Australian Gunner Alexander Macintosh of 7 Field Artillery Brigade AIF was typical. As the preparation for the forthcoming battle progressed, he noted that Fritz probably had the wind up, for during his move to the 'Plugstreet' area, his battery was shelled all the time. In early May, he wrote:

[My] Section was then moved to the Hill 63 and Hyde Park Corner area, our position for the Messines push . . . the first fortnight was pretty quiet. [But] one night (5 June) just as we were finishing tea, one shell burst just in front of No 5 gun. . . . We all got into a dug-out. There was a Howitzer Battery just behind us, and presently, Fritz got onto that. One Howitzer weighing a couple of tons went about two hundred yards into the air. When [the German gunners] had finished, all but one of this Howitzer Battery were blown to pieces.

The German guns were by now desperately seeking any British targets and this time they were to pinpoint Alex Macintosh's crew: 'The next day (6 June) he shelled us out again, with "five-nines" [5.9 inch guns] and "eight-inches", and we ran off to the flank across a field and the shells followed us: one poor chap was killed and a couple wounded.' Alex was lucky and lived to tell the tale.[6]

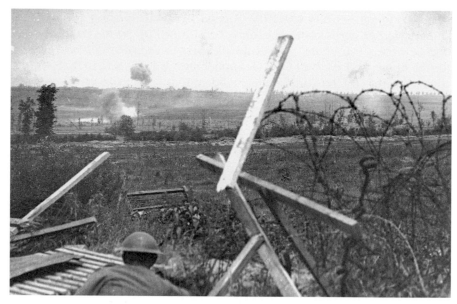

Preliminary bombardment of Messines in early June. The shell explosion on the horizon marks the site of Messines church.

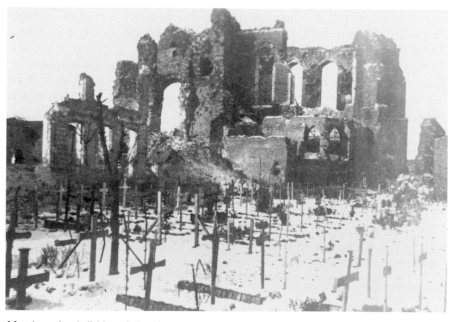

Messines: the shell-blasted church, 1917.

Nevertheless, for all the privations of being on the forward gun line, the experience was made infinitely more bearable by the news that the enemy were having an appalling time. It was estimated that the German artillery lost 50 per cent of its guns before 7 June. Despite the long-distance duelling which had been going on beforehand, the real damage was done during the intensive preparatory bombardment.

Between 26 May and the evening of 6 June, 3,561,530 rounds were fired onto the German defensive zone. The British guns (2,266) were virtually wheel-to-wheel in places. The concentration of accurate fire of different calibres was devastating throughout the battle. The German Gunner was simply not equipped to respond in kind and as the battle progressed his infantry became ever more vulnerable.

On 3 and 5 June, the barrages for zero day were rehearsed, forcing the German garrison to expect an imminent attack and also forcing some of the German batteries to unmask their guns. This, and excellent air photography by the RFC, revealed the German gun positions which became perfect CB targets. These were opportunities which could not be missed – and nor were they.

II The Royal Flying Corps (RFC)

'Such fighting as blind Homer never sung,
Nor Hector, nor Achilles ever knew,
High in the empty blue'. Maurice Baring[7]

The RFC – Magnificent men all

The contribution of the RFC in the all-arms battle at Messines cannot be overstated. (See map 9) This was the first time that the RFC were used explicitly to provide almost real-time information to the guns and timely intelligence on enemy movements. This alleviated the threats from counter-attacks, as information on enemy troop movements could be relayed to the guns more rapidly than before. Most novel was the deliberate use of the RFC to conduct what was to become known as Fighter Ground Attack or FGA. This supported the troops on the ground by strafing German gun emplacements, machine-gun posts, reinforcements, counter-attack forces and any other opportunity targets. The Allied planes dominated the skies around Messines for weeks before the attack. The implications of this were profound, though unknown at the time for certain. In effect, it blinded the German intelligence effort and seriously limited the German command's ability to make sound judgements on the scale and ultimate intent of the British threat.

The RFC attached were No. 6 Squadron, to X Corps; No. 53 Squadron to IX Corps and No. 42 Squadron to II Anzac Corps. Each squadron was increased to a battle strength of 21 aircraft. In the Second Army area, Eleventh Army Wing had a strength of two fighter-reconnaissance squadrons (20 and 45), and three single-seater fighter squadrons (1, 41, and 46). The Wing was reinforced by 1 June with No. 10 (Naval) Squadron from Dunkirk (fifteen Sopwith Triplanes) and No. 1 (Naval) Squadron (also fifteen Sopwith

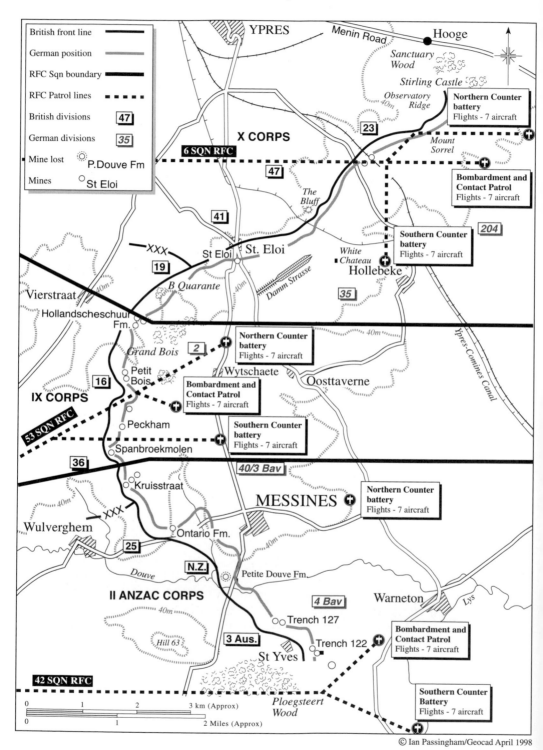

Legend:

- British front line
- German position
- RFC Sqn boundary
- RFC Patrol lines
- British divisions — 47
- German divisions — 35
- Mine lost — P.Douve Fm
- Mines — St Eloi

YPRES

Menin Road

Hooge

Sanctuary Wood

Stirling Castle

Observatory Ridge 40m

Northern Counter battery Flights - 7 aircraft

X CORPS

6 SQN RFC

23

Mount Sorrel

47

Bombardment and Contact Patrol Flights - 7 aircraft

41

The Bluff

204

XXX

St Eloi St. Eloi

White Chateau

Southern Counter battery Flights - 7 aircraft

19

B Quarante

Damm Strasse

Hollebeke

Vierstraat

40m

35

Hollandscheschuur Fm.

Grand Bois

2

Northern Counter battery Flights - 7 aircraft

40m

Ypres-Comines Canal

Petit Bois

16

Wytschaete

Oosttaverne

IX CORPS

Bombardment and Contact Patrol Flights - 7 aircraft

53 SQN RFC

Peckham

Southern Counter battery Flights - 7 aircraft

Spanbroekmolen

36

40/3 Bav

40m

Kruisstraat

MESSINES

Northern Counter battery Flights - 7 aircraft

40m

Wulverghem

XXX

25

Ontario Fm.

40m

Douve

N.Z.

Petite Douve Fm.

Lys

II ANZAC CORPS

4 Bav

Warneton

40m

3 Aus.

Trench 127

Hill 63

Trench 122

Bombardment and Contact Patrol Flights - 7 aircraft

St Yves

42 SQN RFC

Ploegsteert Wood

Southern Counter Battery Flights - 7 aircraft

0 1 2 3 km (Approx)

0 1 2 Miles (Approx)

© Ian Passingham/Geocad April 1998

Map 9: Messines, June 1917: dispositions of RFC squadrons.

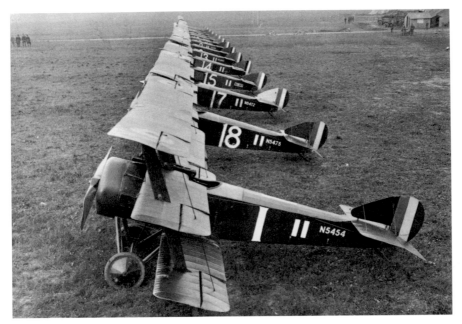

Sopwith triplanes.

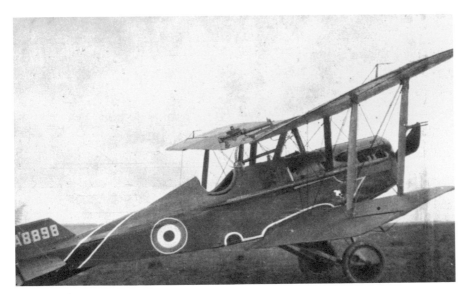

SE 5 aeroplane.

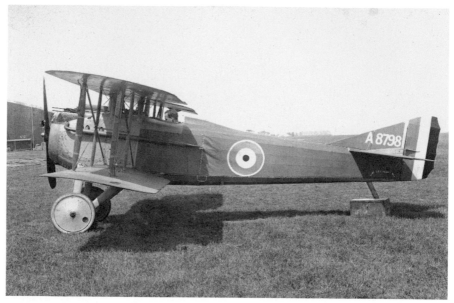

Spad S7 Scout.

Triplanes) attached from Third Army. In addition, No. 70 Squadron, from the HQ Ninth Wing, was tasked for distant photographic reconnaissance. (The remaining squadrons of the Ninth Wing were Nos 19, 56 and 66 (fighters), Nos 27 and 55 (day bombers) and a Special Duty Flight.) The squadrons in the actual battle area had 300 aeroplanes serviceable on the opening day of the battle. More than one-third were single-seater fighters.[8]

The Germans were not totally idle in the air. Between 4 May and 7 June, *General Sixt von Armin*'s *Fourth Army* along the front from the River Douve to the sea was increased from fifteen flights (ten reconnaissance and artillery flights and five fighter flights) to forty-four (nineteen reconnaissance, eight protection, eleven single-seater fighter, and six bomber-fighter flights). These units represented a nominal strength of about 300 aeroplanes, of which half were fighters. However, the German air strength from Messines to the sea was approximately the same as the RFC strength available for the ten-mile front along the Messines Ridge. The total British air strength along the whole front opposed to *Gen Sixt von Armin*'s army was approximately 500 aircraft.

The artillery plans were worked out in close cooperation with the RFC HQ staffs. German gun positions, wire, and selected strong points were to be subjected to systematic concentrated fire. As new British batteries came into the area they took up their allotted tasks in accordance with the prearranged programmes. For deception purposes, the number of batteries to be disclosed in any one corps area on any one day was carefully limited.

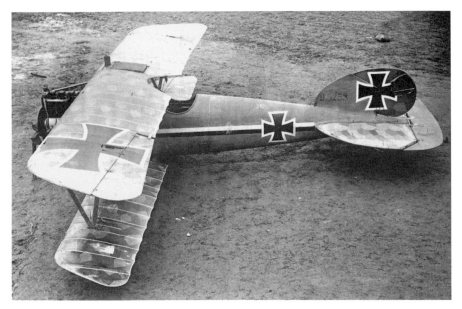

German Albatros.

Systematic trench bombardment and wire-cutting were begun on 21 May. The bombardment of the enemy's rear area by 6-inch howitzers was directed from the air. The full dress rehearsal of the artillery bombardment took place on 3 June. The fire plan would be the same as that to be used at zero hour on 7 June. The hour for this rehearsal was fixed on the advice of the RFC, as it was essential to choose conditions favourable for putting up the maximum number of aircraft to be able to identify the 'masked' enemy guns. Thirty-one aircraft took part, but the German response was very poor. However, the air photographs taken to show the accuracy of the barrage on 3 June did prove to be of great value. They showed gaps in the barrage at different stages; firing short by specific guns and German batteries were identified. The resulting special counter-battery (CB) effort made on 5 and 6 June led to the destruction of a number of the German gun pits most recently discovered via the air photography on 3 June.

Tasking/Objectives

The RFC were to give the maximum help to the British guns, to establish and maintain air superiority and to support the infantry. The air offensive was more concentrated than those during the Somme and the Arras offensives. At Messines, the RFC had to secure total air superiority of the immediate battle area. The enemy balloon line some 10,000 yards away from the British front line was the main offensive patrol area for the fighters of the Second Army Wing squadrons. Patrolling this line gave the British artillery

aircraft ample depth in which to work. It was designed to make it impossible for enemy air observers to make accurate ranging of their own guns.

This barrage-line was divided into a northern and southern 'beat'. Each beat was patrolled from dawn to dusk throughout the preliminary bombardment by formations of fighters flying at 15,000 feet upwards. The central section of the barrage-line was strengthened by a patrol of a further six to eight fighters, at 12,000 feet or under, to ensure two layers of fighting aircraft over the more important sector of the battle front.

Army wireless bases, or 'Compass' stations, were used for the rapid identification of enemy aircraft over the British lines. Making use of wireless, the stations took bearings on a German aircraft and, once they had determined its position by intersection, the information was passed to the RFC and to forward ground stations. The ground stations then displayed code strip signals to notify patrolling British fighter pilots of the areas in which German aircraft had been reported.

Air-to-ground communications
The infantry carried supplies of the Watson fan – a pleated disk, white on one side and of a neutral tint on the other – which, when rapidly turned, attracted the attention of the air observers. In general, the contact-patrol officers had no difficulty in plotting the progress of those troops who had previously practised similar cooperation with aircraft. Four copies of each report and map – on specially prepared map blocks (scale, 1:10,000) – were made in the air and then dropped, by message bag, at divisional HQ and at the Corps report centres.

Before battle
By the evening of 6 June, the RFC squadrons were confident that they would provide comprehensive support across the front once battle was joined. Their confidence was well-founded.

III Tanks

The Tank Corps 2nd Brigade (A and B Battalions) was to be the designated armoured support for the attack. It was equipped with seventy-six of the new Mark IV tanks. Each battalion was given two spare tanks in addition to the establishment total of thirty-six. Each also added another six Mark II 'supply' tanks, each one converted to carry petrol and ammunition to replenish five Mk IV 'fighting' tanks, as well as spare ammunition and equipment for the infantry. This was an important evolutionary stage of the tank's development, as it would help to maintain the momentum of an attack with infantry and tanks working together.[9]

This concentrated use of tanks and infantry would come, first at Cambrai and then in 1918. The principal role for the Mk IV tanks for Messines was to provide armoured support for the infantry, particularly for the capture of enemy machine-gun posts and strongpoints. The allocation of tanks

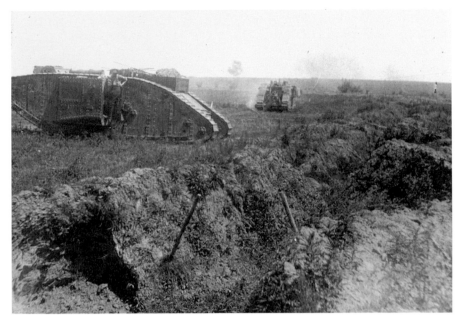

Mk II supply tank and Mk IV fighting tank, Messines Ridge.

to respective corps was: twelve to X Corps on the left (where the final objective was only three-quarters of a mile deep compared with nearly three miles in the centre and right centre), twenty-eight to IX Corps in the centre, of which twenty-four were reserved for the afternoon advance on the Oosttaverne Line, and thirty-two to II Anzac Corps on the right.

In the event, forty-eight tanks were ditched in the battle, compared with eleven disabled by direct hits. The new Mark IV tanks proved impervious to the Germans' new 'K' armour-piercing bullets. Not until the autumn, at Cambrai, did the enemy produce a fresh counter-direct fire by field guns.

IV RE: the Sappers in the Field

The Engineer preparations for the battle were on a huge scale. The main requirements were for additional roads and railways. Much had been achieved in 1916 to improve the railways. For example, the main line between Hazebrouck and Ypres had been doubled. From the standard gauge line, narrow gauge branches were laid to serve the ammunition dumps, and to relieve the road traffic. All the existing roads were improved, and metalled roads were carried through to the forward area, in some places almost to the front line. Large dumps of stone and beechwood slabs were accumulated for the rapid extension of the roads over the ground which was to be taken by Second Army. The use of timber roadways had become more common.

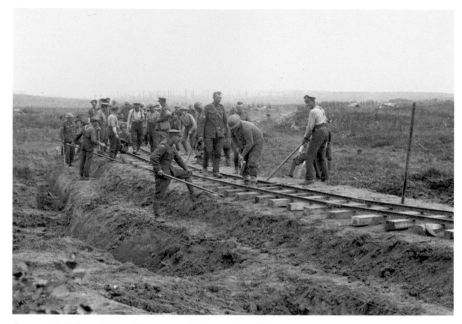

Sappers building a light railway towards forward positions.

One of the important lessons learned during the Somme offensive was that a timber road could be laid and used much more rapidly than a metalled one. The timber slabs, ten to twelve feet long and two and a half inches thick, were cut by the Forestry Coys, RE, in the corps and Army rear areas. Once prepared, they were laid by the infantry Pioneer battalions, RE Labour Coys, Tunnelling Coys and occasionally by 'resting' Field Coys.[10]

The construction and maintenance of these improvised roads, often under heavy shell-fire, involved high casualties; but without them the artillery would not have been kept supplied with the necessary ammunition. The plank roads served the artillery battery positions and formed the traffic circuits; the duckboard tracks led forward to the infantry positions. Light railways and tramways were laid wherever a firm enough foundation could be prepared. They were of great value for the transport of wounded, who would otherwise have had to be carried along duckboard tracks by a relay of stretcher-bearers (SBs).

In addition to the corps and army work on the mines, roads and railways, there was the usual heavy programme for the divisions during the preparatory phase. Field Coys and Pioneer Battalions were continuously deployed and worked right through to zero day, building battery positions; artillery group, brigade and battalion headquarters; advanced dressing stations; water pipelines; assembly, communications and sap trenches; ammunition stores and RE dumps.

As an example of the preparatory work, 25th Division took over the Wulverghem sector on 6 April. It had the practical advantage of making the preparations for the battle entirely from within the sector from which they were to attack. The division was almost continuously employed in these preparations up to the day of the assault. For the battle, the field coys and the Pioneer Battalion were held in the Divisional reserve. The only exception was 106th Field Coy, which would assist 75th Brigade's (25th Division) operations during the attack. 'Anticipation' tasks were allocated to the remainder. Two coys of the 5th Battalion, South Wales Borderers (SWB), the pioneers, were to clear the Wulverghem–Messines road. The other two pioneer coys would extend an existing tramline to the Messines Ridge.

105th Field Coy would have one section to clear a track forward to enable artillery field guns to advance; the remainder of the company was to make tracks across no man's land, passable at first by pack transport and later by wheeled transport. 130th Coy was to assist 7th and 74th Brigades to dig communication trenches across no man's land into the captured area. 130th Coy would work on the communication trenches for most of the first day of the battle. These detailed preparations were made across the whole of Second Army front by the other divisional field coys and Pioneer battalions.

V RE: the War beneath Flanders

'**Property**'
Building land for sale on Hill 60:
Bright, breezy and invigorating. Commands an excellent view of the historic town of Ypres.
For particulars of Sale, **apply: Boche & Co., Menin.**[11]

The 'Big Idea'

Mining was the 'Big Idea' for the attack on Messines. The blowing of the Messines–Wytschaete Ridge was to be the culmination of over two years' planning. Yet the final hours before zero were to be the most intense hours of the tunnellers' lives. After the battle, Capt W. Grant Grieve wrote: 'Messines is to the Tunneller what Waterloo was to Wellington. Never in the history of warfare has the miner played such a great and vital part in a battle.'[12]

The 'Big Idea' very nearly foundered, and it was only the initial impetus and energy of one man, John Norton-Griffiths, that forced the General Staff to accept the notion of tunnelling at all. Norton-Griffiths was an MP, engineer, soldier and entrepreneur. His nickname 'Empire Jack' was a fitting one. In his capacity as a civil engineer, he had been involved in literally building parts of the pre-war Empire. Soon after the war began, he used his influence to establish an apparently motley crew of miners and engineers, all volunteers, to counter a threat from German mining. He had to influence senior commanders and even Kitchener to win approval. He had absolutely no scruples about doing so. In short, he would not be dissuaded by anyone.

Mining began as a response to German activity in the British sector of the Western Front. By the end of 1915, the tables had been turned.

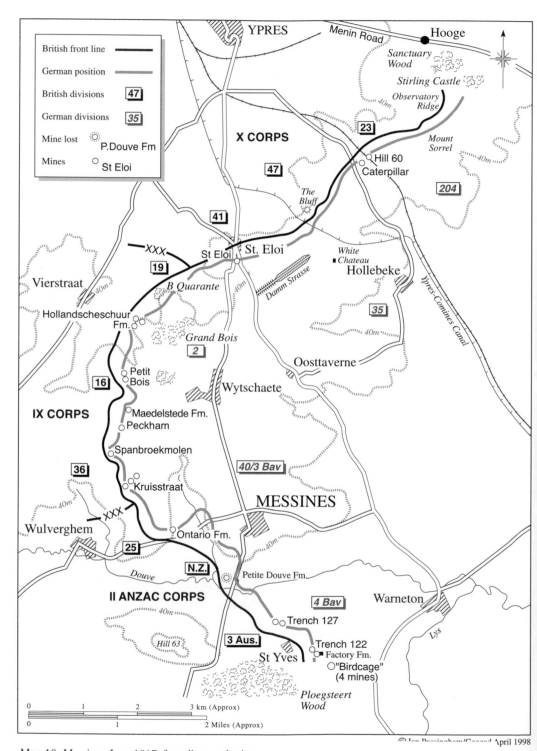

Map 10: Messines, June 1917: front lines and mines.

Name of Mine	Date of Completion of Charging	Depth of Charge in feet	Charge in Lbs.	Crater Dimensions in Feet			Length of Gallery in Feet	Diagram of Mines
				Diameter at Ground Level	Width of Rim	Diameter of Complete Obliteration		
HILL 60								
A LEFT	1.8.16	90	45,700 Am. 7,800 Gc. 53,500	191	47	285	Branch 240	
B CATERPILLAR	18.10.16	100	Ammonal 70,000	260	77	380	1,380	
ST. ELOI	28.5.17	125	Ammonal 95,600	176	77	330	1,340 300	
HOLLANDSCHESCHOUR								
No. 1	20.6.16	60	30,000 Am. 4,200 Blas. 34,200	183	80	343	825	
No. 2	11.7.16	55	12,500 Am. 2,400 Bla. 14,900	105	55	215	Branch 45	
No. 3	20.8.16	55	15,000 Am. 2,500 Bla. 17,500	141	30	201	Branch 395	
PETIT BOIS								
No. 2 LEFT	15.8.16	57	21,000 Am. 3,000 Bla. 30,000	217	100	417	Branch 210	
No. 1 RIGHT	30.7.16	70	21,000 Am. 9,000 Bla. 30,000	175	100	375	2,070	
MAEDELSTEDE FM.	2.6.17	100	90,000 Am. 4,000 Gc. 94,000	205	90	385	1,610	
PECKHAM	19.7.16	70	65,000 Am. 15,000 Blas. 7,000 Gc, Dyn. 87,000	240	45	330	1,145	
SPANBROEKMOLEN	28.6.16 (Recovered 6.6.17)	88	Ammonal 91,000	250	90	430	1,710	
KRUISSTRAAT								
Nos. 1 AND 4	5.7.16	57	Ammonal 30,000					
	11.4.17	57	18,500 Am. 1,000 Gc. 19,500	235	80	395	—	
No. 2	12.7.16	62	Ammonal 30,000	217	75	367	Branch 170	
No. 3	23.8.16	50	Ammonal 30,000	202	65	332	2,160	
ONTARIO FM.	6.6.17	104	Ammonal 60,000	200	10	220	1,290	
TRENCH 127								
No. 7 LEFT	20.4.16	75	Ammonal 36,000	182	25	232	Branch 250	
No. 8 RIGHT	9.5.16	76	Ammonal 50,000	210	65	342	1,355	
TRENCH 122								
No. 5 LEFT	14.5.16	60	Ammonal 20,000	195	64	323	Branch 440	
No. 6 RIGHT	11.6.16	75	Ammonal 40,000	228	64	356	970	

The Messines mines—particulars in brief.

Table 11: The Messines mines – particulars.

Maj John Norton-Griffiths (hands in pockets) 'on tour', Ypres Salient.

British resources and technology outweighed those of the enemy, and expertise was imported from Australia, New Zealand and Canada, as well as from the coal pits of the British Isles. Theirs was a specialist war and Messines demanded something special. The mining effort was designed to disrupt mining activity by the Germans and destroy their own lines of defence by going beneath the enemy positions and laying explosives.

The evolution of the Messines mining plan

Mining in the Flanders sector had grown from tentative digging to less than 20 feet below the surface in early 1915 to the scheme which was about to be tested across the Messines–Wytschaete front. Brig G.H. Fowke, the Engineer-in-Chief in 1915, had become a firm disciple of the potential effects of mining so enthusiastically advocated by Norton-Griffiths. Fowke, though in his fifties, was out of a similar mould as 'Empire Jack'. He was a man of unstoppable energy, enthusiasm and determination to see things through. In short, he was the right Engineer-in-Chief at the right time to champion the cause of the sappers' vital role at Messines.

The plan for the use of mines under the Messines–Wytschaete Ridge had been under discussion since July 1915. The idea had evolved from a thumbnail sketch on a scrap of paper by Norton-Griffiths, which showed only the 'bow' of the German front line, Wytschaete and Messines. The rest would follow, although Hill 60, St Eloi, Spanbroekmolen and St Yves were already in Norton-Griffiths' sights for special treatment using mines.

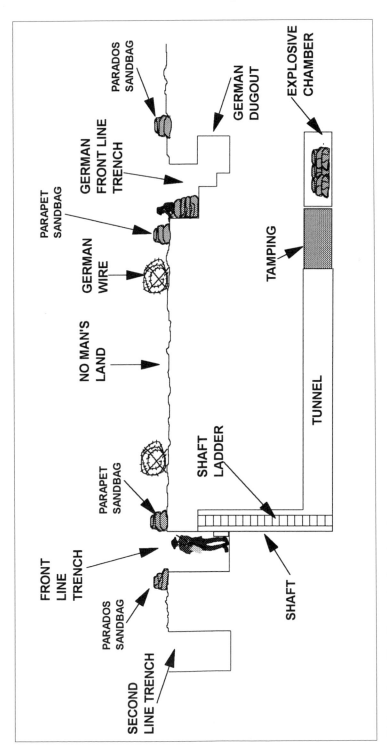

Mining and tunnelling diagram: horizontal section.

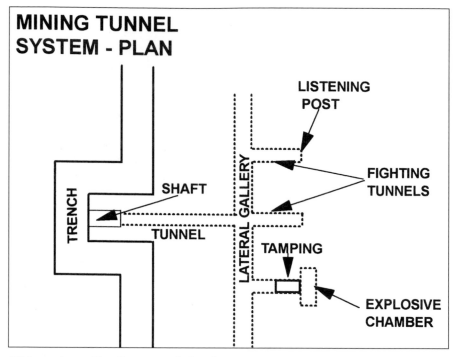

MINING TUNNEL SYSTEM - PLAN

LISTENING POST

FIGHTING TUNNELS

TRENCH

SHAFT

LATERAL GALLERY

TUNNEL

TAMPING

EXPLOSIVE CHAMBER

Mining and tunnelling diagram: vertical section.

Diagram showing a 'clay kicker'.

In September 1915 Brig Fowke had put forward plans for driving galleries to ninety feet below the surface and beyond, thus making the grand scheme suggested by Norton-Griffiths a real possibility. Fowkes' suggestion was approved in late January 1916, but only after Sir Douglas Haig had been appointed Commander-in-Chief BEF. However, it was not until February 1916 that it was finally agreed to begin mining on the scale necessary to blow the Germans off the ridge.

As usual, the sappers had anticipated the requirement and had begun digging six mine shafts, all sign-posted as 'Deep Wells' for secrecy, by the end of January 1916. In Flanders, it was necessary to dig deep. The most reliable element of the Flanders plain was the 'Blue' clay, as it was more solid and less likely to collapse. It was this factor which gave the British tunnellers and miners the edge, as they soon had the capability to dig down to below 100 feet, which the Germans could not.[13] The mining operations were systematically and assiduously prepared. Once the foundations of the scheme were laid by Norton-Griffiths and Brig G.H. Fowke, they were completed under the direction of the British army's controller of Mines, Brig R.N. Harvey, supported by the Second Army Controller of Mines, Lt-Col A.G. Stevenson.

Recruitment – every man a volunteer

Recruits were found and the tunnelling companies were formed. The story of every man who became a member of this strange fraternity is fascinating. In Sapper John McCreesh's case it must have been unique. McCreesh, an Irish Catholic born in South Armagh, had settled in North East England and become a miner. He was married with children, in a reserved occupation and nearly 40 years old when war was declared, but he volunteered immediately. At first, he was turned down flat. John had decided that he would be an infantryman and volunteered for the Durham Light Infantry (DLI). The Recruiting Sergeant dismissed him for being – too short (he was 5 feet-and-a-bit); too old (on the threshold of 40); too puny (only 135 lbs) and too blind: he had had only one eye since birth. Nevertheless, when Norton-Griffiths advertised for volunteers for 'specialist mining in France' in early 1915, John McCreesh applied, was invited for interview and on that same day signed on at Norton-Griffiths' Westminster office. Within days he was on his way to France and then Flanders to join 175 and later 250 Tunnelling Company.[14]

Norton-Griffiths had inspired these new 'troops' by explaining that their task would be a simple one. All they had to do was dig underneath the German lines, place explosives there, wire them up and then retire to a safe distance. When the explosives beneath the enemy, the mines, were fired, these new military miners would have a front-row seat to see the Germans 'going up' as Norton-Griffiths explained it.[15]

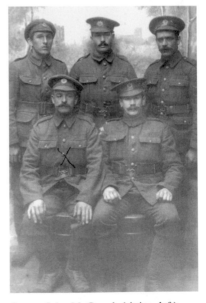

Sapper John McCreesh (sitting, left), 250 Tunnelling Company. Sapper Henry James Gibson is standing on the end of the row behind McCreesh.

'Specialist mining in France'

Specialist mining meant specialist skills and offered the volunteers a spirit of adventure. The vast majority were coal miners and they were used to the danger and privations of mining life. Although they were employed in a reserved occupation, which excluded them from military service, these men had decided that they would be able to make a greater contribution at the front, and so it was to be.

The specialist mining (in Norton-Griffiths' phrase) had its unique qualities and equally unique dangers. A gallery had to be dug in the main by hand. Additionally, most of the spoil had to be manhandled and sent by trolley from the tunnel/mine face to the entrance and then dispersed to avoid enemy detection of the British mining efforts. The men would work on a rotational basis, but the tunnelling task would be continuous. There were the constant dangers of collapsing walls, flooding and the build-up of methane gas, all of which could be lethal. Tunnellers employed white mice or canaries to provide early warning of any poisonous gas concentration. These creatures saved many lives.

The particular difficulties of cutting through the cloying clay of the deeper parts of the Flanders soil were solved by the recruitment of thousands of 'clay kickers' who were employed in the excavations necessary to build the London Underground and the city's sewerage system. The men were known as 'clay kickers' as this described a method of excavation in which the tunneller lay on his back on an angled board and literally kicked the blade of his spade into the clay, which was then removed by a colleague known as 'kicker's mate'.[16]

A troglodyte world

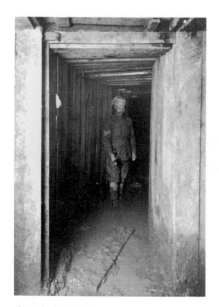

A typical tunnel.

It was relentlessly demanding for the tunneller, both physically and mentally. The tunnels were cramped, dank and foul-smelling; the digging and clay-kicking were back-breaking and had to be carried out as quietly as possible, due to the threat from German counter-mining. The British tunnellers soon established listening galleries within the main galleries to give warning of this counter-mining activity. The British, Anzac and Canadian tunnellers had a distinct advantage in this area of expertise also. Stethoscopes and, later, geophones were used to listen for signs of German movement. The German methods were more primitive, so that their discovery of British mining was often, though not exclusively, by

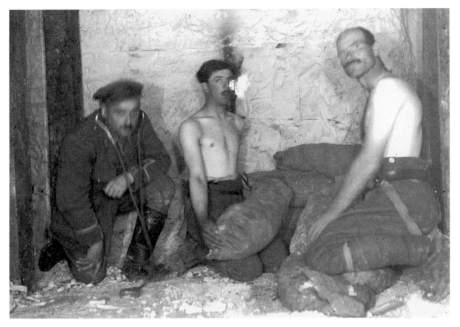

Laying a mine.

accident. Consequently, early warning gave our troops the edge and time to decide on how best to defeat the German counter-mining.

There were three main options: to stop mining and trust that the enemy would remain unaware of our own gallery, to dig through to the German gallery and confront the enemy mining party, or to prepare and blow a 'camouflet' to destroy the enemy gallery. A camouflet was an explosive charge set in a chamber dug towards the enemy tunnel and blown to wreck the enemy gallery without disturbing the ground surface. When the tunnellers did break through to each others' galleries, fighting was nasty, brutal and short. Special weapons were used in the confined space: short-handled rifles with bayonets, knuckle-dusters with a stabbing knife built into them, spiked and short-handled maces and revolvers. In the darkness and confusion, no quarter was asked or given.

The mines themselves would be packed with an explosive known as 'ammonal'. This was an improved and more robust explosive mix, and it replaced the usual combination of gunpowder and gun-cotton. Gun-cotton and blasting gelatine would still be used as primers to assist the firing of the main explosive charge.

Sapper 'Jack' Lyon, a member of 171 Tunnelling Company, gave a vivid description of the routine activity of a typical Tunnelling Unit:

> Each shift comprised twelve men with an RE Corporal in charge. At the face were three men who were RE Sappers. Three men worked the trolleys, one man manned the 'windjammer'

or air pump. One man at the tunnel shaft-bottom kept the sump there empty and hitched sandbags to the rope from the windlass at the pithead. [There were] two men at this windlass, one man unhitching the bags and passing them back to the other, who took them to the dumping ground. At the tunnel-face one man was engaged in 'clay-kicking'. Sitting with his back against an inclined plank fixed between the floor and the roof, he used both feet to press a small sharp spade called a 'grafter' into the face and lever out a lump of clay. [His 'mate'] put this into a sandbag. When full, the bag was passed to the third man who dragged it to the end of the trolley rails. As each man was a Sapper, they could relieve each other so the face-man 'kicked' for two hours in the six hour shift. . . . The personnel of 171 Tunnelling Coy were drawn from every mining area in the UK. At least half were what was called 'permanently attached' infantry, mostly miners who had enlisted in infantry units early in the war. (Some of the RE men had gone with Norton-Griffiths to sabotage Balkan oil-wells, some of the infantrymen had taken part in the actions of 1914 & early 1915.) The latter were paid at the rate of two shillings per day but as one only received 5 or 10 francs each pay day (the franc being equivalent to one twenty-sixth of a pound), everyone's pay book had a credit balance. Everyone worked three shifts in two days, had one day at rest camp, then back to the sap again. [After] fifteen days we went down . . . for a bath and de-lousing operation, the latter being only partially successful.[17]

The horror of entombment – victims and mine-rescue

The dreadful risk of entombment in the mining galleries or the effects of gas were always at the back of every tunneller's mind. Mine Rescue schools were set up to train selected men in the skills necessary to reduce the consequences of this very real problem. Sapper John McCreesh volunteered for mine-rescue

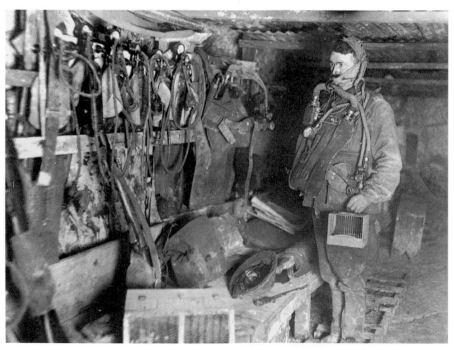

A tunneller demonstrates the Proto-Mask, used for mine rescue work.

training and soon became a vital member of 250 Tunnelling Company. He was to be involved in a number of incidents and was to save many of his colleagues. The most dramatic was the desperate attempt to save his 250 Tunnelling Company colleagues at Petit Bois in June 1916. Early on the morning of 10 June twelve men were working on the gallery which was to fork at the 1,600 feet point to lead to the two chosen mine sites. The Germans had detected their work and blew a camouflet right over the 250 tunnel.

A rescue squad in Proto anti-gas equipment was rushed to the site. John McCreesh was one of the team. They estimated that 300 ft of debris would have to be shifted to get to the trapped men and that they would have an almost impossible task in trying to reach the trapped men in time. They decided to try the impossible. For all they knew, the men inside could already be dead, but there was an equal chance that they may have survived the explosion at least. Maj Cecil Cropper, the mastermind behind the 250 Tunnelling Company effort, was not going to allow even the faintest possibility of rescue slip away.

The special relationship which existed amongst these amazing mining men was never more apparent than when they were up against it, especially when their own kind were in trouble. The decision was made to dig a tunnel alongside the damaged one and listen as they went for any signs of movement. Capt Haydn Rees was brought in from his work at Peckham House for his experience of rescue work from his days in the Welsh collieries. The would-be rescuers ripped through the clay at over 40 feet a day, well over twice the normal rate.

The trapped men had all survived the concussion of the German camouflet, but soon found they were trapped. Most of the men thought that they should dig themselves out. One man, Sapper Bedson, a miner from Cumberland, suggested that their only real chance was to preserve the air which they still had in the chamber and wait for help. He had seen it before at the White Haven collieries back home. Frantic activity would almost certainly be fatal. He was the only dissenter, so the rest went at the debris strewn through the tunnel in a desperate bid for freedom. It was an equally hopeless task and the lack of air soon stopped them.

One by one they crawled towards the collapsed end of the tunnel, drawing pathetically for air. A broken ventilation pipe was their only source, but that too collapsed and the air source had gone. Later, Bedson advised the others to spread out and made his own way slowly to the tunnel-face end. The face end was slightly elevated and the air that remained was less fetid there. The others remained where they were, gasping together, until early the next morning. Some did try to spread out at last, but it was already too late. 'Soon there was silence but for a cough, an occasional moan and the jerky, exaggerated breathing of eleven men slowly suffocating to death.' The first died that afternoon and by the evening of the next day, all but Bedson were dead.

Bedson had made a bed of sandbags on the first day at the face end and did what he had advised the others to do. He had a water bottle from which he

occasionally sipped, and a watch to mark the hours and then the days go by. After four days even Capt Rees had abandoned any realistic hope that the men trapped in the tunnel could have survived. Some on the outside, including John McCreesh, would not abandon the task, at least until they had found those inside. Meanwhile, twelve graves were prepared in a village churchyard.

After nearly seven days, the rescuers had their reward. Bedson was heard and a final push was made to reach him. Incredibly, Bedson was found standing at the hole when they broke in. No one could find the words to describe the moment, except Bedson: 'It's been a long shift. For God's sake give me a drink.' The medics soon had him on his way to Blighty and one of the graves in the churchyard was left vacant.[18]

Towards Berlin?
In early 1915, Maj Hunter Cowan, OC 175 Tunnelling Company, had initiated the digging 200 yd behind the British front line to go under the German garrison on Hill 60. It was difficult and at times impossible work, but the company persevered. In November they were driving a major tunnel through the blue clay towards the infamous Hill. One of the company wags made an off-hand remark that 'at this rate the bloomin' thing will come out in Berlin'. The 'Berlin Tunnel' it was to be.[19]

Flanders – towards the tunnellers' final act
By the end of 1916, the Germans were slacking off their mining effort, in the hope that their opponents would follow suit. But at least fifteen enormous mines had been lodged beneath Messines Ridge by then. There could be no letting up. By 1917 even the Germans could not hide the fact that the British were winning the war underground. It was not just a matter of the number of mines fired, but of the accuracy, size and speed at which they could be laid. Brigadier Harvey's moles were well ahead on every count.

The mining effort to assist the opening of the Somme offensive in 1916 had been one of very mixed fortunes. Eight large and eleven small charges were blown at the opening of the Somme offensive on 1 July 1916. The smaller ones contained only a few hundred pounds of explosive, compared to an *average* of 48,000 lbs (21 tons) per mine at Messines, twice that of most of the large mines blown on the Somme.

However, the Somme had shown already that the German tunnellers could not compete effectively against their better resourced and trained British and Empire rivals. Also, it had demonstrated the enormous potential for the surprise use of mines. The lessons of the Somme were not lost on the mining effort or by Plumer. It was clear that one of the reasons for the failure of the mines to make a greater impact was their dispersal. At Messines, the mines would be concentrated on a narrower front, but also placed under the most important German forward defences. The Germans would be affected most by the cumulative nature of simultaneous explosions, all scheduled to blow at zero hour, unlike when mines were

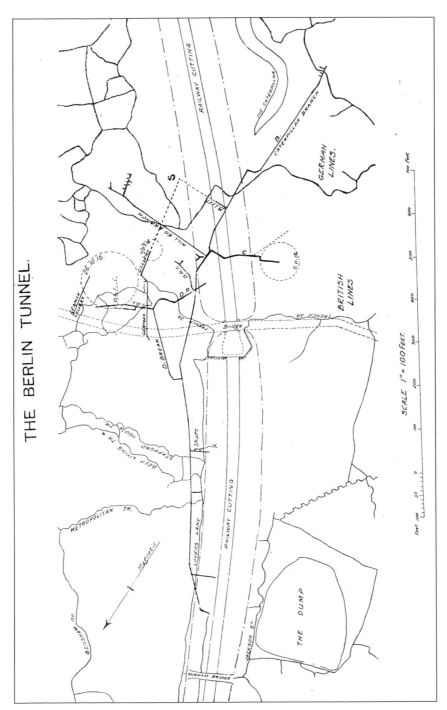

Map 12: The 'Berlin' Tunnel.

detonated on 1 July 1916. Furthermore, the amount of ammonal placed in the respective mine chambers was immense: just short of one million lb. (See table 11)

Big idea – big bangs

Plumer's prediction that all would be ready by 7 June had caused the tunnelling companies a good deal of final frantic effort. Excluding the lost mine at Petit Douve (*see* Chapter 4), the scheme was developing as a 23-charge barrage, laid from twelve main shafts and tunnels. As zero day approached, Plumer decided that the 'Birdcage' mines (30,000 lb of ammonal each) were too far to the right of his attack front to be of immediate use. The plan had been to assist II Anzac Corps' offensive effort by exploding the four mines of the 'Birdcage' near Le Gheer. (See map 10) In the event, the enemy had already withdrawn from this area on 7 June. Therefore the mines were not blown. Orders went out that they were to be readied in all respects, but held in reserve.[20]

As many as possible of the remainder were to be prepared for simultaneous firing at zero hour across the ten miles of the ridge. Exactly how many mines would he wholly complete by the 7th was even now in doubt. Three were still being dug or loaded and one, Spanbroekmolen, was not yet repaired. The revised plan envisaged nineteen explosions at eleven sites: 1. Hill 60/Caterpillar; 2. St Eloi; 3. three mines at Hollandscheschuur; 4. two at Petit Bois; 5. Maedelstede; 6. Peckham; 7. Spanbroekmolen; 8. three at Kruisstraat; 9. Ontario Farm; 10. two at Trench 127 and, finally, 11. two at Trench 122/Factory Farm. (See map 10 and table 11)

The Tunnelling Companies were 171, 175, 250, 1st and 3rd Canadian and 1st Australian; the 183, 2nd Canadian and 2nd Australian Tunnelling Companies were simultaneously responsible for building or improving underground shelters in the Second Army sector. The northernmost mine was a 53,500 lb mixture of ammonal and guncotton beneath Hill 60. Next came 70,000 lbs of ammonal at the Caterpillar spoil heap. Both charges had been laid from the 'Berlin Tunnel'. Although the two charges had actually been placed by the 3rd Canadian Company in the autumn of 1916, in November the Company moved on south (to the St Yves end of the ridge), leaving the job to the 1st Australian Tunnelling Company. The responsibility was beginning to strain the nerves of all of the Aussies involved.

One of the greatest strains was the problem of water: water, water everywhere, and all of it running deep. 'Caterpillar' was flooded. Over sixty men were kept constantly at work on the handpumps. After months of exhausting effort and involving the use of circular steel caissons, a deep vertical shaft was successfully sunk through the running sandy soil here to replace the original incline shaft. Finally, electric pumping was introduced and with such painstaking effort, the conditions improved, to the obvious relief of the men who had carried out the operation.

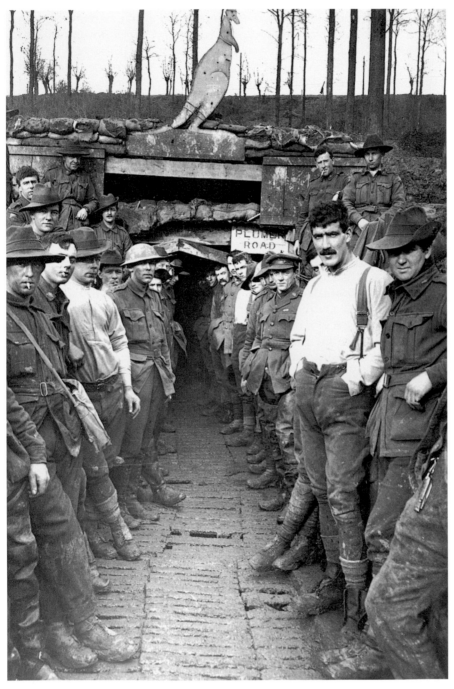

Australian sappers at the main entrance to the Catacombs, Hill 63.

On 15 May Capt Oliver Woodward was put in charge of the firing party. He had a good crew: two officers, Lts Royle and James Bowry, an NCO, and forty sappers. The waiting and the anxiety would soon be over. On 3 June some of the final tamping arrangements were made. It coincided with the dress rehearsal for the guns, designed to rub German nerves raw by simulating the artillery bombardment immediately before the Second Army assault. On Tuesday 5 June, Woodward reported to Brig T.S. Lambert, commanding 69th Brigade (23rd Division). Lambert announced formally that zero hour had been fixed for 3.10 a.m. on 7 June. He planned to be present in the firing dug-out himself to give the signal.

The next deep mine to the Hill 60 pair was a vast single charge lying two miles to the south (and somewhat west) at St Eloi, another long-standing mining hot spot. Here, Maj Cy North's 1st Canadian Tunnelling Company had developed a 1,650-foot tunnel. The Canadians, under the immediate control of Section Officer Capt Stuart Thorne, had laid the biggest charge of the war, 95,600 lb of ammonal. It was also at the greatest depth – 125 feet. The job, which had started late in August 1916, was only just completed in time. Charging finished on 28 May, just a week or so before the big day.

South of St Eloi came the mines laid by Maj Cecil Cropper's 250 Tunnelling Company: a total of seven major charges. Cropper himself was not present to see the finishing touches put to them. The long strain of commanding an overworked company through its most difficult times had told. In December 1916 he caught German measles, and Lt-Col A. Stevenson told him firmly that he must go for treatment. He never returned to Messines.

The first of the 250 Company mines was a cluster of three at Hollandscheschuur: 34,200, 15,900 and 17,500 lb. They were completed at the rate of one a month between June and August 1916. About 1,000 yd to the right lay twin ammonal-with-blastine mines: 30,000 lb each, more than 1,800 ft down the tunnel of Petit Bois. Next to Petit Bois came the second biggest charge of the series: Maedelstede Farm. Here 94,000 lb of (mostly) ammonal was still being laid on 2 June, but the job was done in time. This, and the two Petit Bois charges, were all elaborately wired for firing by lighting-set electricity. South of Maedelstede Farm was Peckham House, the last of the 250 Tunnelling Company mines. Captain Haydn Rees, who had been involved in Bedson's rescue, was the section officer in charge.

The situation at 171 Tunnelling Company's Spanbroekmolen mine (next in line running south) was uncertain to the end. A new tunnel had been driven past the section crushed by German camouflets to reach the 91,000 lb charge of ammonal no more than hours ahead of zero. Beyond Spanbroekmolen came another 171 Company site, Kruisstraat, a three-mine cluster of one 49,000 lb and two 30,000 lb charges, again almost exclusively ammonal. This Kruisstraat Tunnel, at 2,160 ft the longest of them all, reached as far as the German third line of defence, where one of the mines was placed. Its controlling officer, Maj H. Hudspeth, had proposed that the forward mine should go off some seconds later than the others, to catch

German soldiers running back. But Tim Harington, Chief of Staff of Second Army, refused. The plans were not going to change at this late stage.

Next in line, and the last of the 171 Company mines, was a heavy single charge at Ontario Farm: 60,000 lbs of ammonal laid 103 ft below the surface. Here, too, there had been a desperate rush to complete in time, due to almost continuous trouble from fast running sand, met deep underground. No more than hours before zero, duplicated firing wires were run out ready for connecting to two exploders.

The last four mines were arranged in two pairs, at Trench 127 and Trench 122/Factory Farm. They were to be fired by 3rd Canadian Tunnelling Company, commanded by Maj Angus Davis. Trench 127 consisted of a 36,000- and a 50,000-lb mine. They would be fired by Lt Garner and a colleague. Lts Cecil Hall and George Dickson would fire the other two at Factory Farm (or Trench 122): 20,000 and 40,000 lb each. In the event Hall would be left with his section NCO, Sgt Beer, to do the job.[21]

At 4 p.m. on 6 June, Capt Harry Urie, the section officer, walked over with sealed orders and a service watch. Cecil Hall opened the orders to learn for the first time that zero was to be 3.10 a.m., 7 June. He also noted that he was not to operate from the base of the shaft but should extend the firing leads up the 70 ft and into an adjoining trench. The mine had been equipped with the astonishing number of six separate circuits (twelve wires) and Hall calculated he would need every minute he had to be ready in time.

It was to be a long night.[22]

Notes

1. Farndale, Gen Sir Martin, KCB, *History of Royal Regiment of Artillery on the Western Front, 1914–1918* (RA Institution, 1986), p. 184; Edmonds, *BOH*, 1917, vol. II, pp. 41–9.
2 Specifically, this consisted of: 186 × 60-pounders; 316 × 6-inch howitzers; 20 × 6-inch guns; 108 × 8-inch howitzers; 108 × 9.2-inch howitzers; 2 × 9.2-inch guns; 12 × 12-inch howitzers; one × 12-inch gun and; 3 × 15-inch howitzers. *See* Farndale, *History*, p. 185, Edmonds, *BOH*, 1917, vol. II, pp. 41–9.
3 Priestley, R.E., *The Signal Service 1914–1918* (Mackays Co. Ltd, 1921).
4 Brig-Gen Humphreys RA; quoted in Farndale, *History*, p. 186.
5 *GOH, Band 12* (1917), Chapter VIII, Der Verlust des Wytschaete-Bogens (Berlin, Mittler, 1925/1944) pp. 449–52.
6 AWM Private Records: PR00092 Gunner Alexander Keith Macintosh, 7 Field Artillery Brigade AIF, Private Papers, Letters and Diary – 1917.
7 Revell, Alex, *High in the Empty Blue: The History of 56 Squadron, RFC/RAF 1916–1920* (USA, Flying Machine Press, 1995), p. 74.
8 Jones, H.A., *The War in the Air: Official History of the Great War (RFC/RAF)*, vol. IV (Oxford University Press, 1934); Air Historical Branch, *The Royal Air Force in the Great War* (originally published 1936) (London/Nashville, IWM/Battery Press, 1936/1997), pp. 197–200.
9 Liddell Hart, Capt Basil, *The Tanks, Volume I, 1914–1939* (London, Cassell, 1959).
10 Institution of the Royal Engineers (RE), *RE Journal*, vol. XL, Chatham, V Mar–Dec 1926.
11 *Wipers Times*, 1917.
12 Grant Grieve, Capt W. and Newman, Bernard, *Tunnellers: the Story of Tunnelling Companies, RE, during the World War* (London, Herbert Jenkins, 1936), p. 204.
13 Barrie, Alexander, *War Underground* (London, Frederick Muller Ltd, 1961), pp. 192–6.

14 Sapper John McCreesh, Private Records in the care of his grandson, Mr Terry Middleton OBE.
15 Barrie, *War Underground*, p. 34.
16 Ibid, p. 28.
17 Sapper J.L. Lyon, 171 Tunnelling Company, *Recollections and Memoirs*, 1924: A rare record held by the Liddle Collection, Brotherton Library, University of Leeds.
18 Barrie, *War Underground*, pp. 215–18. The tale as described by Sapper John McCreesh confirmed Sapper Bedson's extraordinary comment at the end of his entombment. (Terry Middleton OBE, McCreesh Memoirs).
19. Barrie, *War Underground*, p. 192.
20 The 'Birdcage' mines: one was set off, probably by lightning, on 17 July 1955. The others are still lurking beneath the farmland east of 'Plugstreet' Wood. (Note that there are still three beneath the Flanders soil, not one.)
21 Capt B.C. (Cecil) Hall, 3rd Canadian Tunnelling Company, referred to in his personal memoirs, *Round the World in Ninety Years*, Chapter 21: 'Before and After Zero'. Liddle Collection, General Aspects Box: Mining/Battle of Messines, June 1917, University of Leeds.
22 Ibid.

Across the Wire: Towards *Soldatendämmerung*[1]

Inactivity and mere waiting undermine morale and rub nerves raw.
Capt Adolf von Schell

Alberich

The German failure in the offensive against Verdun and in defending the Somme in 1916 had led to a return to a defensive strategy on the Western Front, as had existed for most of 1915. *Ludendorff* had anticipated further offensives in the Somme area in early 1917 and the German casualties in the previous year had left their defences thin and dangerously exposed around Bapaume, Péronne and Soissons. (See map 1) Throughout the winter of 1916/17 German engineers built the *Siegfried Stellung*, or Hindenburg Line (see map 5), which would run from Arras to Rheims. Although kept secret from the Allies, it was widely advocated by the German General staff to a weary German population at home for its impregnability. Operation *Alberich*, that is, the construction of the Hindenburg Line and the withdrawal to it, was a most impressive feat of military engineering, deception and discipline.

From the beginning of February 1917, *Ludendorff* co-ordinated a bold and swift withdrawal to it from existing positions. Even when the main withdrawal was under way from 16 March, it took the Allies a further nine days to detect this operation, and much too late to attempt any counter-move. The German front line was accordingly reduced by over twenty-five miles. No fewer than thirteen infantry divisions were released from front line duty and assigned to a Western Front strategic reserve.

The professional and disciplined conduct of this withdrawal militarily was marred by the ruthless execution of a scorched earth policy. This led to widespread destruction of much of the French infrastructure, including roads, rail and waterways, the laying of booby-traps to maim or kill any advancing Allied troops, and the wanton devastation of the countryside which had been abandoned by the German army. The Allied pursuit was slow and faltering, partly for these reasons. It will be recalled that the German move caused major problems for the Allied plans for early 1917, especially the Nivelle offensive.

The Hindenburg (Siegfried) Line

The Hindenburg Line was a masterpiece of the siege-war on the Western Front. *Colonel Fritz von Lossberg*, Chief-of-Staff to *General von Below*'s *Second Army*, was the mastermind behind the masterpiece itself. His outstanding reputation as an innovative and pragmatic defensive expert was founded on the proposals which he had put forward for this 'little project', as he described it. The German High Command had the flexibility to appoint officers with special talents such as *Lossberg* to positions of real influence, regardless of rank. *Ludendorff* therefore employed him in *OHL* (*Oberste Heeresleitung* – the German Supreme Command HQ) to devise the new designs for the defensive front and the tactics to go with them.

Lossberg was highly valued and crucial to *OHL* in forming new tactics based on his operational experience. Having served as a corps Chief-of-Staff (COS) in 1914 and deputy chief of operations in *OHL* the following year, he was appointed as COS German *Third Army*, then sent to the Somme as COS *Second*, then *First Army*. Here, he implemented new defensive tactics in response to the heavy losses suffered prior to *Gen von Falkenhayn*'s removal from command and his replacement by *von Hindenburg* and *Ludendorff*. In April 1917 he was sent to the Arras sector to strengthen the shattered defences there also. In short, he was regarded as the German army's defensive 'fireman', appointed to the appropriate army staff where his expertise was most needed.[2]

The most important principle of the new defensive philosophy or doctrine was that of flexible, or elastic, defence. The defence was organised in depth – that is, well-spaced – so that each defensive line had to be taken systematically by the attacker (*see* diagram opposite). The troops selected for the forward zone were to reflect the flexibility of the defensive philosophy also. Their main task was to shift constantly from one position to another in order to survive the enemy artillery bombardment and inflict casualties on the enemy's infantry once it had begun to advance. In effect, they would rely on shell holes for cover, rather than rigid trench lines. The main defensive positions had reserves, counter-attack units and artillery in increasing strength. The flexible, or elastic, nature of the defence was evident in the notion that it would resist, bend and then snap back.

The fundamental feature of the new defensive line was the siting of the main defensive position on a reverse slope. A small garrison of outposts with machine-guns and artillery observers (FOOs) manned the forward slope to provide a defensive screen and give warning time for the troops in the main defensive position. From the reverse slope, German guns were able to sweep any attacking troops as they advanced over the crest of the high ground. Pillboxes and reinforced-concrete bunkers would provide protection for troops throughout the main defensive position. The Hindenburg Line was to hold fast until the final months of the war, but other sectors which should have been bringing their defensive positions up to date in line with the new doctrine, such as at the *Wytschaete-Bogen*, would not be such a reliable bulwark.

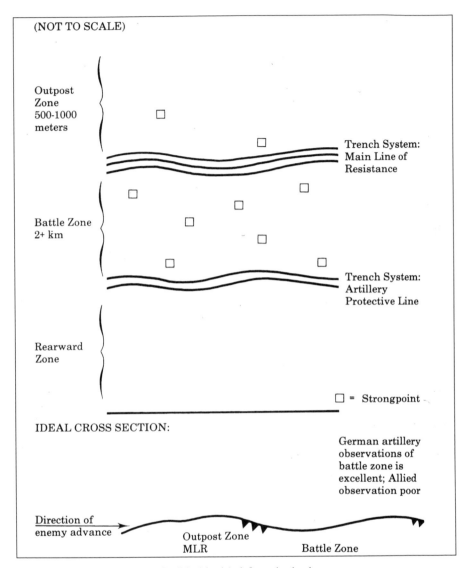

Diagram 13: German zones in flexible (elastic) defence-in-depth.

Background to Nemesis

Since the Somme offensive in 1916, *Wytschaete-Bogen* had been held by elements of two German corps, namely the *XIXth (Gruppe Wytschaete)*, covering the defences from Mount Sorrel and Observatory Ridge to the immediate north of the River Douve; and *II Bavarian (Gruppe Lille)* to the south of it. *Gruppe Wytschaete* was commanded by *General von Laffert* and was part of *General Sixt von Armin's Fourth Army*, which held the bow

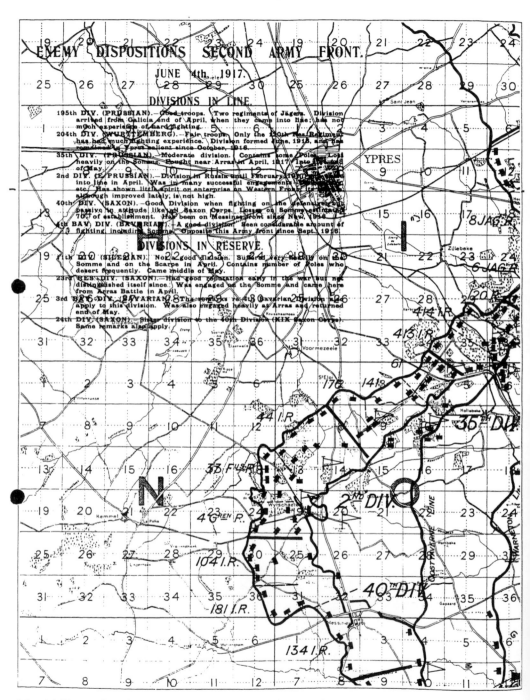

Map 14: Enemy dispositions, Second Army front, 4 June 1917. Assessment corrected to situation just three days prior to Second Army's attack. Note that 3rd Bavarian Division is still expected to act in its *Eingreif* (counter-attack) role.

Gen der Kavallerie von Laffert, Commander Gruppe Wytschaete.

of high ground dominating the whole southern sector of the salient. (See Appendix 2, page 199)

By mid-January 1917, the German High Command was already contemplating the real possibility of a major attack against the Messines sector. In February, reports confirmed the reinforcement of British artillery batteries and improvements in the roads and other infrastructure in this area. The Arras offensive, which began on 9 April, did little to reduce *Crown Prince Rupprecht*'s fears that the Messines–Wytschaete Ridge remained vulnerable. He concluded that an attack here to coincide with the unfolding events around Arras and Vimy Ridge would leave him with few, if any, reserves.[3]

In the second week in April, *Fourth Army* staff drafted an apocryphal intelligence estimate on the enemy's intentions in the Ypres Salient. It was presented to *Crown Prince Rupprecht* and the *OHL*. It was to be the catalyst for the series of misjudgements leading to the German defenders' nemesis

Gen Sixt von Armin, Commander German Fourth Army.

on the Messines–Wytschaete Ridge. The first conclusion drawn was that British offensive operations around the Ypres Salient could not be carried out until later in the year. Also, the assessment concluded that that there were simply insufficient Allied troops available for a simultaneous attack in the Ypres area while the Arras offensive continued. The intelligence reports had reassured *Fourth Army* staff that the British main effort would be ultimately identified in the Arras sector and that Ypres would be a diversionary offensive.[4]

These reassurances were short-lived. On 25 April, German air reconnaissance further confirmed the burgeoning of British forces and materiel in the Messines area. On 27 April, *Crown Prince Rupprecht* realised that the British would be in a strong position to attack here as soon as they had the troops, but on that day he considered this to be unlikely so long as the Arras offensive continued. However, on 28 April, a reliable German spy gave *OHL* vital and worrying news. He reported that the British

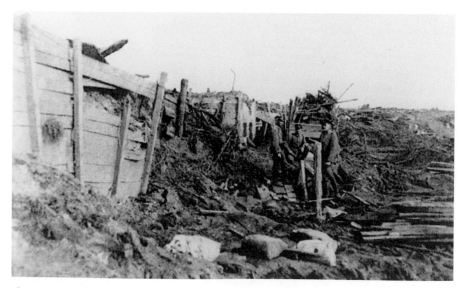

German defences within the Wytschaete-Bogen: I

Crown Prince Rupprecht of Bavaria, who was highly regarded by friend and foe, commanded Sixth Army in 1914 and 1915, then his own Group of Armies until the end of the war. (*Rudolph Stratz, Weltkrieg*)

would transfer their main offensive effort to Messines within two weeks if they failed to achieve the desired breakthrough at Arras.[5]

His own source had already intimated that the British were preparing to continue an offensive effort without French support, as Nivelle's failure unfolded in the south. The report was almost 100 per cent accurate, as events were to prove. *Ludendorff* and the *OHL* were both impressed and depressed by what they had heard. The news was passed on to *Crown Prince Rupprecht*. On the same day, *Ludendorff* ordered that the necessary preparations to prevent a British breakthrough must be taken in the Messines–Wytschaete sector immediately.

The Germans had begun to adopt a system of defence-in-depth here in common with the new doctrine. Each of their forward regiments (normally three battalions and roughly equivalent to a British brigade), had a sector about 1,500 yd wide and 3,000 yd in depth within which were the main network of machine-gun nests, bunkers and strongpoints. The forward zone, or the outpost front line, was theoretically thinly held. The front and support companies of the forward battalions were divided into *Stossen* or local counter-attack troops, which made up 50–75 per cent, and the strongpoint garrison (*Sicherheitsbesatzung*) platoons and squads. The principal task of the latter units was to hold each strongpoint until they were overwhelmed, or relieved by a stronger counter-attack (*Eingreif*) force, normally of divisional strength. In order to provide some reassurance that this scheme would work along the Wytschaete front, *Rupprecht* and *Ludendorff* realised that reinforcement was vital.

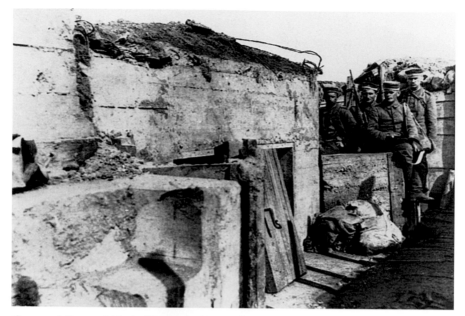

German defences within the Wytschaete-Bogen: II

The *204th (Württemberg) Infantry Division* was accordingly brought into the line north of Wytschaete village and the *3rd Bavarian Division* was ordered to Warneton to the rear of the main defensive position as an additional counter-attack division. (The *3rd Bavarian Division* had already suffered 2,000 casualties during its actions at Arras, but it had a very good reputation. It was to be even more sorely tested during the battle in June.) By 1 May, *Gruppe Lille (II Bavarian Corps)* had been subordinated to *General Sixt von Armin's Fourth Army* in the interests of a more unified command structure. *Gruppe Lille's* right-flank division, *4th Bavarian*, moved further north to strengthen the defensive garrison south of the River Douve. *Crown Prince Rupprecht* requested that *OHL* order more artillery and aircraft to reinforce the sector. Unfortunately, this decisive action by *Ludendorff* and the *Crown Prince* was then undermined by a touch of fatal arrogance which was to cost the German front line troops dear, well before the 7 June.

Local Knowledge is a Dangerous Thing

By the end of April, the revised German intelligence assessments concluded that the British were planning to attack the whole of the Messines–Wytschaete Ridge, i.e., the *Wytschaete–Bogen*, from Mount Sorrel and St Eloi in the north to St Yves and Ploegsteert Wood in the south. The build-up of British forces, particularly artillery and aircraft, was a real cause for

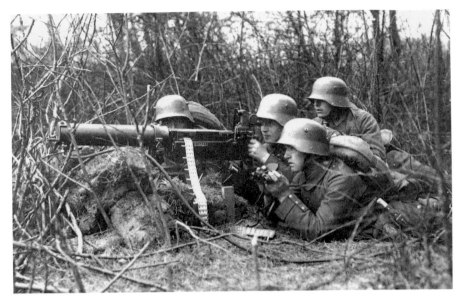

German machine-gun crew.

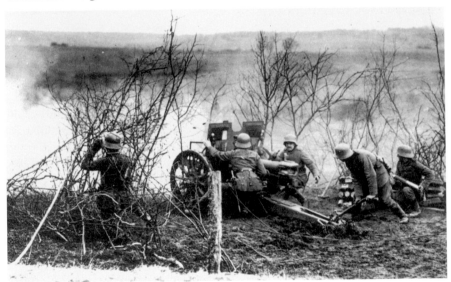

German 77mm field gun in action.

concern. There was the unknown quantity of the mine threat to consider as well. *Lt-Gen von Kuhl*, the *Crown Prince*'s Chief of Staff (COS), therefore suggested a bold yet pragmatic alternative for the defence of the ridge: '[To] evacuate the [southern] Salient and withdraw behind the R. Lys'.[6] A tactical withdrawal had some merit and *Crown Prince Rupprecht* agreed in principle

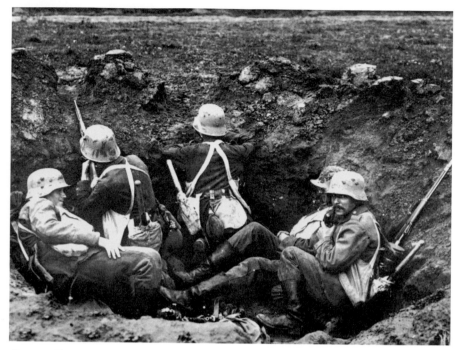

German *Eingreif* (counter-attack) troops taking cover in a shell hole.

to the idea. It had the advantages of negating any mining threat and would preserve the hard-pressed infantry and artillery units, allowing time for rest, reorganisation, training and re-equipment.

On 30 April, he consulted with his subordinate commanders. They promptly rejected such a notion. Their reasons were clear enough. However, their rationale was based on false assumptions and a misguided, though understandable, assurance that they knew their own sectors better than the German High Command.[7] In this case, their local knowledge was to prove a key factor in their subsequent failure.

The arguments against a withdrawal were put strongly by the field commanders, *General von Stetten* (*Gruppe Lille*) and *General von Laffert* (*Gruppe Wytschaete*). They argued that despite the recent *OHL* intelligence reports, they saw no threat of an imminent assault in their sector. Besides, even if such an attack materialised, they reasoned that it was vital to hold the commanding position of the ridge line itself, rather than voluntarily withdrawing to the *Sehnen Stellung* (Oosttaverne Line). Such a move would put their troops in a more vulnerable position, as the *Sehnen Stellung* was overlooked by the Messines–Wytschaete Ridge and provided poor observation compared to that on the ridge itself.

Also, *General von Laffert* could see no reason why the defence should rely

on counter-attack forces when, in his opinion, the *Wytschaete-Bogen* defensive system was solid and recently updated. The defence-in-depth tactics would over extend and then expose any enemy attack to overpowering German artillery bombardments. The *Commander of Artillery, Gruppe Wytschaete*, was convinced that his guns would easily defeat the British in any artillery duel, although the evidence for such optimism was thin. However, based on this assumption, *von Laffert* explained that only after the British artillery had been neutralised would it be necessary to counter-attack in strength. *General von Kuhl* believed the whole of the argument presented by the commanders of *Gruppe Lille* and *Gruppe Wytschaete* to be flawed. In his opinion, *General von Laffert* in particular showed a remarkably inflexible and complacent attitude in the face of the evidence. He expressed these reservations privately to *Crown Prince Rupprecht*.

But *Gen von Stetten* and *Gen von Laffert* won the day. *Von Laffert* assured the *Crown Prince* that he would easily hold the front crest of the Messines Ridge for a minimum of twelve hours, giving ample time for *Eingreif* divisions to be brought into play. *Von Laffert*'s miscalculations were based mainly on his smug self-assurance and a dismissive attitude towards the threat of the British concentration of forces against him, especially by the artillery. There was another factor, and a grave error it was to prove to be: his rejection of any threat from British mines.[8]

A Monstrous Miscalculation – the Underground War is Lost

Events in 1916 had convinced the German *Mineure* (their miners) that the *Wytschaete-Bogen* was of special interest to their enemy counterparts. *Lt-Col Füsslein, Kommandeur der Mineure*, was, in effect, the Controller of Mines for the German *Fourth Army*. During the summer, while the Somme offensive went on down south, *Füsslein*'s men had been probing away beneath Flanders in order to establish the extent of the British mining efforts. By this time, their underground war was defensive also. The Germans had neither resources nor men to conduct aggressive mining themselves.

In August, one group was threading its way gingerly below Petit Douve Farm, when they struck timber. They had dug deeper than most German tunnellers, to approximately 80 ft. They had found a British gallery. One officer and eight men went in to confirm the find. They discovered that they were looking into a mine chamber, packed with 35 tons of ammonal in tins. They began to remove the charge, but as the ammonal was taken out, the mine's firing wires became exposed. The German officer went forward to cut them. As he was about to make the explosive safe, the British simultaneously, yet quite by chance, realised that there was German activity in this adjacent tunnel and blew a heavy camouflet. The German officer and all eight men were killed instantly.

The Petit Douve Farm mine had been laid by the British 171 Tunnelling Company beneath a major German strongpoint along the Messines–Wytschaete front line and had been set under the German garrison in July 1916. Almost as soon as work on a subsidiary tunnel began, rival minework had

3rd Bavarian Tunnelling Company troops.

been heard and it was soon obvious that the German miners were about to enter the main tunnel. The British Tunnellers asked for permission to fire the main charge at once, but it was refused. On 28 August, *Füsslein*'s miners fired back with a heavy camouflet, equivalent to 6,000 lbs of ammonal. It wrecked the whole of the main tunnel, burying and killing four of the British tunnellers. *Füsslein*'s men had scored their most notable (and only real) success against the British mining effort around the ridge.[9]

The encounter had at once suggested to *Füsslein* that something special was happening. The fear was confirmed by an extraordinary defection. One evening, 3rd Canadian Tunnelling Company lost one of its men when he decided to go absent (AWOL) *towards* the German lines. He was no doubt disgruntled by the fact that he had just been placed under open arrest for drunkenness, but this seemed a rather drastic protest. He managed to slip away and then darted across no-man's-land, jumping into the nearest German trench to give himself up to an astonished German sentry. He had a cracking tale to tell. His revelations gave a grateful *Füsslein* details of the location of the mineshafts for Trench 122 and Factory Farm. The British front line opposite was soon heavily shelled and a week later, a large raid was carried out. The ultimate fate of the defector is not known.[10]

Füsslein reported to the German General Staff that British deep mining operations in the area were probably intended to support a surface attack. He asked for additional mining companies to help him fight back, and was granted three. However, he was already fighting a losing battle. His superiors the German commanders still did not take the mining threat seriously. Therefore, he could not hope to secure the manpower and resources which he knew he needed. *Füsslein* regarded his superior officers as being both 'arrogant and ignorant' about the potential mine threat. He was proved right on both counts.

In mid-February, 1917, *Füsslein*'s men had another success. They heard tunnelling work under way at Spanbroekmolen. A camouflet attack was prepared. The British 171 Tunnelling Company was again the target, as at Petit Douve Farm. A branch had been broken out from the main tunnel and aimed at a secondary target far back in the German lines. The first German camouflet went off when the branch had been pushed more than 1,000 ft

The inner chamber of a German tunnel.

The effects of a British camouflet after it had destroyed the same chamber.

forward. It caused negligible damage, but the experience of Petit Douve persuaded the British not to retaliate. A few days later, a second camouflet did cause significant damage. The Germans were confident that they had forced a considerable delay, if not abandonment, of the Spanbroekmolen mine. They were right about the first option, but very wrong about the second.

March and April 1917 gave the German miners more confidence as they managed to fire a camouflet close to the main Spanbroekmolen tunnel, causing further damage. Their attention turned back to the infamous and blood-soaked stump of high ground that was Hill 60. Still they continued, both with raids and their own underground efforts, especially around the rabbit warren of Hill 60. There were no fewer than four galleries here, at 15, 45, 90 and 100 ft. The 45-foot level gallery was a constant hive of frenetic activity. Four of its listening posts were located a mere six to ten feet clear of a main German gallery. On 4 and 5 April, the Germans blew two camouflets, causing some damage.

Then, in the late-evening of Easter Monday, 9 April, a large German raiding party attacked overland, entered the British front line and threw portable charges into several mine-shafts causing casualties and damage. A costly and exhausting action followed as the Australian tunnellers helped the infantry to fight the raiders off, with hand grenades and rifles. Hours later, on the morning of Tuesday 10 April, another German camouflet went off doing further damage to the galleries.

After all this special attention, the British mines, underneath Hill 60 and at the Caterpillar, still appeared to be intact. Nevertheless, the Australians were openly questioning their chances of protecting them much longer. Early in May, *Füsslein*'s miners caused a new wave of anxiety by working up close to the main Hill 60 charge; at one stage they were unwittingly as close as two feet to the British tunnel.

This had been a 'purple patch' for the German counter-mining, but *Füsslein* had enjoyed only fleeting success. Most of the British mines were still entirely intact and lay undiscovered. The plain truth was that the Germans never had the manpower or resources to match the massive subterranean effort which was going on across the proposed Messines front.

The tables were now turned against *Füsslein*'s troops and he was largely to blame. In April, he had reported at the fateful meeting of field commanders and *Crown Prince Rupprecht* that his counter-mining had been so successful that a major British mining attack against the Messines Ridge was no longer possible. The *OHL* were uneasy, but *Füsslein* was confident that the British mining threat was coming to an end. It was decided that probing would go on, but a major mining attack was unlikely. As late as 24 May, both *Lt-Col Füsslein* and *Gen von Laffert* believed that even if the British did blow a few mines, the effects would be localised and they would not affect the general defence of the ridge. From 12 May, the mining threat report was discontinued in the weekly Situation Report sent to German Supreme HQ. *Gen Von Laffert* and *Lt-Col Füsslein* sat back and waited for the battle with a mutually supreme confidence that they would be proved right. Their assessments of the threat were somewhat awry.

At the Kaiser's Court

By mid-May, the general situation was in danger of being assessed with almost comic naïveté at the *Kaiser*'s Court, based at Kreuznach. *Admiral Georg von Müller*, the *Kaiser*'s Aide, kept a succinct yet telling account of the events leading up to Messines and Third Ypres. The German agony and the irony were plain to see. On 31 May, as the Second Army's preliminary bombardment was already causing havoc among the German troops manning the defences along *Wytschaete-Bogen*, *Admiral Müller* wrote:

> Yesterday evening there was champagne. To the general surprise [of those attending] His Majesty suddenly rose to his feet and said: 'General Ludendorff has just reported to me that the Spring offensive at Arras, on the Aisne and in Champagne, has been defeated. We have gained a famous victory. (We have incidentally lost hundreds of guns and over 50,000 prisoners.)'[11]

In the Front Line

As the *Kaiser* celebrated the news of these dubious successes, the troops of *Gruppe Wytschaete* could not share His Majesty's optimism. The artillery

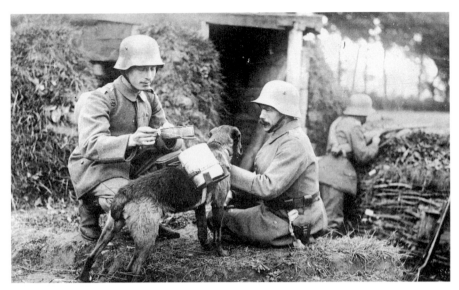

Dogs were used to bring rations, water and ammunition to the German defenders.

bombardment became so intense at the end of May that dogs were brought into the line to deliver some of the rations, water, medical supplies and ammunition. They, at least, had a better chance of reaching the tired, frightened, hungry and parched front line troops. The German defenders had to wear gas masks most of the time, as the relentless British bombardment included gas and smoke shells, as well as high explosives.

Sanitätssoldat (medical orderly) *Wilhelm Scholl,* a stretcher-bearer and orderly with *2nd (E. Prussian) Division* around Wytschaete, kept a diary of the week leading up to the battle. His views of the experience speak for themselves:

> 1 June: The English are bombarding all the trenches and as far as possible, destroying all the dug-outs. . . . They send over shot after shot. . . . The casualties increase terribly.
> 3 June: The English are trying to demolish our dug-out, too.
> 4 June: The casualties are becoming more numerous all the time. No shelter to bring the men under. They (the wounded) must now lie out and sleep in the open; only a few dug-outs left.
> 6 June: The English are all over us. They blow up the earth all around us and there is shell hole after shell hole, some of them being large enough to build a house in . . . more casualties.[12]

The road towards *Soldatendämmerung* had been laid by the extraordinary arrogance, indecision and self-delusion of *Gen von Laffert* and his HQ staff. By the early morning of 7 June that road would be littered with the dead and wounded men of *Gruppe Wytschaete,* as well as the desperate troops who still held the line in the face of the relentless British artillery bombardment.

Notes

1 The term *Soldatendämmerung* is used here as an allusion to Richard Wagner's Ring Cycle (Der Ring des Nibelungen), namely *Götterdämmerung* (the Twilight of the Gods), indicating their imminent destruction.
2 Lupfer, Capt Timothy T., *The Dynamics of Doctrine: The Changes in German Tactical Doctrine During the First World War* (Fort Leavenworth, Kansas, USA, Combat Studies Institute, 1981).
3 *GOH, Band 12* (1917), Chapter VIII, Der Verlust des Wytschaete-Bogens (Berlin, Mittler, 1925/1944), pp. 425–76. *See also* Cron, H. *Geschichte der Deutschen Heeres im Weltkriege, 1914–1918* (Berlin, Sigismund, 1937); Edmonds, *BOH*, 1917, vol. II, p. 90–1, 93.
4 Ibid., p. 93.
5 Wolff, *In Flanders Fields*, p. 128.
6 Kuhl, Gen Hermann von, *Der Weltkrieg 1914–1918* (Berlin, Weller, 1921).
7 Beumelburg, Walter, *Flandern 1917, Schlacten des Weltkrieges* (Berlin, 1928), pp. 18–65; *GOH, Band 12* (1917), pp. 431–3.
8 Barrie, *War Underground*, pp. 243–4.
9 Ibid., p. 244.
10 Ibid.
11 Müller, Admiral Georg von, *At Court with the Kaiser: Letters and diaries.* (Courtesy of the Liddle Collection.)
12 Extract from GHQ BEF captured documents, quoted in *The Times Illustrated History of the War, Vol. 15* (London, 1919).

Overture: 1–6 June

Concentration of Force sums up in itself all the other factors,
the entire alphabet of military efficiency in war.
Lt-Gen Antoine-Henri Baron de Jomini

The Final Path to Zero

In the final days there were the inevitable rumours and gossip. The attack would surely come now, but when? Even FM Haig was nervous, believing that the Germans must know about the mines. He suggested that they should be blown before zero. Plumer was resolute. The mines would be blown at zero hour, and not a moment sooner. Haig acquiesced. The troops carried out their final preparations, most of them oblivious of the fact that the miners were making their own final adjustments to the forthcoming earthquake. But the rumours persisted.

Pte Victor Maes, a 24-year-old conscripted Belgian, was on short leave in Bailleul, near the Messines area, on 5 June. He had been flirting with some pretty young women when one told him there was to be a great attack by mines at Messines. Maes asked when, and the girls said 'Thursday morning.' Maes asked what time. 'Three o'clock'. Maes was incredulous. 'How do you know this?' The girls happily confessed that some young British officers had let them in on the secret. Fortunately, the German grapevine had not run as far as these two lucky girls.[1]

The British bombardment was relentless and the German defenders continued to suffer. A *Grenadier* of the *4th Grenadier Regiment*, facing 16th Irish Division around Wytschaete, was typical. He wrote in his diary:

> 1.6.17 – For a long time we have supposed that the enemy offensive from Arras would extend north – the time appears to have come – to-day is now the 13th day on which our trenches and the ground behind us have been exposed to heavy fire, which very often increases to drum fire. All the trenches are smashed in, no more shelter is to hand, battery emplacements up to 2 metres thick are completely destroyed, and even 6-metre deep galleries are not safe from guns of heavy calibre – thus are we forced into the open without any protection, and have to submit to the passing over of iron hailstones – our losses consequently are very heavy – each day we must thank God that we are still alive.[2]

On 3 June, the artillery stepped up the bombardment according to plan in order to convince the enemy that the attack was imminent. The Germans responded with an artillery barrage of their own, but it was relatively weak.

The real damage done on this day was the wholesale flattening of both Messines and Wytschaete, the latter of which received special attention. The stronghold (*Festung*), so carefully crafted over the past two years, was wrecked. Heavy and super heavy artillery destroyed bunkers, concrete gun emplacements and even some of the reinforced cellars. By 7 June, Wytschaete would be reduced to a pile of twisted defensive materiel and powdered bricks. Furthermore, the woods, including Wytschaete Wood, were fired by the discharge of 2,000 oil drums on the night of 3 and 4 June, a terrifying and destructive barrage which had been devised by the Sappers.[3]

During the training and rehearsals in May and early June, the front line in the Second Army sector was lightly held by one battalion for each divisional front. At the same time, a continuous programme of trench raids took place across the Messines front. IX Corps, for example, used elements of all three assault divisions (19th (Western), 16th (Irish) and 36th (Ulster) Divisions) to conduct nineteen raids against the defences held by *2nd (E. Prussian)* and *40th (Saxon)/3rd Bavarian Divisions* between 16 May and 6 June. Ranging from small fighting patrols of twelve men to battalion raiding parties of 300 men, they took seventeen German prisoners and gained vital intelligence on German strengths and low morale.[4]

6 June – Zero Minus One

On the afternoon of 6 June, Second Army HQ briefed the Press Corps on the forthcoming battle. The press, including prominent correspondents of the day such as Perry Robinson (*The Times*), Beach Thomas and Philip Gibbs (*Daily Chronicle*) were received warmly. Although the full details could not be given for obvious security reasons, the war correspondents were given most of it in confidence. They had enough information to prepare their stories for the newspapers back home. The rest would be revealed by the success or failure of 7 June. Maj-Gen Tim Harington, Plumer's Chief of Staff, invited them all to return at 5 p.m. During questions after the briefing, he was asked whether he thought that tomorrow's battle might help to change the course of the war. He smiled, thought for a moment, then answered: 'Gentlemen, I do not know whether we shall change history tomorrow, but we shall certainly alter the geography.'[5] There was a palpable air of optimism within HQ Second Army, a sense which was not lost on the assembled press men.

At dusk, the roads were alive with continuous streams of transport limbers, wagons and pack mules carrying ammunition. The guns continued firing. It caused the enemy grief, but it was good for the morale of the British, Irish and Anzac troops moving up to their assault positions. It gave them confidence that the artillery was far superior to that which the Germans had been able to reply with. Above all, and above the clouds, it seemed that the RFC were on permanent patrol. The enemy aircraft were nowhere. This air superiority instilled further trust among the men that 7 June would go their way.

Among the one hundred or so battalions on their final move up were the 3rd Worcesters. Among the leading companies, Pte Ky Walker managed to joke with the less experienced men, making them feel at ease as best as he knew how. He was a veteran in more ways than one: almost 40 years old, yet still fit and a man of endless energy. He was one of those men who appeared to have a charmed life. He had fought in the front line at Hooge in 1915 and on the Somme before returning to the salient. He was a canny, likeable rogue and the younger men imagined him immortal.[6]

The Germans continued to hold the ridge and were responding as best they could to the British build-up. One potential disaster came in the form of a gas-shell bombardment, which concentrated on Hill 63 and 'Plugstreet' Wood. Gunners, medical men and above all, 9th and 10th Brigades of 3rd Australian Division were caught up in it. The Aussies' silent approach march was disturbed by the gentle 'plop' of the gas shells as they hit their target. Many of the Aussie troops were not wearing gas masks at the time and suffered as a result.

Capt William Aitken, a Medical Officer (MO) with the NZ Division, was close to the German gas bombardment:

> Our first MDS (Medical Dressing Station) was set up in the hunting lodge belonging to one Henessy, the Brandy millionaire. . . . On the night of the assault, the different units commenced assembling after dark and soon the Huns sent over tear gas shells, a few of which fell into our FDS (Forward Dressing Station); we were all reduced to tears – wearing our gas masks only aggravated the situation. We were glad when the advance started and we got clear of that area![7]

The ordeal for the 3rd Australian Division was the product of the random German artillery success at about midnight. The barrage hit the assault battalions moving through it, causing some 500 casualties. The barrage had consisted principally of gas shells, with a mix of phosgene and chlorine, but mainly tear gas. The battalions were forced to put on their gas masks and this made them temporarily lose direction. They were then lashed by a couple of smaller high explosive and incendiary barrages, causing further casualties. However, they were determined to make it to their jumping-off positions by zero and they pressed on.

Everywhere else, the move was going according to plan. Pte Frank Dunham of the 1/7th London (City Of London) Regiment, 140th Bde, 47th (2nd London) Division, recorded that:

> After two nights' rest in the cellars . . . we were moved towards the line. It was . . . slow work because of the traffic along the road and tracks. . . . We were still ignorant of the day of the attack, . . . our officers would only refer to it as 'Zero' day. [For security reasons]. But we knew that it couldn't be far off. . . . [Then] we finally learned that the attack was to take place on the following morning and were ordered to move at 10 p.m.[8]

The last hours were a relief to most, once they knew the time. The prevailing attitude was now to get on with it. Frank Dunham nervously counted the hours down before he was due to follow the company up the line. Then they were off. The company moved up the communication trench at 10.30 p.m. and were incredulous at what they saw as they did so.

The 1/7th Londons had been out of this line for four weeks. Everywhere there were new dug-outs, gun-pits and ammunition dumps, all prepared for the anticipated advance of the field guns as soon as the leading assault battalions had captured their respective objectives. Most had been camouflaged and many of them had been dug and made ready for the battle in broad daylight, under cover of camouflage netting.

Just before reaching the front line, Frank Dunham's company was led into a shallow jumping-off trench. The trench was so crowded that a few of the company were forced to use nearby shell holes instead. Then, to Frank's obvious relief, '. . . we were told that 'Zero', the hour of the attack [was to be] 3.10 a.m.'[9] Only then was the company informed that the attack would begin with the explosion of the mines.

The overall confidence of the troops as they trudged up through the communication trenches was naturally not reflected by all: 2/Lt Firstbrooke Clarke, a platoon commander in 8th Bn. N. Staffords (57th Brigade of 19th Division), was to admit that:

> We had been very much overworked for weeks and I was feeling dejected, funky and most utterly and completely fed up. I thought we should get it in the neck and I couldn't see that I personally stood a dog's chance. We went into our trenches that night, having taken aboard bombs, flares, shovels etc, etc; you know – 'imitation Christmas tree; très difficile'. I think nearly everyone except me was in good spirits. . . . [We moved into the jumping-off trenches.] I then lay in the trench dozing.[10]

'Ta ta for now'

There was just time for the last letters home, or scribbled notes to friends elsewhere in the line, who were not involved in this 'stunt'. Rifleman Malcolm McCaskill, with the NZ Rifle Brigade, wrote to his brother and sister on the evening before the battle:

> 'Somewhere in France' 6th June 1917
>
> My dearest Ern' and Poll;
>
> Just a few lines to you before going over the top; we are going into battle in 6 hours' time, so God only knows what will happen. The artillery fire now is like a living Hell. By this time tomorrow, things will be a lot worse. You cannot imagine it without seeing it for yourself. If we are successful it means a lot to the Western Front. As to the place we have to take, it is a very strong position, so I hope we will be successful. Everything is at high tension now: one feels quite excited until 'Zero' time arrives.
>
> Well, I meant to write much, but I cannot possibly put my mind to it; but I hope to have the luck to come through it all right. Remember me to everyone – the Trebleys, Peter and Jim and all the Cockardinie folk when you write to them. I am just sending a field card to Maud as I have no more writing material. I shall send you one as soon as we come through this stunt, if lucky. Au Revoir for this time.
>
> From your loving Bro'.
>
> M
>
> PS I wrote to Lawrence, but got no reply so far. If anything does happen to me, see you get all the money due, and I hope that it will be of some use to you. Ta Ta'.

McCaskill survived the Battle of Messines, and the war.[11]

At Second Army – just before 'Zero'

On the night before the battle, Maj-Gen Tim Harington went to bed at the unprecedented time of 9 p.m. For once, there was nothing more for him to do. By then, the troops were on the move and everything was in place for 3.10 a.m. At 2.30 a.m., 7 June, the Second Army staff had breakfast with Gen Plumer. He wished everyone good luck. All except Plumer then went to the top of Cassel hill to watch the mines go off and therefore witness the beginning of the following attack. Plumer went to his room before the battle began and kneeled in silent prayer for the men who were about to go 'over the top'.[12]

Notes

1 Barrie, *War Underground*, p. 251.
2 IWM SS568: GHQ BEF; Captured Letters and Documents Section (G2). This letter was found on a dead German soldier from 4th Grenadier Regiment (2nd E. Prussian Division) by troops from 16th Irish Division during the attack on Wytschaete village. (IWM SS568, Extract no. 8, June 1917)
3 Edmonds, *BOH*, 1917, vol. II, p. 46.
4 Ibid., p. 34.
5 Account of the briefing given in Harington, *Plumer of Messines*; *see also* Gibbs, *Bapaume to Passchendaele*.
6 Pte Ky Walker, 3rd Worcesters. Private Collection of Mr and Mrs John Heritage.
7 AWM 3DRL2422 Capt William Aitken MC, MD, FRACP; NZ Medical Corps. Personal experiences at Messines. Aitken had qualified early, in August 1914, because of the outbreak of war. By September he was commissioned Lt in NZ Mounted Field Ambulance. He served at Gallipoli, and then on the Western Front in the salient and on the Somme before returning to the Ypres Salient for Messines. Aitken had a Maori batman called Piwa. During the Somme campaign, Piwa slept in an old German dug-out full of dead German soldiers as it was warmer than in the open where Aitken preferred to be. Piwa was always happy to sleep anywhere!
8 Haigh R.H. and Turner P.W., 'The Battle of Messines Ridge – 7 June 1917. A view from the British Rank', *RE Journal*, vol. 92, No 4; December 1978. (Originally published as *The Long Carry, The War Diary of Stretcher Bearer Frank Dunham 1916–1918*, edited by Haigh and Turner (Pergamon Press, 1970).)
9 Ibid.
10 Liddle Collection, University of Leeds: 2/Lt Firstbrooke Clarke, 8th Bn N. Staffords: Private Letters and Collection.
11 AWM PR00229 Rifleman Malcolm McCaskill, NZ Rifle Brigade, NZ Infantry Division, II Anzac Corps.
12 Harington, *Plumer of Messines*, p. 103.

The Messines Symphony – First Movement and Phase One: *Soldatendämmerung*, a.m. 7 June

And on that day of wrath, the earth shall melt into the fire,
'Dies Irae', Verdi's Requiem

Standing on the Dangerous Edge of Now

Caught by the frantic, accurate German gas barrage, 3rd Australian Division's leading 9th and 10th Brigades, were forcing a path towards the front line. They stuck grimly to their task, despite the 500 casualties. En route via their selected routes through 'Plugstreet', they would make it to their jumping-off positions – just. Virtually all the other formations and units were moving into their final positions without incident. At 2 a.m. aircraft flew over the area to drown the noise of the tanks moving forward.

Across the Wire

The forward companies of *3rd Bavarian* and *40th Saxon Divisions* were managing to carry out their change-over, despite the attention of the British artillery. The officers and men of both divisions were too exhausted to be cowed by the shells landing close to their positions. Those *Saxons* who still survived had endured so many days and nights of such attention already. As for their Bavarian comrades, most were still seething about the decision to put them in the front line at this eleventh hour. As counter-attack troops they had been training until 24 hours ago to repulse any British attack here. Their place was not in the front-line trenches, but behind them, within striking distance of a developing enemy assault. Yet here they were: muttering, tired men in crowded trenches, incredulous and angry over *Gen von Laffert*'s decision to put them here instead. Their only compensation was the news that they still had 24 hours' grace before the British assault. Or so they were led to believe.[1]

The Final Countdown

The final preparations were now made for the nineteen mines. At Hill 60 and the Caterpillar, Brig Lambert (Commander 69th Brigade, responsible for the following assault), Capt Oliver Woodward, Lt Royle and Lt James Bowry (1st Australian Tunnelling Company) stood side-by-side in their dug-out. Brig Lambert, watch in hand, was calling out each individual minute. Woodward was standing by his switch, his hand resting lightly on the handle. The others waited, patient, watchful, the emergency exploders at their feet. The only sound was that of Lambert's voice calling out the minutes and, at last, right at the end, the seconds.

At all eleven firing points the same tense silence had settled in. Maj Henry Hudspeth was in the Spanbroekmolen post, waiting and wondering, thankful that soon he would know the worst or best about the great charge they had lost and recovered just in time.

Opposite Factory Farm, at 2.50 a.m., Lt Cecil Hall had made it. He was very tired, but he was ready and relatively calm. There was much to be said for having been busy. He had been spared the anxiety of waiting for what might have appeared endless time before the great task was over. Sgt Beer, of his section, had begged to help with the firing. They stood side by side, in their gas masks, peering mistily at the watch.[2]

O Still Small Voice of Calm

By 3 a.m. the British assault troops had slipped noiselessly and unnoticed into their assembly trenches. With silent precision, every man fixed his bayonet and waited. Then, the guns stopped firing. There was an uncanny, eerie silence. Every soldier felt it, smelled it and above all heard it. After weeks of incessant drumming from the guns and the general noise and bustle of an army preparing for this moment, it was suddenly deathly silent. There was time now only for final reflection, hopes, regrets, and silent prayer. The first glimmer of dawn skylined the ridge. The Germans became alarmed; flares shot into the sky from their lines as the minutes slowly passed. They strained their eyes towards the British lines, but saw nothing.

With time before zero running down but tension mounting by the second, the silence was broken briefly by nightingales singing in the woods behind the British front line, heralding a dawn chorus. It must have inspired a brief reverie for any of the troops who heard this impromptu concert. There were silent thoughts of peace and memories of home and loved ones. Then the reveries, the endless waiting and the almost unbearable tension were over.

And the World was Rent Asunder

At Trench 122/Factory Farm, Cecil Hall watched the seconds slip away, paused briefly, and then yelled 'DOWN!' Both he and Beer rammed

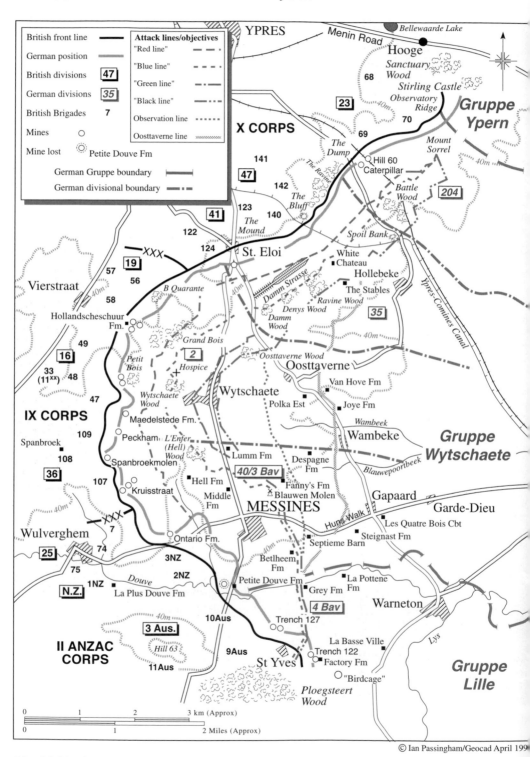

British front line	———	Attack lines/objectives	
German position	———	"Red line"	— — ·
British divisions	47	"Blue line"	— — —
German divisions	35	"Green line"	— · — ·
British Brigades	7	"Black line"	— — —
Mines	○	Observation line	· · · · ·
Mine lost	◎ Petite Douve Fm	Oosttaverne line	××××××××
German Gruppe boundary	———		
German divisional boundary	— · — ·		

Map 15: Messines, June 1917: battle map.

© Ian Passingham/Geocad April 199[?]

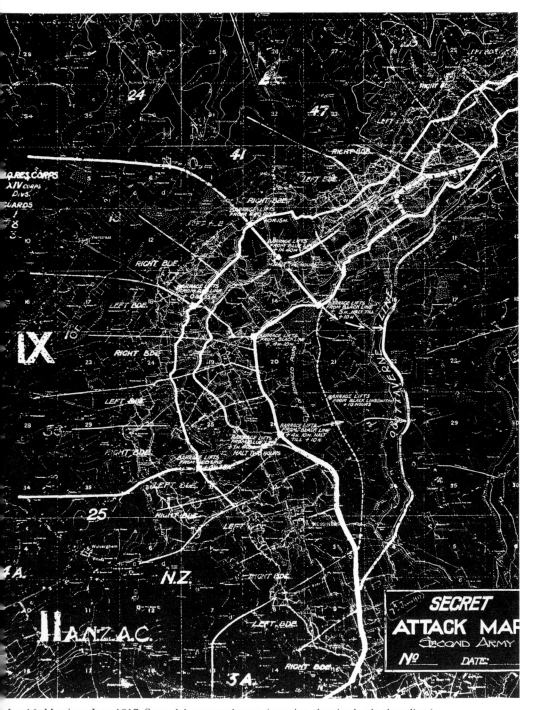

Map 16: Messines, June 1917: Second Army attack map (negative, showing battle phase lines).

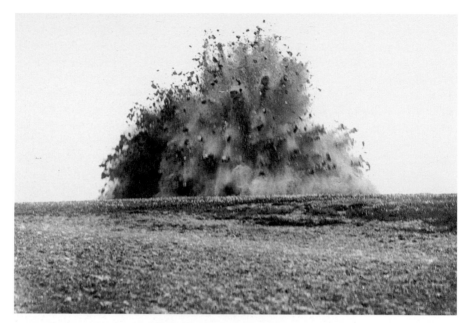

The effects of a large mine, similar to those blown at Messines.

their plungers home and the mines roared, blasting them off their feet. The Trench 127 mines went up simultaneously. The first of the Messines mines had gone off. They were seven seconds early. Oliver Woodward heard the distant rumble and had time for a moment's envy that one lucky firing party's job was safely over. Then Brig Lambert counted down and shouted: 'FIRE!' Woodward was over-eager and received a pole-axing electric shock. It was an unsettling moment after all the checks and re-checks: had the damned things gone? He soon felt that they had: the ground was heaving beneath him, ripping apart the Hill 60 and Caterpillar positions. It was all the proof he needed.

Spanbroekmolen erupted at the same time. Huge clods of clay the size of farm carts were thrown into the air, forming a crater 430 feet across. The great mine, which had been lost to *Lt-Col Füsslein's* counter-miners, and so lately recovered, had gone off after all. St Eloi, Hollandscheschuur, Petit Bois, Maedelstede, Peckham House and Kruisstraat all went off simultaneously. At Ontario Farm, Lts Percy Ellis and Henry Daniell were thrown around by the shock wave of their mine. It left no crater; just a circular, pulpy-looking patch that 'bubbled slowly for days like porridge coming gently to the boil'.[3]

A total of 933,200 lb of ammonal had blown and taken thousands of hapless German soldiers with it. There was not a single failure, after all the heartache of the last months, days, seconds. It must have been a wonderful feeling of elation and relief for the tunnellers across the whole front.

2/Lt Firstbrooke Clarke, 8th Bn N. Staffords, 57th Brigade, 19th

The craters caused by the Petit Bois mines.

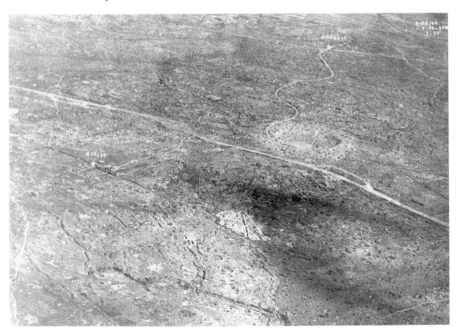

Spanbroekmolen after the mine had ripped it apart.

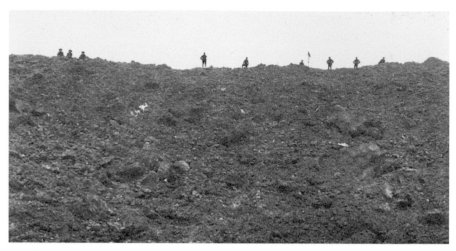

A view from inside the crater at Spanbroekmolen. The men at the rim provide an excellent idea of the scale.

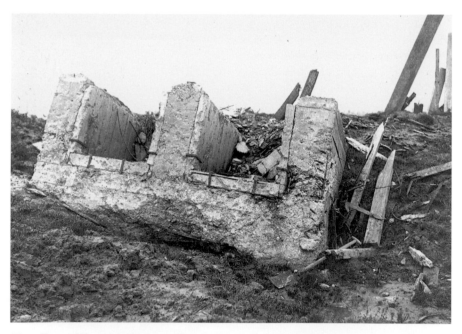

The effects of the mines blown at Trench 122 by Capt Cecil Hall. A German bunker turned upside down at Factory Farm.

(Western) Division, who had been dozing through the final minutes opposite Grand Bois and Bois Quarante, wrote:

> I woke up and looked at my watch: it was 03.08. I said to myself: 'Ladies and gentlemen, the show is about to commence.' I went on to the parapet and looked over. It was just getting light, our artillery had died down, and 'all was peas'. Suddenly, several big mines went up together, the nearest over a mile away. . . . At the same time our artillery opened like fury, <u>all together</u>. I believe it was the hottest artillery show ever put up. I can't describe it; it was terrifying and irresistible. [From our position] we could just see the people in front of us going over the top; it wasn't our turn yet.[4]

The battle of Messines had begun.

A Most Diabolical Splendour

Philip Gibbs, the *Daily Chronicle*'s war correspondent, stood at Mt Kemmel to see the event. Harington's comments on the nature of the battle during the briefing to the Press the day before was now graphically apparent. Gibbs provided one of the best descriptions of those fateful moments:

> The most diabolical splendour I have ever seen. Out of the dark ridges of Messines and Wytschaete and that ill-famed Hill 60, there gushed out and up enormous volumes of scarlet flame from the exploding mines and of earth and smoke all lighted by the flame spilling over into mountains of fierce colour, so that all the countryside was illuminated by red light. Where some of us stood watching, aghast and spellbound by this burning horror, the ground trembled and surged violently to and fro. Truly the earth quaked . . .'[5]

'La Victoire des Sapeurs Anglais – Messines': French cartoon, *Le Petit Journal*, 12 June 1917.

German descriptions of the mines' effects were no less graphic:

> They appeared as nineteen gigantic roses with carmine-coloured petals, or as enormous mushrooms, which rose up slowly and majestically out of the ground and then split into pieces with a mighty roar, sending up multi-coloured columns of flame, mixed with a mass of earth and splinters, high into the sky.[6]

Arthur Gould Lee, a junior pilot and member of 46 Squadron RFC, was stationed at La Gorgue 12 miles away from the front line, but heard the opening crescendo and was himself disturbed by it:

Then . . . there came the most God Almighty roar . . . the sky lit up with a vivid red glare . . . the hut seemed to jump off the ground. I've never heard such a stupendous noise before, like the thunderclap of doom. It seemed so close it could have come from just across the canal instead of a dozen miles away. . . . Then, as the roar ended, a hurricane bombardment began, a continuous rapid throbbing of guns, thousands of them. . . . All Hell had been let loose up north.[7]

The shock-wave of the mine explosions caused consternation many miles back as people thought they were experiencing an earthquake. German troops in the Lille garrison, 15 miles (25 kilometres) away ran panic-stricken through the streets. Prime Minister Lloyd George apparently recorded the sound in his office in No. 10 Downing Street and it was reported that the explosions could be heard as far away as Dublin.[8]

The time officially recorded between the firing of the first and last mine was 19 seconds, with the four mines at Trench 127 & 122/Factory Farm detonating 7 seconds early. The minor gaps between first and last resulted in a cumulative, wave-like acoustic effect. This had a greater shock-effect on the German defenders. Many were convinced that it was the beginning of a natural earthquake. Others believed the explosions were occurring everywhere along the German front line in the Ypres Salient and as far back as Warneton, Comines and Lille. The demoralising effect on the German defenders was much more significant than estimated, as they had been told that the British mine threat was non-existent.

On the other hand, British troops reported that German mines had exploded behind their own support trenches. This was a natural conclusion given the uneven, bow-like shape of the front lines across the Messines–Wytschaete front. Assault troops of 23rd Division, waiting to go over the top near Hill 60, believed that the earth-shattering blasts at Peckham House, Maedelstede, Spanbroekmolen and Kruisstraat had been placed under the actual ridge and split Wytschaete and Messines apart.

The shattering roar of the mines was matched immediately by the equally deafening crescendo of the artillery. As the last mines exploded and threw the smoke, flame, bodies, weapons and equipment into the early dawn sky, the British artillery launched a devastating and highly accurate barrage. All 2,266 guns fired at their maximum rate of fire in order to blow the German defenders off the ridge which they had held so doggedly for so long. Three belts of fire immersed the first 700 yards of the German defensive lines from Hill 60 to St Yves. The flashes from the guns, which stood virtually axle-to-axle, gave a surreal impression that the whole of the British front was ablaze. Counter-battery fire concentrated on the known German artillery positions, using a deadly mix of high explosive and gas shells. *Soldatendämmerung* was assured as the German *Wytschaete-Bogen* was pulverised by the British artillery.

Through the Earthquake, Wind and Fire

As this barrage erupted, 80,000 assault troops in the leading assault divisions climbed out of their trenches or advanced from their forward jumping-off

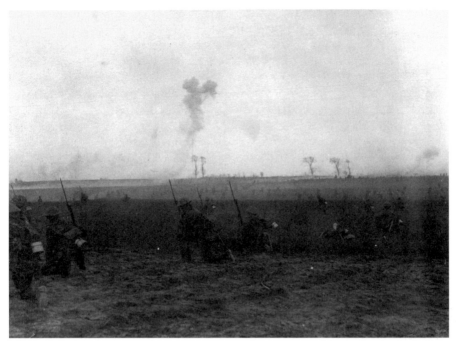

The leading battalions of the NZ Division advance towards Messines on the morning of 7 June.

positions in no man's land. Despite the previously clear skies and the first light of dawn, it was darker than expected, owing principally to the combined smoke, dust and obscuration effect of the mines and the artillery barrage. Visibility in most places across the assault front was down to 50 yd at best. On the other side of the wire, the surviving and less shocked German units sent up white and green SOS flares to call for German artillery support. It was, when it came, weak and practically ineffective. The German gunners had been as hard-hit as the front-line infantry. Nevertheless, when German artillery bombardments did fall on the British assembly trenches, ten minutes or so after zero hour, the British and Anzac assault divisions were clear and the trenches were in effect unoccupied.

The assault went in as planned, for once unhindered in the most part by hostile machine-gun and artillery fire. The German wire had been cut so that clear gaps allowed the attacking troops to bypass what remained. As this bombardment proper began and the vast mushroom-shaped clouds formed by the mine explosions shrouded the ridge line, there was virtually no response from the remaining German guns. Despite the traumatic effect of the mines and the reopening of the artillery onslaught, small groups of German infantry and machine-gun crews did attempt to arrest the tide of British infantrymen as they advanced rapidly towards the ridge itself. They were annihilated by the concentrated infantry small arms and machine-gun

fire and the lethal combination of creeping and standing barrages.[9] The accuracy and intensity of the artillery had already given the assaulting infantry the luxury of not having to fight for every inch of no man's land before occupying an enemy's front-line trench.

The three reserve divisions stood by to follow up the assault, but were well to the rear, out of range of any possible retaliation by German long-range artillery. The 24th, 11th and 4th Australian Divisions made their final preparations for their later assault on the Oosttaverne Line.

The Attack

X Corps (left)

Lt-Gen Sir Thomas Morland's X Corps was in the northern sector and responsible for taking the St Eloi Salient, Mount Sorrel and the formidable strongpoints around Dammstrasse and the White Château. The capture of this summit position on the northern edge of the Messines–Wytschaete

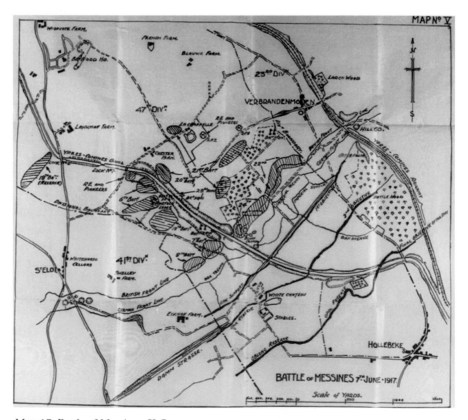

Map 17: Battle of Messines: X Corps area.

Ridge would provide an uninterrupted view towards the German rear area to Zandvoorde and the southern slope of the Gheluvelt plateau. The German defences had been considerably strengthened to prevent the sector's loss and X Corps were assaulting two German divisions: *204th (Württemberg) Division* and *35th (Prussian) Division* across a 6,000-yd frontage. Also, the German artillery positions had a considerable concentration of guns in the Zandvoorde area, making this sector potentially very vulnerable.

In the event, the dramatic effect of the British counter-battery fire forced the undamaged or unidentified German guns to remain masked for as long as possible. The result was a late and weak counter-barrage. The German troops of the beleaguered front-line garrison must have cursed their artillery at the same time as our troops were marvelling at our own. The troops in the front-line positions of *44th Infantry Regiment*, of *2nd (E. Prussian) Division*, opposite 19th (Western) Division were enduring a typically desperate time:

> The English have completely smashed in the whole trench and all the dug-outs. I was almost buried in a dug-out yesterday. It was a concrete one, and the English put a few 38cm shells on it, when it collapsed like a concertina. A whole crowd of men were buried and burnt. I cannot describe what it is like here; soon there will be no hope for us. We have drum-fire day and night, 14 days of it already. We can't compete with the English . . . it is regular hell here for us. The English smash up everything with their artillery, we have frightful losses, . . . and our artillery doesn't speak.[10]

As they muttered and cowered at the bottom of their trenches under this awesome British barrage, and as their own artillery's shells crashed ineffectually into the British jumping-off trenches, X Corps troops were already on top of them and entering the German positions.

Both 23rd Division (Maj-Gen J. Babington) and 47th (2nd London) Division (Maj-Gen Sir George Gorringe) had orders to take the northern high ground of the ridge astride the Ypres–Comines canal and railway and Mount Sorrel. The mines at Hill 60 and the Caterpillar smashed the German defences above them as planned. The deep cuttings through the ridge by which the canal and railway passed were a complex labyrinth of tunnels and dug-outs which were considered to be impregnable. Bypassing Mount Sorrel Ridge, 23rd Division assaulted its crest, with the Yorkshire, Lancashire and Sherwood Foresters battalions of 69th and 70th Brigades in the lead. The effect of the Hill 60/Caterpillar explosions had greatly eased their task, and soon the crest had been taken. The 47th (2nd London) Division managed to cross the 300 yd of the old German front trench lines within 15 minutes. The Londoners of the battalions in 140th and 142nd Brigades witnessed the same abject surrender and shock of the German survivors characteristic of this opening phase of the battle.

Maj-Gen S.T.B. Lawford's 41st Division, assisted by the explosion of the largest mine at St Eloi, converged on the salient with 123rd and 124th Brigades leading. There was some resistance from a few of the comparatively undamaged concrete bunkers, but the brigades swept on.

Across the wire, *204th (Würtemberg) Division* was in disarray from the outset. The battle report reflected the stunning outcome of the British

attack in this sector: 'The ground trembled as in a natural earthquake, heavy concrete shelters rocked, a hurricane of hot air from the explosions swept back for many kilometres, dropping fragments of wood, iron and earth; and gigantic black clouds of smoke and dust spread over the country. The effect on the troops was overpowering and crushing.'[11]

IX Corps (centre)

Maj-Gen C.D. Shute's 19th (Western) Division, just north of the Vierstraat–Wytschaete road, faced the Grand Bois and Bois Quarante woods in the vicinity of the German forward positions. The triple-explosions at Hollandscheschuur Farm ripped the German line apart, making the task of capturing the salient along a prominent spur of the Messines–Wytschaete Ridge (the 'Nag's Nose') a straightforward one. The leading 58th Brigade, under Brig A. Glasgow, and 56th Brigade with Brig Ernest Craig-Brown made rapid, uninterrupted progress. The German defence had crumbled in this sector so completely that the survivors either ran away or rushed forward to surrender. There were some pathetic scenes as veteran German soldiers behaved as though they were abandoned children, reaching out to the assaulting troops to plead for comfort and assurance that they were not to be sacrificed in their sorry state.

Maj-Gen Willie Hickie's 16th (Irish) Division was to take Maedelstede Farm on its left and the German front line to the Vierstraat–Wytschaete road.

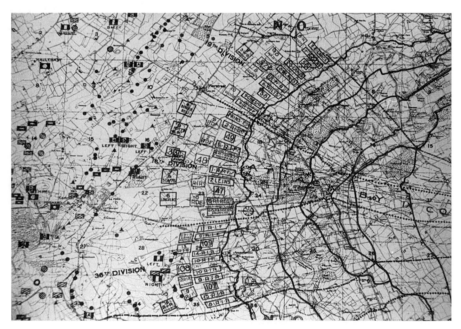

Map 18: Battle of Messines: IX Corps area and the attack.

The explosions at Maedelstede Farm in front of 47th Brigade, commanded by Brig G.E. Pereira, and the explosions at the Petit Bois within Brig P. Leveson-Gower's 49th Brigade boundary simply destroyed the German defence. The defenders covering these two mine-sites were from the forward battalion of *33rd Fusilier Regiment* of *2nd (E. Prussian) Division*. The 7th Leinsters of 47th Brigade found an order to these hapless troops as they swept through their smashed defences. From Divisional HQ, dated 1 June, it read:

> The absolute retention of the natural strong points Wytschaete and Messines becomes of greater importance for the domination of the whole Wytschaete Salient. These points must, therefore, not fall even temporarily into the enemy's hands.[12]

Unfortunately, the Petit Bois mines went off twelve seconds late. As a result, as the leading assault waves began their advance, they were blown off their feet by the explosions and suffered some casualties. However, the advance was not checked, and the assaulting troops soon moved forward in harmony with their creeping barrage.

The dawn of an Irish triumph was marred by a number of individual tragedies, the most prominent of which was that within 16th Division. Almost as soon as the leading waves moved out of their forming-up positions, Maj Willie Redmond, commanding his Company in 6th Royal Irish Regiment, was hit in the thigh by a shrapnel splinter, and then seconds later in the hand. He was swiftly attended to by Stretcher Bearers (SBs) of 36th (Ulster) Division and taken back to 16th Division's Field Ambulance, but to no avail. The MO who attended him noted that nothing vital had been touched by the shrapnel and that a younger man would certainly have lived to tell the tale. However, at the age of 56 and strained by the mental and physical pressures of his political-military life, he was too weak to respond. Shock had set in and he died of his wounds shortly after arriving. Lt-Col Rowland Feilding, CO of 6th Connaught Rangers, was a friend who mourned not only Willie Redmond's death, but also the enduring pettiness of political and religious fervour. After the battle, he was to write:

> He should not have been there at all. . . . How one's ideas change and how war makes one loathe the party politics that condone and even approve when his opponents revile such a [gentle and honourable] man as this.[13]

Maj-Gen Oliver Nugent's 36th (Ulster) Division was tasked to take the formidable Spanbroekmolen position. Four mines, three at Kruisstraat and one of the biggest, under Spanbroekmolen itself, were blown to assist Brig W.M. Withycombe's 107th Brigade. Brig Ambrose St Q. Ricardo's 109th Brigade had the mine at Peckham House to improve its chance of success in its assault. The massive craters produced by the combined explosions went right down to the blue clay, some of which lay on the surface within the craters in huge lumps. Here, the German garrison had been ordered to hold their position at all costs also. The Kruisstraat and Spanbroekmolen mines were held by the *23rd Bavarian Infantry Regiment*, the right flank regiment

of *3rd Bavarian Infantry Division*. The Peckham Farm *Festung* was held by *4th Grenadier Regiment* of *2nd (E. Prussian) Division*.

In the event, the leading Royal Irish Rifles and Royal Inniskilling Fusiliers battalions of the two brigades met little resistance. The scenes which met the Irish troops were those of total devastation. The Germans who had not been vaporized or buried by the explosions were so shocked and dazed that hardly a man was capable of resisting the Irish assault.

The Irish advance was to prove a revelation and a unique event. This was the first time that the Ulstermen and Southern Irishmen had fought alongside each other, even though both divisions had distinguished themselves the previous year on the Somme, at Thiepval and Ginchy respectively. This was just over a year after the Easter Rising, but it showed that Irishmen could settle their differences and combine their remarkable fighting talents, and under a British commander, against a common enemy.[14]

II Anzac Corps (right)

The objective for II Anzac Corps was the southern shoulder of the ridge which included Messines, the Douve and St Yves areas as far south as that to the east of Ploegsteert Wood. Maj-Gen Bainbridge's 25th Division moved swiftly to link up with the New Zealanders; after going 600 yd from their assembly trenches of the higher ground just east of Wulverghem down the gently sloping ground into the Steenbeek, they crossed its dried-up ditch and passed Ontario Farm. The explosion here had eased the division's task so that the leading assault wave of Brig Bethell's 74th Brigade and 7th Brigade, under Brig Onslow, were able to advance in rapid order.

The 3rd Worcesters and 10th Cheshires made excellent progress and were through the forward enemy positions within minutes. The Worcesters worked their way between Ontario Farm and the IX Corps boundary, and then met their first serious opposition at Hell Farm. A bitter, though short, battle then began.

Maj-Gen Sir Andrew Russell's New Zealand Division had approached from the open ground of Hill 63 and reached their assembly trenches without incident. Their left flank was protected by an enfilade barrage, smoke and the explosion at Ontario Farm, in order to minimise the threat posed by the western bulge in the German front line from the Spanbroekmolen crest. The leading battalions of 3rd NZ (Rifle) Brigade, led by Brig Fulton and 2nd NZ Brigade, under Brig Braithwaite, crossed the dried-up bed of the Steenbeeck in no man's land, took the front trench system, and continued without pause up the slope towards Messines itself, regardless of German fire from Petit Douve Farm garrison.[15]

Maj-Gen Sir John Monash's 3rd Australian Division had had to contend with a tricky 3-mile approach march out of Ploegsteert Wood after the German gas attack, but they were not deterred. The 9th Australian Brigade under Brig A. Jobson, and the 10th commanded by Brig W.R. Nicholl had just made it to their jumping-off line. Some men did not stop, going straight

into the assault from the approach march. Their objective lay between St Yves and the Douve. The mines at Trench 127 and Trench 122/Factory Farm were laid to facilitate their task. The explosions erupted a few seconds before zero hour and created craters of 200-foot diameter, obliterating the German defence lines as the assault brigades went over the top.

In common with other assaults that morning, the mine craters forced the 9th and 10th Australian Brigades to veer left or right of them rather than keeping on track and thus the assault organisation became confused as order and direction were lost. It is a testimony to the quality of the training, orders and rehearsals of Second Army for this battle that the officers, NCOs and soldiers of each unit knew their ground, tasks and objectives so well that this potentially difficult situation was only a temporary setback. Within

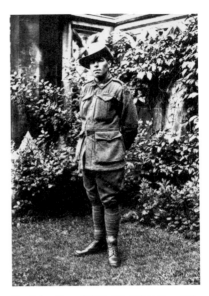

Pte John Carroll VC, 33rd Battalion, 9th Brigade, 3rd Australian Division.

minutes, each company, battalion and brigade was able to sort itself out and continue the original lines of assault. Right from the start, the Australians were determined to prove their mettle as the new Australian Division at the front.

Even among these determined men, Pte John Carroll, of 33rd Battalion, 9th Australian Brigade, was extraordinary. As soon as the mines had gone off and the barrage fell, Carroll jumped out of his trench and sprinted across the pock-marked ground to take out the stunned German defenders. He bayoneted and killed four of the enemy and helped to consolidate the gains before sweeping on. Minutes later, he helped a badly wounded man and then pressed on again. Later in the advance, he attacked a German machine-gun crew of four, killed three of them, captured the gun and turned it on some withdrawing enemy with devastating effect. Despite heavy shelling and machine-gun fire, he also patiently dug out two members of his battalion who had been buried by a shell explosion. His example was astonishing and he was not finished. His courage throughout the next four days would earn him the VC.[16]

The Ridge is Taken

The German forward zone had been easily engulfed and taken. The first objective was gained in the 35 min allotted by the barrage timetable. The two supporting battalions of each brigade then passed through the leading battalion to continue the advance to the next objective, along the near crest of the entire ridge, an average of 500–800 yd up the slope. The character of

the attack began to change as the assaulting troops now approached the belt of strongpoints and machine-gun nests covering the defences of the German Second line. In many areas the resistance stiffened.

The ridge – X Corps (left)

Despite the relatively short attack distances of X Corps, the northern sector, especially around Dammstrasse and the White Château, was expected to be a particularly tough problem. The German *35th (Prussian) Division* held the sector from St Eloi to the main road. Its *176th, 141st* and *61st Regiments* held the line, with their support battalions along the Dammstrasse and behind it, in the second line. It had held this area since 31 May and was therefore relatively fresh in comparison with *2nd (E. Prussian) Division*.

On the left flank of the entire operation, 23rd Division cut across the 300 yd towards its second objective to establish the northern flank near Mount Sorrel in 20 minutes. Here, elements of *204th (Württemberg) Division* (this division held the 2,000-yd sector from Ypres–Hollebeke road to north of Mount Sorrel), *413th* and *120th Reserve Regiments* held the forward and second lines. The *414th Regiment*, the reserve, was behind the Third (*Warneton*) Defensive Line and resting in Menin. The *204th Division* had been in the line since 23 February. Its forward zone extended to an average depth of only 600 yd, on the forward slope, and in the large concrete shelters on and behind the ridge, it had not been so seriously affected by the bombardment. Its regiments were tasked to make a stand in the *OG* (Old German) trenches on the southern side of Mount Sorrel, where the two British assault brigades were expected to meet up. Their task was doomed to fail without reserves or artillery fire to support them and they were soon overwhelmed. Those that survived surrendered.

The second objective of 47th (2nd London) Division was principally the White Château. It fell to the Londoners, but not without a fight. The initial stage of the assault had been covered by an effective smoke screen, but once the leading battalions reached the forward edge of the Château grounds, they were hit by machine-gun, mortar and stick-grenade volleys, directed from the high piles of rubble which offered excellent local cover for the defending troops.

The first assault on the Château failed, but a second attack after swift reorganisation and attack orders, was able to secure a foothold on the edge of the ruins. The German resistance continued until 7.50 a.m. and a severe, accurate shelling by medium trench mortars, supported by a Vickers medium machine-gun barrage, at last broke the defence and one officer and sixty-three other ranks surrendered.

As the 15th London (Civil Service Rifles) battalion began to consolidate its position here, Pte Walter Humphrys, acting as a stretcher-bearer for the battle, moved up with his mate to attend to the wounded. They were loading a wounded man from their own company on to a stretcher when a stray German shell landed close to the edge of the canal and blew Walter off his feet. He had felt a thump on his chest as he went down, but

managed to jump up immediately. Both his colleague and the wounded man had survived also. Walter caught his breath and looked down. His gas mask and its carrier had been smashed by a piece of shrapnel. Rather unconventionally, the gas mask had saved his life.[17]

Dammstrasse was a mile-long Roman road from White Château to the St Eloi–Wytschaete road, festooned with well-sited German dug-outs and strongpoints. Some bitter fighting occurred along it at first, but 41st Division's home counties' battalions were in no mood to let that hold them back. The German garrison was soon forced to surrender and the division swept on. By 5.a.m., the sun was up and it was apparent that it was going to be a very hot day. By the same time, the second intermediate objective, including the forward trenches of the German second line, had been secured.

The formerly strong and immovable crust of the whole German defence had proved brittle and had been broken open. The German defensive plan had estimated that, at worst, the forward divisions would resist the British attack until the *Eingreif* divisions could move from their concentration areas and arrive in force to retake any lost ground. The German operational and intelligence estimates had been proved very badly wrong. The combined effects of the mining, artillery barrage in depth and confident, swift and determined advance of the Second Army assault divisions had been dramatically underestimated.

The morale effect on the German defenders and the High Command was profound and led to serious soul-searching after the battle. Now, and for the ensuing days of the battle itself, it was an effect from which the German army was simply unable to recover. One *Gefreiter* (Lance-corporal) commanding a machine-gun detachment wrote:

> This is far worse than the battle of Arras. Our artillery is left sitting and is scarcely able to fire a round. [At best] . . . our artillery moves forward in the night, unlimbers, lets loose some thousands of gas shells, and retires before dawn. What is taking place in Flanders at the present moment is no longer war, and borders close on murder. For this reason, the sole object of every arm that enters the battle is to play itself out, in order to be withdrawn as quickly as possible.[18]

The ridge – IX Corps (centre)

The shattered remains of L'Enfer (Hell) wood still contained Germans who attempted to resist 36th (Ulster) Division's characteristic onrush. It was a hopeless battle and they were overwhelmed, although the Irish did take casualties. Bogaert Farm, just south of Wytschaete village, had a stronghold with machine-guns and deep trench systems (like Hell Farm in 25th Division's area). Once again, an apparently deadly obstacle was rapidly captured. More than 150 German prisoners taken. The Irish from both sides of the sectarian divide were storming the heights and would not be diverted by the enemy. It must have been a sweet experience for the men in both divisions who had fought so courageously on the Somme in 1916. The devastation caused by the artillery in particular was evident here: the ground around the strongpoints had been ripped open and many of

the concrete bunkers badly damaged. The deeply laid wire entanglements were thrown out of the ground and lay in twisted, ineffectual heaps. Some bunkers and dug-outs had been wrecked by the artillery alone.

Finally, the woods, including Wytschaete Wood, had been fired by the discharge of 2,000 oil drums on the night of 3/4 June, which greatly facilitated this secondary assault by both 16th (Irish) and 19th (Western) Divisions. The garrison at L'Hospice, a ruined hostel at the northern end of Wytschaete Wood, was able to hold out until almost 7 a.m., despite being surrounded and bypassed. It then received a highly concentrated, swift barrage by the British guns, followed by a final assault which carried the position.

The German garrison between the 4,000-yd sector running from north of Spanbroekmolen and St Eloi was *2nd (E. Prussian) Division*. Considered to be a reliable and tenacious division, it had held this sector since mid-April. Since its deployment it had suffered consistent casualties. By early June it was an exhausted and depleted unit. On 4 June, its commander requested, then demanded, immediate relief. The decision was made to do so on the night of 7/8 June. The tale of *40th* and *3rd Bavarian Divisions*, was very nearly repeated here. The *2nd (E. Prussian) Division* was preparing for its handover when the British attack was launched. In the event, as the battle opened, its casualties were devastating. It was reported later that only one officer and three runners returned from the front and support battalions of the right-flank *44th Regiment*; a pitiful handful of men returned from the centre, *33rd Regiment*; and not one man returned from the left flank, *4th Grenadier Regiment*.[19]

The ridge: II Anzac Corps (right)

On the left flank of the II Anzac sector, 25th Division had reached the Messines–Wytschaete road, gaining the high ground of the ridge itself, as the New Zealanders inexorably reduced the Messines garrison. The only significant opposition had been from Hell Farm, some 700 yd north and slightly west of the NZ action, which stood immediately below the ridge line. After a sharp and swiftly organised attack, the Farm was taken together with fifty Germans and eight machine-guns. The 3rd Worcesters were doing well, together with the rest of the brigade. There was time to take stock, reorganise and prepare for the next move.

It was here that L/Cpl Ky Walker's luck finally ran out. As he was gathering information for the Platoon Sergeant on casualties, ammunition states and the like, he was no doubt singled out by an enemy sniper. The old schemer was killed instantly. It was a dreadful blow to the men in his section, who had always assumed that he would survive this stunt as well.[20]

Messines was the principal first objective of II Anzac Corps. Its pivotal position at the southern edge of the main ridge made it one which was vital to hold at all costs. Thus, it had become a fortress of deep trench systems and wire entanglements which surrounded the town, and within it every available cellar had been converted into a shell-proof dug-out. The inner defence was based on five great concrete strongpoints. The New Zealanders

L/Cpl Samuel Frickleton VC, NZ Rifle Battalion, NZ Division.

at once rushed and overwhelmed two machine-guns in action at the edge of the town, thanks to the swift action of L/Cpl Samuel Frickleton of the 3rd NZ Rifle Battalion and his section. His company had been pinned down by fire from these positions and began to take heavy casualties. Those that were not hit took the initiative, broke for cover and then returned fire, but the German machine-gun continued to inflict further casualties.

Frickleton's frustration turned to anger as he realised the appalling effect which this machine-gun was having against his men. He decided to deal with the gun without waiting for orders and in his own way. Despite being already wounded himself, he called his section together and ordered them to advance on the machine-gun post in open order through their own creeping artillery barrage. There was no hesitation. The rumble of the barrage and the debris/shrapnel and smoke thrown out by the exploding shells concealed Frickleton and his section's approach. He stopped within yards of the German machine gun, briefly recced the ground close to him for possible flanking guns, then lobbed a grenade into the German position, killing some of the crew. He then rushed it and bayoneted the survivors before moving on to deal with a second machine-gun about 20 yd away. Covered by the fire of his men, Frickleton stalked right up to the edge of the post and again single-handedly destroyed the gun and a crew of a dozen enemy.

The 2nd and 3rd New Zealand Brigades advanced on the left and right flanks of Messines; 1st Brigade fought through the village itself against the remnants of *18th Bavarian Regiment* of *3rd Bavarian Division*. These troops, lodged in windows, doorways, behind the rubble of former homes and garden walls and in prepared positions linked by tunnels across the village, attempted to stem the Kiwi tide.

Frickleton was prominent in this phase also, rallying his men and setting an example which contributed materially to the dash and aggressiveness of his and other units. As he continued to do this, he was wounded by sniper fire for a second time, this time severely, and was carried from the battlefield.[21]

On the left flank, the advance was stalled by a machine-gun sweeping across the New Zealanders from Swayne's Farm, approximately 400 yd north of the town. Here, the Mk IV tank proved its worth by clambering up the slope to crash through the Swayne's Farm defences. Thirty Germans within this small garrison then surrendered almost immediately and the machine-gun was silenced. The 4th NZ Rifle Battalion and 2nd Canterbury Battalion once again picked up the pace of the advance and weaved their way through the now shattered wire and outer trench system, and into the town itself as the barrage was adjusted to force the German garrison to remain in cover.

Amazingly, the German resistance was more determined than perhaps expected at this time, in part due to the quality of the German troops of the *18th Bavarian Regiment* which manned the garrison. Small parties of Germans sniped from doorways or cellar entrances and others lobbed grenades into the crouching, steadily advancing New Zealanders. Machine-guns opened up

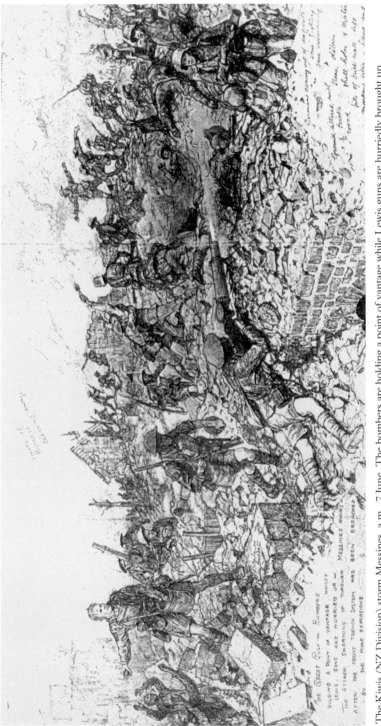

The Kiwis (NZ Division) storm Messines, a.m., 7 June. The bombers are holding a point of vantage while Lewis guns are hurriedly brought up.

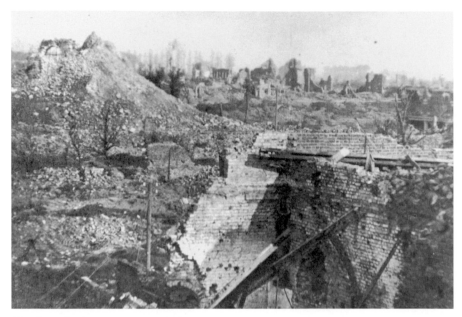

Messines after its capture: general view.

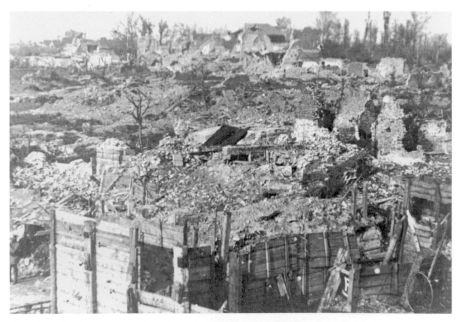

Messines after its capture: ruined houses and remains of the German defences.

from all sides and briefly the previously rapid advance was reduced to that which characterises fighting in a built-up area (FIBUA) – slow, methodical and desperate close-quarter and hand-to-hand struggles.

The Kiwis were not going to let the initiative slip away. Five machine-guns were taken as they were about to be brought into action, another five were rushed and taken from behind, and two which were causing local havoc as they fired across the open town square were destroyed by rifle grenades.

The *pièce de résistance* now came: as the remaining *Bavarians* were hiding or attempting to regroup in the multitude of cellar dug-outs, they were systematically bombed out or killed and the Commandant of the Messines garrison and his entire HQ staff were captured in the massive dug-out which lay beneath the grounds of the former Institution Royale on the edge of the village.

Meanwhile, 3rd Australian Division consolidated the southern flank of the Second Army operation by gaining a firm grip on the southern shoulder of the ridge, St Yves and the Douve valley. The Germans attempted vainly to reoccupy the former front-line area around the craters at Factory Farm (Trench 122) and then lost their remaining local garrison around Trench 127, where two field guns and two machine-guns were captured, after a successful attack by the 38th Battalion, 10th Australian Brigade.

Beyond the Ridge Line – 5 a.m. to 9 a.m.

Introduction

The first main objective was the next rock to be smashed by Plumer's 'Chain Gang', the main ridge or 'Black' Line. At a distance of 400–500 yd, it included the rear trench-line of the German *II* (*Höhe*) line which stretched across the eastern slopes of the ridge. The plan allowed for a two-hour pause for consolidation of the ground taken and to bring up and ensure final briefings for the fresh assault battalions. There was, of course, the anticipated threat from either the *7th* or *1st Guards Reserve Eingreif Divisions* to contend with. To account for this, a protective barrage covered the consolidation work; Vickers machine-guns and heavy mortars were brought up to add further protection from possible local counter-attacks.

The protective barrage first concentrated on a belt 300 yd in front of the objective and then systematically swept the ground ahead, moving both forward and backward to disrupt any enemy movement. The barrage was from 18-pounder guns only, at a rate of one round per minute. The remaining guns and howitzers of the standing barrages were masked throughout the two-hour pause and only fired to respond to any SOS (emergency) signals.

Administration and logistics

The detailed logistics plan which supported the operation was executed to excellent effect at this stage. Communication trenches were dug to link the front line. Defensive materiel, water, rations, mortars, Vickers machine-guns and ammunition were brought up in quantity across the front. Pack transport

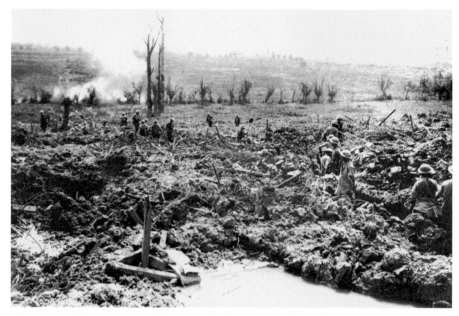

Sappers and infantry pioneers dig communication trenches during the battle.

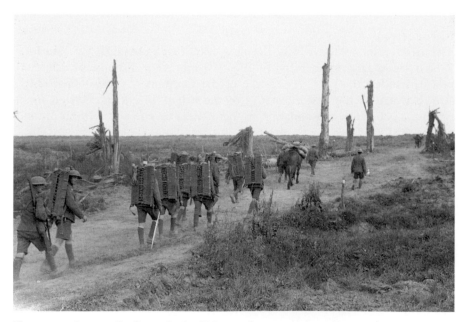

Troops carrying supplies forward using Yukon packs.

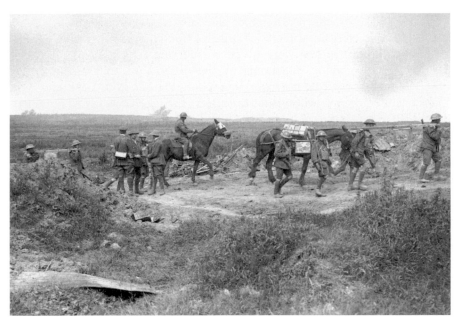

Pack-mules move up the line: p.m. 7 June.

and Yukon packs were a great advantage. Mule pits were dug as close to the front line as possible, 300 extra pack saddles brought each divisional establishment up to 453 and the success of the pack transport was a revelation. Throughout the battle, the mules gave excellent, reliable service. They moved right up to the front line in places, saving much physical effort by the troops toiling as they dug in through the blistering heat.

Furthermore, Yukon packs were issued on a scale of 250 per Division. The Yukon pack was a Canadian design, allowing one man to carry 50–65 lb of rations, water, ammunition and equipment with the aid of a balance-strap across the forehead. The Yukon pack proved its worth: some of the carrying parties equipped with them arrived within five minutes of the capture of an objective, despite the broken ground over which the carriers were forced to cross.

Strongpoints were dug or former German positions 'reoriented' and wired under the supervision of Sapper parties; in the intermediate areas, machine-guns were deployed in depth throughout the captured positions. At 7.a.m. the main barrage opened up once more, the 18-pounders additionally providing the protective barrage for the assaulting troops, at a rate of three rounds per minute per gun, and began their forward creep by 100-yd lifts every three minutes. The attack continued and the leading battalions moved confidently forward behind the creeping barrage. Although few of the planned number of forty-eight tanks were able to keep pace with the advance, those that did were to provide notable support.

In this phase, further evidence of the tactical flexibility which was to become a characteristic of the final British offensive in 1918 was apparent. Divisional Commanders were given a free rein to plan and use their own assault formations, depending on the distance to, and width of, the objectives within their boundaries. As a result, the NZ 25th, 19th and 41st Divisions used their third brigades to capture the final objective. The others continued to retain their third brigade in reserve.

The German situation at 7 a.m. was a sorry one. Their front line regiments had been defeated in detail. As an example, only three officers and thirty other ranks could be mustered from the entire strength of the forward battalions of the three regiments of *3rd Bavarian Division* holding the Messines sector. The support battalions of the front-line regiments had been subsequently overrun before the reserve battalions could move forward in any strength. The fate of these reserve battalions was equally unnerving: some had attempted local counter-attacks to restore the line and been practically annihilated; the remainder had stayed in their reserve trenches or shell holes awaiting the order to move. Either way, the British artillery barrage had torn great gaps in their ranks and their casualties inexorably mounted.[22]

Beyond the ridge – X Corps (left)

The most bitter fighting at this stage was going on the left flank of the offensive within X Corps' Sector. On the left, 23rd Division suffered considerable casualties in its efforts to clear Battle Wood, and its position on the northern flank was only consolidated after a bitter struggle. The 11th Sherwood Foresters, who were the left flank battalion along the whole offensive front at this stage, had not only to overcome resistance from the German defenders on the right flank of *204th Division*, but also to account for protective machine-gun and artillery fire from *119th Infantry Division* of *Gruppe Ypern* to the north, who were not physically engaged in the main battle. It was to take until late on the evening of this first day to fully establish its position astride the German trenches east of Mount Sorrel.

The 47th (2nd London) Division was to take the 400-yard bank of earth built from local canal and rail excavations and known as the 'Spoil Bank' (*Kanalkoffer* to the Germans). This was on the northern edge of the Ypres–Comines canal. This position was on the divisional boundary of the *204th (Württemberg) Division* and the next unit in the line, *35th (Prussian) Division*. The latter had a small permanent garrison which occupied the Spoil Bank, defending it from machine-gun posts and strongpoints dug into the bank itself. On the morning of 7 June it was occupied by the survivors of the two forward companies and the support company of the *61st Regiment*.

The 1/21st London (1st Surrey Rifles) Battalion, 142nd Brigade, made several attempts to capture this objective, all of them unsuccessful. The battalion took heavy casualties for the 'prize' of gaining a foothold on the

western edge of the Spoil Bank. A later attack by 1/23rd London Battalion, 142nd Brigade, supported by machine-gun fire and from the south bank was also checked and dispersed by heavy enemy fire from both the Spoil Bank and from Battle Wood to the left flank of the objective. At 9 a.m., the assault was temporarily called off and the battered battalions withdrew under cover of protective artillery barrage.

At midday, the German garrison here was reinforced by four machine-gun teams and all were ordered by the regimental commander to hold the position at all costs, which they proceeded to do, despite the efforts of the British attackers and extremely hostile artillery fire. They were to be reinforced at 2 a.m. the following morning by a company of *26th Regiment* of *7th Infantry Division* (one of the principal counter-attack divisions brought in to attempt to reverse Second Army's success). It was to be the most tenacious German garrison throughout the battle.

South of the canal, 47th Division's capture of the White Château had broken the defence and the objective across the park towards the stables was occupied without difficulty. The events so far for 140th Brigade south of the canal were summed up by Frank Dunham, stretcher bearing with 1/7th London (City of London) Battalion:

All our troops in the first attack had walked casually towards their objectives, as they followed a creeping barrage. . . . Jerry's front line was a mess: bits of wire all over the place. Our guns had really done their work, blowing his wire to bits. We saw our first Jerry prisoners in the charge of some 'D' Company lads close by a concrete dug-out. . . . All the small dug-outs were bashed in and even some of the larger concrete ones were badly damaged. Jerry was . . . sheltering in their concrete dug-outs from our shell fire. Immediately our boys reached them, they rushed out with their hands up. These prisoners were scared and fatigued, and we learned later that due to our heavy shelling, they had received very few rations and had served longer in the front line, as the relieving troops could not reach them. . . . All the prisoners' brace buttons were removed so they would need both their hands to keep their trousers up and so they were harmless! . . . I could now see our Company's objective – The White Château – ahead and it appeared to be a most formidable fortress. It had been an immense building, three storeys high and with steel girder supports, but it had been reduced to a large heap of broken masonry over the cellars. Our Company made an unsuccessful attempt to capture the White Château, as the enemy had a number of machine guns sited behind the Château and these opened fire immediately the troops attempted to close in. . . . Then the 6th Londons appeared on the scene. . . . One of the leading Company officers was Captain 'Gussy' Collins, who had been my Company officer. He was strolling about the battlefield, carrying his cane and wearing his renowned monocle as though doing some training exercise. As he came level with our Company he shouted, 'Haven't you captured this bally place yet?' Later on we had it tied up.[23]

On the right too, 41st Division managed to achieve a spectacularly swift advance across some 500 yards of ground with Brig F.W. Towsey's 122nd Brigade reaching its objective along the back crest of the ridge line. From here, men of the 15th Hampshire, 12th East Surrey, 11th Royal West Kent and 18th KRRC Battalions were able to see the eastern slope which ran down towards the 'Oosttaverne Line'. Many Germans were killed or captured near the numerous concrete shelters of the second line in Denys and Ravine Woods. Any resistance from snipers or the odd group of riflemen was rapidly dealt with.

Beyond the ridge – IX Corps (centre)

To the left, Brig Cubitt's 57th Brigade had made excellent progress covering the front of 19th (Western) Division and achieved its objective along the line from north-east of Wytschaete village to Oosttaverne Wood. Wytschaete village, on the summit, was the principal and potentially most difficult objective for IX Corps. Naturally, it represented the northern edge of the Messines–Wytschaete Ridge line. It had been converted into a fortress or *Festung* in the same manner as at Messines, with a permanent and well-protected garrison, guns, mortars and machine-guns providing a formidable all-round defence. An outer line of trenches followed the perimeter of the village and an inner ring of trenches and outposts enclosed the houses which had looked onto the village square, with the church at its centre. The major strength of the defensive complex lay in the machine-gun emplacements and vaulted cellars along the western side.

However, the special bombardment of the village on 3 June by siege and heavy batteries, followed by gas and HE from field howitzers, had so shattered these formerly stout and worrying defences that the two assaulting battalions, 8/R Munster Fusiliers (47th Brigade) and 6 Royal Irish Regiment (49th Brigade), had closed with the forward trenches in rapid time and discovered that only rubble and remains of collapsed houses were left.

In the event, the battle for Wytschaete was over almost before it had begun. The Munsters and Royal Irish, led by a tank, swept through the

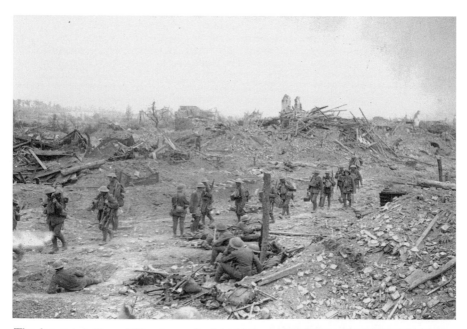

The devastated village of Wytschaete after it had fallen to 16th Irish and 36th Ulster Divisions.

broken bones of the German defences and mopped up with ease. The troops of the German garrison who had survived their local holocaust were generally only too ready to surrender.

By 8 a.m. 16th (Irish) Division's objective beyond the St Eloi–Messines road had been taken. By then, 36th (Ulster) Division had moved to a consolidating position abreast and to the right of their Irish counterparts, assisted by two Mk IV tanks. They emulated the Kiwi achievement by taking a further prize of the complete German Battalion HQ staff of *4th Grenadier Regiment*, including thirty officers and men, in the cellars of a house next to the Wytschaete–Messines road.

Beyond the ridge – II Anzac Corps (right)

Pushed forward after being tasked as reserve in the first phase, 75th Brigade of 25th Division, continued to carry the line to the north of the NZ Division, coming against its only 'worthwhile' opposition of Lumm Farm. Assisted by 36th (Ulster) Division to its left, the resistance here was crushed, eventually falling to the 1st Wiltshires, a company of which killed or captured the remains of its 40 man garrison.

At 8.40 a.m., half an hour after the 'Black Line' was planned to be reached, a company from each of the leading battalions advanced behind the barrage to the observation line in the centre of the offensive front a few hundred yards down the eastern slope of the Messines–Wytschaete Ridge.

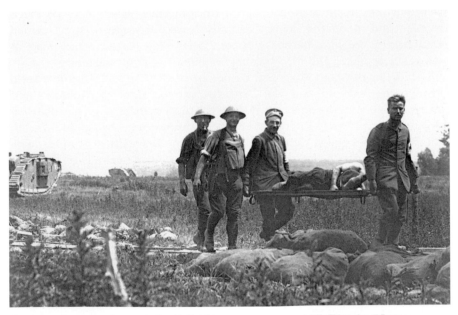

German prisoners and wounded, with British escorts, move past Mk IV tanks, 7 June.

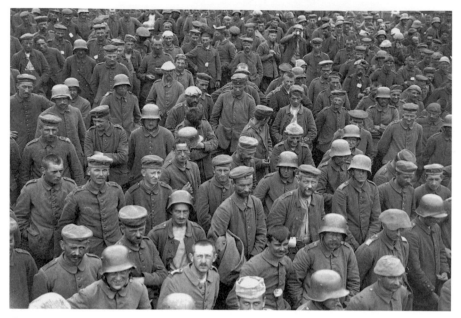

German prisoners en masse, 8 June.

They were supported by eight tanks and by corps cavalry patrols to assist in clearing the area. Of the forty tanks tasked to assist in the morning assault, twenty-five eventually arrived along the first objective, where many provided excellent aid along the line by initially breaking some of the German resistance by crushing barbed wire and destroying machine-gun posts as well as strongpoints, and then assisting in the task of consolidation.

The Wellington and Auckland battalions of the 1st NZ Brigade passed through the 3rd and 2nd NZ Brigades, moved right of Messines and advanced 700 yd to its objective. A German artillery battery HQ at Blauwen Molen, a ruined windmill 500 yd east of Messines, was rushed and the left battalion of the brigade captured Fanny's Farm, 300 yd further north, with the assistance of a tank which smashed in the remaining walls of the farm complex. Immediately, 100 Germans surrendered.

Over the ground gained, the Brigade secured 200 or so prisoners, 7 machine-guns, 5 mortars and, significantly, 2 field guns which their crews were desperately attempting to manhandle out of the NZ Brigade's line of advance.

The 3rd Australian Division was well ahead, 9th Australian Brigade pushing on beyond Grey Farm on the right and 10th Australian Brigade veering left towards Septième Barn, north of the Douve. The German resistance where heavy was generally brushed aside by tanks and artillery before the infantry companies had to become too involved. It was a happy enough state

of affairs, but the tone of the attacks in this sector would soon change. So far, *4th Bavarian Division*'s artillery had made little impact but, as the day wore on, 3rd and later 4th Australian Division would have to take them on.

Summary to 9 a.m.

At this stage, after less than six hours since zero hour, the centre appeared to be crumbling wholesale. Most Germans were now surrendering freely, bewildered by the apparent disappearance of the entire forward defence. Large groups of them were found cowering in shell-holes, in ditches and culverts and behind the scraggy remains of hedges, utterly demoralised and shell-shocked. Here it was the guns rather than the effects of the mining which had caused the psychological damage. Some enemy troops put up a fight from the cover of the concrete shelters in Oosttaverne Wood, but even these encounters were half-hearted affairs.

To add to the German misery, the RFC, flying fast scouts on specific patrols and with total air superiority, was beginning to exploit its new formal role of ground strafing. Contact patrols flying at low altitudes of 2,000 ft or less raked with machine-gun fire any Germans they saw in front of the advancing British troops. Many of the flyers were buzzing

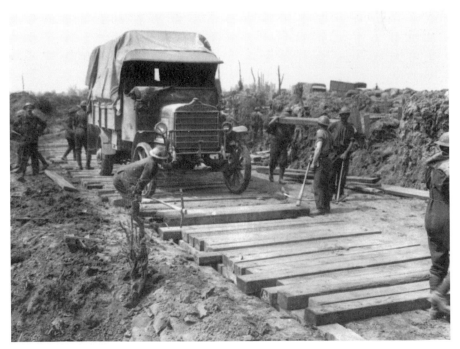

NZ Pioneers lay a new road immediately after the taking of Messines village and the ridge.

the Germans from less than 100 ft and made the most of their task to attack any German troops, guns or equipment that they saw. The RFC also continued to provide timely information both to the guns and to the Second Army Report Centre at Locre by sending situation reports on the assaulting infantry's progress.

The observation line was reached with few casualties by the forward assault companies. The observation line ran from the eastern edge of Oosttaverne Wood through Despagne Farm via the lower slopes of the ground running east from Wytschaete and Messines to Bethleem Farm, just south of Messines. Tapes and coloured flags were placed to mark the jumping-off line for the three reserve divisions which were to make the afternoon assaults towards the Oosttaverne Line: 24th, 11th and 4th Australian. Strongpoints were then dug to act initially as the OPs and later as the defence line to act as supports or rallying points behind the Oosttaverne Line.

Therefore, the situation by 9 a.m. was undoubtedly better than even Plumer had dared hope for. Second Army was firmly established along the whole line of the Messines–Wytschaete Ridge from the River Douve to Mount Sorrel.

Unfortunate Consequences of Success

The amazing success of the first six hours now had unfortunate consequences. The relatively light casualties so far had led to a massing of more men than had been calculated on the crest of the ridge as they began to consolidate their positions, move forward to continue the advance, or resupply those already forward of the ridge. By then it was hot; the early morning mist and dankness had been dissipated by a risen and blazing sun.

The British troops along the ridge line began to strip down to their waists as they dug in. German officers from the *104th Regiment* of *40th (Saxon) Division*, watching this spectacle from the Oosttaverne Line defences noted that 'crowds of British Infantry between Messines and Wytschaete were seen to be taking off their coats on this warm summer morning and begin to dig in along the skyline of the ridge; working in their lighter coloured shirt-sleeves, they made admirable targets for our machine guns'.[24]

In estimating the density of the allotted frontages, it had been expected that casualties among the leading brigades for the capture of the first intermediate objective would amount to 50 per cent. Roughly 60 per cent of the troops assaulting the Black Line, the first main objective, were expected to become casualties also. Naturally, events had by now proved that the casualties had been only a fraction of the percentages calculated. Ironically, as a result of this success, little thought had been given to the possible implications of the crowding which now occurred. The German response from the safer Oosttaverne positions at this time was swift, and enemy machine-guns and artillery barrages began to sweep the skylined targets before them. British casualties began to mount.[25]

German Counter-attacks – Plans and Reality

The Germans were reeling, but were attempting to stem the British tide by the predictable use of their *Eingreif* troops and artillery. German recovery and response had been expected by Plumer. He was convinced that the most severe fighting of the first day would be at this time. The Second Army Intelligence Summary of 4 June had identified two fresh German Divisions in reserve and concentrating their troops in the Lys valley in order to counter-attack. To deal with this potential problem, it was pre-arranged that the protective barrage should be strengthened by the masked batteries – until now silent in forward positions – of the three Divisions of the reserve, XIV Corps. The German *Eingreif* divisions were expected, but nothing happened. No formed body of infantry materialised, only the scattered remnants of units already affected by the assaults and elements of the enemy apparently withdrawing towards Oosttaverne.

Reports were received at about 8 a.m. from an air observer that a large body of troops was crossing the River Lys at Warneton, but no action developed. This was a sighting of the reserve regiment, *5th Bavarian Reserve Regiment*, and a field artillery brigade of the *4th Bavarian Division*, on the march from its assembly area near Warneton. It had been ordered to recapture the ground lost between the Douve and Messines, held principally by the 3rd Australian Division, at 7 a.m. While the regiment was moving forward the order was cancelled and the units were diverted to reinforce the new German defensive line south of the River Douve.[26]

The failure to attempt a major counter-attack to catch the British while they were relatively vulnerable was directly attributable to the Commander of *Gruppe Wytschaete*, *Gen von Laffert*. This was another damning indictment on his arrogant assurance that the British could not hope to penetrate his forward defences for anything less than twelve hours, as he had boasted. These reserves had therefore been kept well back as *von Laffert* saw no reason to bring them closer, as he had imagined that there would be ample time to bring them forward as the battle developed. There was not, he could not have been more wrong, and the consequences for the Germans were devastating.[27]

The stage was set for further farce in the use of the counter-attack divisions, neither of which had been specifically trained to carry out this specialist task and neither of which were familiar with the area over which they were about to fight. The foolishness of replacing *24th (Saxon) Division* with the *35th (Prussian) Eingreif Division* and *40th (Saxon) Division* with *3rd Bavarian Eingreif Division* in the front line was now only too apparent.

At the same time as the implications of this miscalculation were sinking in at *Gruppe Wytschaete* command HQ, Plumer's Second Army was both consolidating and enjoying the scarcely credible view. The scene across most of the battle front had become almost surreal: a protective barrage was methodically laid down to offer some cover to the digging troops on the ridge and those now manning the observation line; there were occasional

bursts of machine-gun fire; but otherwise there was a strange calm. Officers and men looking down from the Messines Ridge saw the stark contrast between the pock-marked former front line and chaos of the main German defences compared with the green and tree-lined countryside which stretched out before them. The lower half of this eastern slope was lost to view, but in the distance the towns, woods and verdant panorama of the Lys valley could be seen. Somewhere out there, there had to be a counter-attack response, but it was a long time coming.

At about 11 a.m. some of the thousands of men digging in along the ridge saw German troops marching towards them along the road from Wervicq and crossing the canal. They were about two and a half miles away. (See map 19) The enemy column was then lost to view because of the dead ground formed by the convex nature of the eastern slope, but then seen again advancing towards the observation line and apparently oblivious of the presence of the new British garrison in this area. The sun was now very hot and the heat of the late morning led to a thick haze which settled over the low ground, making it difficult to observe the advancing enemy.

Nevertheless, independent reports from II Anzac and IX Corps and aerial OPs, all received at Second Army Report Centre, confirmed the approach of a significant force from the Wervicq/Wambeek area. From II Anzac came a figure of 1,000 troops, with 36th (Ulster) Division of IX Corps reporting up to 3,000 German troops advancing up the Wambeek valley north of Garde Dieu.

At 12.15 p.m., 25th Division, north of Messines, revealed that the German infantry identified as assembling around Garde Dieu were advancing up the Blauwepoortbeek (a tributary of the Wambeek); by 12.45 p.m. its leading elements were close behind the Oosttaverne Line. An hour later, further reports had confirmed enemy field artillery action in support of these counter-attack moves and an additional 800 German troops moving at the double to the north of Gapaard. Second Army Report Centre at Locre received these messages quickly and acted on them with equal speed; the details were passed to the SOS and CB batteries concerned and they were able to keep the German movements under continual shell fire.

At 1.45 p.m., the reinforced battalion-strength German formation which had been seen moving up the Blauwepoortbeek crossed the Oosttaverne Line. They did so in a number of waves, supported by their own barrage onto their objective, on a frontage of 1,000 yd from astride the Gapaard–Messines road to Blauwepoortbeek. The objective appeared to be a line running from east of Messines to the area of Lumm Farm.

The New Zealand advanced posts along the observation line were completely untouched by this barrage and saw ten lines of German troops approaching them from across open ground. They were a perfect target for the Vickers and then the Lewis machine-guns. Further north, about 600 of the enemy advancing in four waves were cut up by the frontal and enfilade fire of twelve machine-guns of 25th Division sited in advanced positions during that morning by the Divisional machine-gun officer.

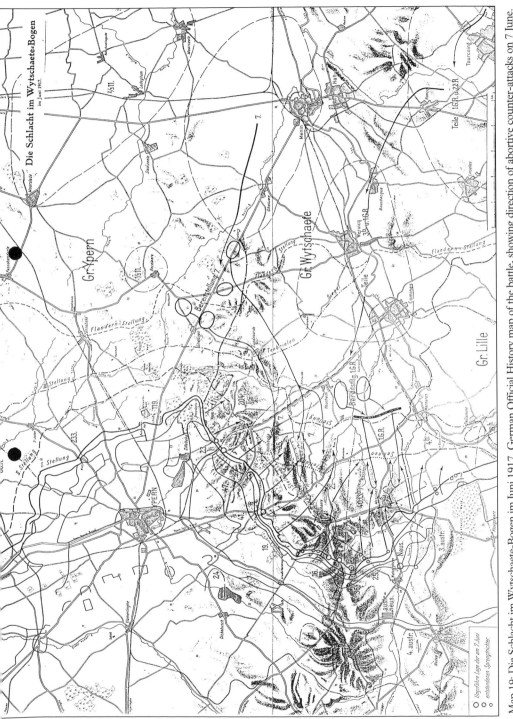

Map 19: Die Schlacht im Wytschaete-Bogen im Juni 1917. German Official History map of the battle, showing direction of abortive counter-attacks on 7 June.

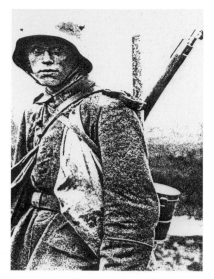

A typical *Eingreif* (counter-attack) soldier. Counter-attack troops were the backbone of the new flexible (or elastic) in-depth defence adopted by the German army in the West in 1917. However, they were to prove ultimately as vulnerable to British artillery and direct-fire weapons as their predecessors had been in the early months of the Somme campaign.

At 2.10 p.m., the British artillery barrage became intense in front of the Oosttaverne Line. It had been ordered in response to a balloon observation post (OP) report at 1.45 p.m. that the counter-attack was imminent. This was confirmed by Second Army observers on Mount Kemmel who had seen the German barrage through binoculars. The attempted counter-attacks by the leading regiment of *1st Guards Reserve Division* were met by withering barrages of artillery, machine-gun and rifle fire under which the German units just melted away. The few survivors fell back to any available cover or shell-holes. The German division had suffered over 70 per cent casualties.

The fate of *1st Guards Reserve Division* is worth recounting at this stage of the battle. It underlines the problems which the German commanders had inflicted on themselves. They had grossly underestimated the British threat before the battle and, worse still, had tasked divisions to carry out operations for which they were not trained. The *1st Guards Reserve Division* had just replaced *3rd Bavarian Division*. The latter was specifically trained for counter-attack operations. Therefore, it was brought into this area several weeks before the battle and rehearsed so that it was familiar with the ground over which it was expected to fight. Then, on 6 June it was ordered to relieve *40th (Saxon) Division* in the *front line*.

Thus, at the last minute, *1st Guards Reserve Division* took on an important role and its situation thereafter had to be witnessed to be believed. At 3.30 a.m. on 7 June, it was ordered to march with all speed to the counter-attack assembly areas at Garde Dieu. However, the division was only partially assembled at Wervicq at that time, its advance party only having arrived less than twenty-four hours beforehand. Some of the companies were still arriving by train from the Arras sector. As they were entirely new to the area, the company commanders had to be briefed in detail on the ground as well as on their tasks, then brief their companies, before they could move on. This lost vital time.

At 7.30 a.m., *1st Guards Reserve Division* was placed under the orders of the divisional commander of the Messines-defensive sector, *3rd Bavarian Division*. He ordered it to attack the ridge on either side of Messines village and to recapture the original German forward zone (lost during the first

hour or so of the battle) and the British sortie trenches beyond. The leading regiment, *1st Guards Reserve Regiment*, did not reach its assembly point near Garde Dieu until 11 a.m. Then it deployed immediately to the east of Oosttaverne between 1.00 and 1.30 p.m. Owing to the heavy losses and the failure of its leading regiment to make any progress, the Divisional Commander decided to keep his remaining two regiments intact behind the Third Defensive (*Warneton*) Line.

At around 2 p.m., British X Corps confirmed enemy movement to the east of Mount Sorrel. It was of regimental strength and moving south-west towards the Ypres–Comines canal. It was moving at the double in column and supported by transport and field artillery. An hour later there were further reports from 23rd Division units that approximately 1,500 German troops were advancing in half-company-sized subunits (groups of 50 men). They were attempting to infiltrate along the eastern side of the canal. Commander Heavy Artillery, X Corps immediately ordered his 6-inch and 60-pounder batteries to fire on pre-planned targets along the eastern canal road. Most of the German groups were simply blown away.

The same unfortunate story began to unfold for the second of the two designated counter-attack divisions. The fear of a simultaneous British attack astride the Ypres–Menin road to capture the important and commanding area of Stirling Castle on the Gheluvelt plateau led to the decision by *Gen Sixt von Armin, Fourth Army* commander, to change the assembly area for the northern *Gruppe Wytschaete Eingreif* division to the east of Gheluvelt.

The principle was that this would give the division two options and therefore the flexibility to execute an immediate counter-attack. One option would be to attack west – towards Ypres across the Menin Road; the alternative was to move south-west across the Ypres–Comines canal and outflank any possible British assault across the German second line around Wytschaete. This theoretical flexibility had two distinct disadvantages. First, it meant an additional five miles for the troops to cover for the second option before reaching the battlefield proper; and second, the division in question, *7th Infantry Division*, not properly trained for counter-attack operations, was unfamiliar with the terrain over which it was about to fight. Furthermore, they had replaced a designated counter-attack division, *35th (Prussian) Division*, because the latter had been put in the line at the last minute just as *3rd Bavarian Division* had been fated to do. These were exactly the same problems which cursed *1st Guards Reserve Division* in the south.

On 1 June, *35th (Prussian) Division* had been put into the line to relieve the battered *24th (Saxon) Division*. Although *7th Division* had then been warned off as the replacement for *35th Division*, and in *35th*'s original counter-attack role, its specialist training had been rudimentary. Also, because of the protracted British preparatory barrage, its commanders had been unable to carry out any significant reconnaissance of their new operational area. On the day, *Gen Sixt von Armin* could not release the division for its task until it was clear which of the two options should be

expedited. At 7 a.m., he decided that the Gheluvelt plateau was not an objective for this British offensive and therefore ordered the *7th Division* to carry out the Wytschaete option.

It took most of the morning to assemble, move and reach the canal area, and this in intense heat and under the artillery fire which had been ordered by Commander Heavy Artillery, X Corps. The leading battalions did not begin to cross the canal at Houthem and Hollebeke until about 1 p.m., and as they did so, they took heavy casualties from the British protective barrages ranged in on these crossing/choke points. Shortly after this, *7th Division* was placed under the command of the front-line divisional commander of the Wytschaete sector, *2nd (E. Prussian) Division*. *7th Division* was ordered to counter-attack through Wytschaete on the right of *1st Guards Reserve Division*, but the operation was cancelled when half of the division was diverted to assist a hard-pressed Hollebeke sector division, *35th (Prussian) Division*, and the remainder of *7th Division* was used to reinforce the remnants of *2nd Division* in the line east of Wytschaete at around 5 p.m.

The original plan to counter-attack and recapture the Messines–Wytschaete area was swiftly abandoned and the counter-attack divisions ultimately provided only reinforcements to the beleaguered garrison of the Oosttaverne/Sehnen Line in the Hollebeke and Wytschaete sectors. Uncertainty and disaster were to become the hallmarks of the counter-attack operations from 7 June to the end of the battle. It was a severe blow to confidence of the troops in their higher commanders and in turn to the commanders themselves.[28]

Notes

1 *GOH, Band 12* (1917), pp. 450–1.
2 Capt B.C. Hall, *Round the World in Ninety Years*. Chapter 21. (Courtesy of the Liddle Collection, University of Leeds.)
3 Barrie, *War Underground*.
4 2/Lt Firstbrooke Clarke, 8th Bn. N. Staffords: Private Letters and Collection. (Courtesy of Liddle Collection, University of Leeds.)
5 Gibbs, Philip, *The War Despatches* (London, Gibbs & Phillips Ltd, 1964), p. 235.
6 *GOH, Band 12* (1917), p. 453.
7 Lee, Arthur Gould, *No Parachute* (Jarrolds, 1969), quoted in Revell, *High in the Empty Blue*, p. 74.
8 The debate on the distance at which the mines were heard continues. It is more likely that the reverberations and 'rumblings' reported in London at least could well have been the effect of the opening of the unprecedented artillery barrage of more than 2,500 guns rather than the mines *per se*. Some soldiers and officers who were there hardly heard the explosions of the mines, although all that have been recorded by the author make considerable comment on the 'stupendous' artillery barrage.
9 *GOH, Band 12* (1917), pp. 456–7.
10 IWM SS568: Extract from letters and documents found on dead and prisoners of *44th Infantry Regiment, 2nd (E. Prussian) Division*. Captured German Letters and Documents, GHQ BEF, June/July 1917, p. 2.
11 Berger, G., *Die 204e Infanterie Division im Weltkrieg, 1914–1918* (Stuttgart, 1922). Quoted in Edmonds, *BOH*, vol. II, 1917, p. 61.
12 Quoted in Denman, *Ireland's Unknown Soldiers*, pp. 108–10. See also: Cyril Falls, *The History of the 36th (Ulster) Division in the War 1914–1918* (Belfast, McCaw, Stevenson & Orr, 1922), pp. 82–106.

13 For a more definitive account of Willie Redmond's life and death, read 'A Lonely Grave'
 and introduction to his background in Tony Spagnoly and Ted Smith's book, *Salient Points:
 Cameos of the Western Front, Ypres, 1914–1918* (London, Leo Cooper, 1993), pp. 26–33.
14 The two divisions had fought with distinction on the Somme. Initially 36th (Ulster)
 Division had carried all before them and taken the German strongpoint of Schwaben
 Redoubt near Thiepval on 1 July 1916. They were forced to retire with heavy losses when
 their flanking divisions failed to make similar progress, whereas 16th (Irish) Division had
 fought with great gallantry at Ginchy, near Delville Wood and Guillemont, capturing
 Ginchy with 20th Division on 9 September 1916.
15 This had been the only successful German counter-mining operation at Messines. The
 British mine had been successfully placed under Petit Douve Farm, but on 27 August
 1916, the German Sappers blew a heavy camouflet which smashed in the main gallery for
 about 400 ft, killing four men. The charge, already in position, was therefore abandoned.
16 During the battle, 33rd Battalion was in action for four continuous days. Carroll's courage
 and selflessness throughout his 96 hours in the line earned him his VC. He was wounded
 in July, but remained in the line, was promoted L/Cpl in September and fought with the
 Division in the latter battles of the Third Ypres Campaign. On 12 October, during the
 opening phase of the final attempts to secure Passchendaele, he was severely wounded
 and evacuated to the UK, but he was to survive. He was presented with his VC by King
 George V at Buckingham Palace on 23 March 1918, but did not rejoin his unit again until
 June. In late July, he was transferred to AIF HQ in London and returned to Australia in
 August 1918.
17 Pte Walter Humphrys, 15th London (Civil Service Rifles) Bn, 140 Bde, 47th (2nd
 London) Division. Private recollections.
18 IWM SS573, German captured documents Reference GHQ, July 1917, p. 1. (Letter
 dated late June 1917.).
19 GOH, *Band 12* (1917), p. 456.
20 Extract no. 9, Pte Ky Walker. Private Collection of Mr and Mrs John Heritage.
21 Frickleton was to be awarded the VC. The VC citation declared that: 'By the destruction
 of these two [machine-] guns L/Cpl Frickleton undoubtedly saved the lives of his own and
 other units from severe casualties. His action, carried out with magnificent courage and
 gallantry, enabled the advance to continue and ensured the capture of the objective.'
 After the Battle of Messines, he was evacuated to the UK (Walton-on-Thames) and spent
 some months recuperating before re-joining his battalion in July as a Sergeant. He was
 again taken ill and evacuated to the UK in October 1917. The VC was awarded to him
 by King George V personally at Buckingham Palace on 20 October 1917. He was then
 posted to OCTU Cambridge and graduated on 24 March 1918 as a Second Lieutenant.
 He never returned to active service because of a recurrent illness and he was demobbed in
 December 1918 in New Zealand, having returned there in June of that year.
22 *GOH, Band 12* (1917), pp. 456–7.
23 Dunham, Frank: 1/7th London (City Of London) Regiment, 140 Bde, 47th (2nd
 London) Division. See article in *RE Institution Magazine*, Volume XXIII, 1975.
24 Divisional History, 40th (Saxon) Division, 104th Regiment diary; Edmonds, *BOH*, 1917,
 vol. II, p. 71.
25 Edmonds, *BOH*, 1917, vol. II, pp. 71–2.
26 *GOH, Band 12* (1917), p. 456.
27 Ibid, pp. 457–8; Edmonds, *BOH*, 1917, vol. II, p. 72.
28 *GOH, Band 12* (1917), pp. 458–61.

Second Movement and Phase Two: 'Strike the Chord', p.m. 7 June

Over the Ridge and on to the Final Objective

By the early afternoon Second Army was ready for the ultimate prize: the Oosttaverne Line. This final objective lay over the German *Sehnen Stellung* position, which represented the chord or bow-string of the entire *Wytschaete-Bogen* defence. The reserve divisions would strike at that chord and take it. If they could achieve it, the German defences would become untenable and the Messines–Wytschaete Ridge would be securely held by Plumer. (See map 20)

Advance to the Oosttaverne Line (I)

Plumer's original plan was to advance across the eastern slopes of the ridge towards the Oosttaverne Line in a continuous rolling movement. The three reserve divisions, 4th Australian, 11th and 24th, would be supported by the six previously masked artillery brigades of the reserve (XIVth) Corps. (Guards Division artillery was allotted to support II Anzac Corps, 1st Division artillery supported IX Corps, and 32nd Division artillery supported X Corps.) The new line (the Oosttaverne Line), once taken, would be reinforced at nightfall. (See map 21)

However, after detailed consideration and discussion with his Corps commanders, Plumer modified this phase in the amended Operation Order of 19 May. The main concerns had been the expected counter-attacks and the need to allow time to bring up sufficient artillery to support this later advance. The 19 May Order therefore allowed a five-hour halt along the first objective.[1]

Despite the outstandingly swift initial advance after zero hour, it was clear that the state of the ground would hinder advance rates of transport and especially the move forward of the necessary supporting artillery, so that morning Plumer allowed an additional two hours to prepare for the final advance. At 10 a.m., the new zero hour for the final advance was fixed for 3.10 p.m., exactly 12 hours after the offensive had begun.

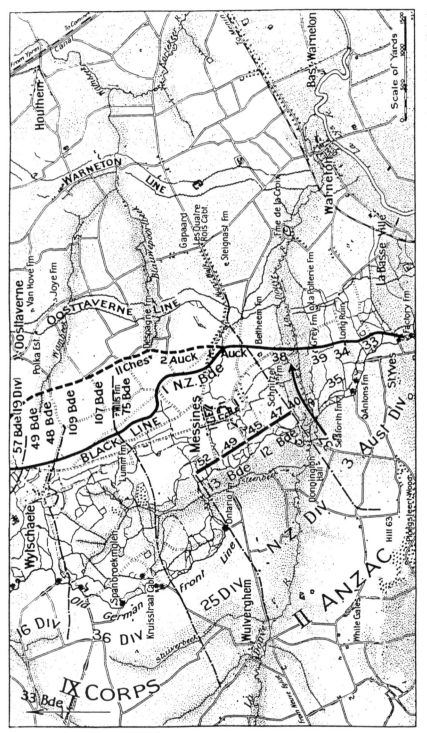

Map 20: The situation at Messines at 11.30 hours on 7 June between Wytschaete and St Yves (north-to-south). The 'Black Line' (the ridge itself) is in British/ANZAC hands and the reserve divisions (including 4th Australian Division) are moving forward for the afternoon attack on the 'Oosttaverne Line'. (Source: Bean, *Australian Official History*, vol. IV)

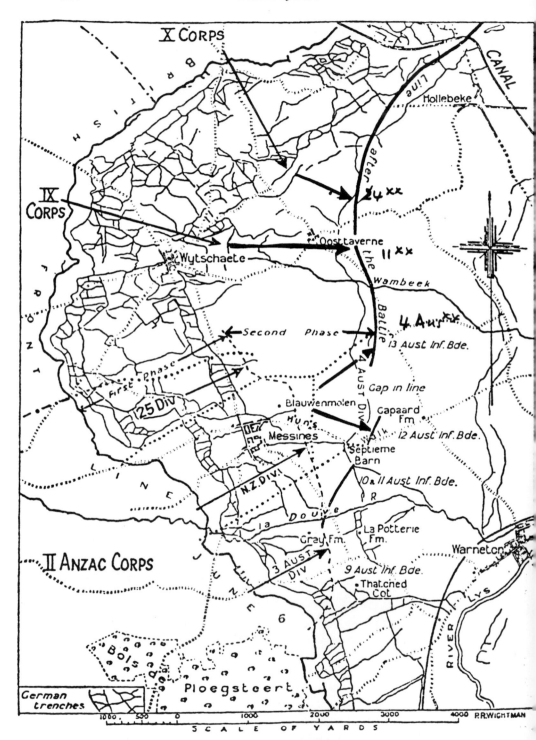

Map 21: 'Strike the Chord', Phase Two: the assault on the Oosttaverne Line/plan of attack and the ground to b
captured on 7 June. Phase Two assault divisions are: 24th Division (X Corps), 11th Division (IX Corps) an
4th Australian Division (II ANZAC Corps). (Source: Bean, *ANZAC to Amiens* (Canberra, AWM, 1946))

The organisation and pre-planning which had gone into this phase was immense. By early afternoon, several heavy and forty field batteries had advanced, many to previously prepared gun pits with 300 rounds per gun pre-dumped alongside. A number of the field batteries were pushed out into no man's land and established themselves just below the main ridge line. These batteries were in addition to those allotted from XIV Corps. In all for this phase, one 18-pdr gun was available for every 17 yd of front of the creeping barrage, in addition to a number of guns and howitzers not expected to be fully registered, and to be used for standing barrages on selected targets in the vicinity of the Oosttaverne Line.

The artillery was reinforced by a Vickers machine-gun barrage of 146 guns on the near crest of the ridge; and 16 guns from each division were already in strongpoints behind the observation line on the eastern slope. All-arms cooperation was to be complete with the use of 24 tanks for the afternoon advance from Second Army reserve, 12 allocated to each of II Anzac and IX Corps, with the tanks already assembled in Denys and Damm Woods after the morning assaults ready to continue to support X Corps.

Preparation – X Corps (left)

To Brig P.V.P. Stone's 17th Brigade and Brig W.J. Dugan's 73rd Brigade, 24th Division had given the task of taking the Oosttaverne Line in X Corps' Sector. They had moved from their previous night's holding area near Dickebusch Lake during mid-morning and were at their forward assembly area opposite the Dammstrasse in good time for the afternoon advance, arriving at 1p.m. At 1.30 p.m., the two leading battalions of each of the brigades took up their jumping-off positions close to 41st Division's earlier first objective and waited. Their frontage ran from the White Château, just south of the canal, to the St Eloi–Oosttaverne road on the right.

Preparation – IX Corps (centre)

The plan for IX Corps was to use only Brig A.C. Daly's 33rd Brigade of the reserve, 11th (Northern) Division, as the Corps boundaries were narrower here for the advance to the Oosttaverne Line. On arrival at its night assembly area three miles west of Wytschaete it came under command of 16th (Irish) Division HQ at Scherpenberg, near Kemmel. As a result of a minor breakdown in communications, it was released an hour later than planned to move up the line via Vandamme Farm to the ridge for the afternoon attack. The move was fraught with delay because of German artillery fire and the difficult ground which the brigade had to cross over the old no-man's-land and old German forward defences.

The result was that 33rd Brigade's leading battalions did not arrive at their forward assembly positions around Rommens Farm until 3.50 p.m., over half an hour later than the afternoon zero hour. The potential problem which would often have occurred in this situation was averted by the use of flexible command and communications within IX Corps. It illustrated the

way in which commanders in this battle had a more devolved command responsibility and confidence, under Plumer, to make decisions which might not have been as laid down in the orders, but were made to achieve the necessary objective.

At 12.15 p.m., Lt-Gen Sir Alexander Hamilton-Gordon warned off 19th (Western) Division that the anticipated delay in 33rd Brigade's move forward would need to be covered by Maj-Gen Shute's reserve, 57th Brigade, which was still intact after the morning's advance. That 57th Brigade would be responsible for capturing 600 yd of the Oosttaverne Line which would include the village of Oosttaverne itself. This would allow 33rd Brigade an objective of 1,200 rather than 1,800 yd.

The change of plan did not reach 57th Brigade HQ in Grand Bois until 1.35 p.m., with the leading battalions receiving the news as the barrage for the afternoon attack was about to begin. Maj-Gen Shute had telephoned IX Corps HQ to attempt to delay this barrage at 1.30 p.m., but it was impossible to alter. Therefore, he ordered Brig Cubitt's 57th Brigade to go ahead and assault under the cover of the protective creeping barrage, without waiting for 33rd Brigade.

Preparation – II Anzac Corps (right)

Maj-Gen William Holmes' 4th Australian Division was ordered to move forward from their holding area at Neuve Eglise during the morning and reached their assembly tapes beyond the old British front line at 11.30 a.m. Their objective was the southern sector of the Oosttaverne Line, covering the front of II Anzac Corps from the Douve to Wambeke. It would carry out the advance with two brigades up, each with two leading assault battalions. So 13th Australian Brigade, commanded by Brig-Gen T.W. Glasgow,[2] was on the left and would move up to its final start line via the northern part of Messines, paralleling the right brigade, which snaked round to the south of Messines. (See map 21)

The brigade received the news of the delayed zero hour in time to hold its leading troops back until 1.40 p.m. The two leading battalions then crossed the crest of the ridge and took up their start-line positions. The brigade's boundaries were Lumm Farm on the left and the mound of the destroyed Blauwen Molen as its right marker.

With the Blauwen Molen as its left boundary and Bethleem Farm/River Douve as its extreme right marker, Brig J.C. Robertson's 12th Australian Brigade was the right assault brigade. It passed through an apparently withering German artillery barrage as it crossed the shoulder of the ridge line without significant casualties. It was only on reaching the tapes that the troops of the lead battalions of this assault brigade learned their zero hour for the attack towards the Oosttaverne Line had been postponed to 3.10 p.m., a two-hour delay. Already at the assembly tapes, the brigade had little choice but to lie out in no man's land and pray that the increasing enemy protective artillery and machine gun fire would find another victim. Casualties began to mount, but the brigade held on.[3]

The Barrage and Whirlwind Success

At 3.10 p.m., the barrage and depth CB fire began. Once more, the sheer concentration and accuracy of the artillery was overwhelming. Its effects at the other end were most graphically illustrated by a German Corporal (*Gefreiter*) who ultimately died near Oosttaverne, and probably by this afternoon barrage, in a letter he had written on 6 June as he described it as: 'From a shell hole in hell':

> You have no idea what it is like: fourteen days spent under hellish fire night and day. In this beautiful weather we crouch in shell holes and await our doom. Here the dead are piled in heaps from the effect of their artillery alone, which is far superior to ours. All night long we lie ready for action, with our gas masks on, for 'Tommy' shoots all night with gas shells and also shrapnel firemany are killed by the gas. . . . We are quite powerless against the English. We all look forward with joy to being taken prisoner.[4]

Advance to the Oosttaverne Line (II)

Action – X Corps (left)

On Second Army's left, 73rd and 17th Brigades of 24th Division made amazing progress. There were tanks to assist 73rd Brigade in its attack on Ravine Wood, where a large battalion-strength garrison of *413 Infantry Regiment* of *204th (Württemberg) Division* was expected to offer strong resistance. In the event, it appeared as a forest version of the *Marie Celeste*: the wood was virtually unoccupied and weapons, equipment and untouched meals, hastily prepared and hastily abandoned, were the only evidence of recent occupation. The unopposed capture of Ravine Wood allowed the brigade to withdraw its left-flank battalion to the area of White Château, where it linked up with the right of 47th (2nd London) Division, which was still held up by the German machine-gunners of *61st Regiment (35th (Prussian) Division)* in Spoil Bank.

Sweeping across no man's land, 17th Brigade easily captured their part of the objective, including Bug and Rose Woods. The German defence had crumbled with barely a shot fired by the enemy. The northern sector of the Oosttaverne Line was festooned with pillboxes and other strongpoints, but they were occupied by the British troops in quick time. The scale of success in this sector alone was reflected by the fact that the two leading battalions of 17th Brigade had a total of six casualties between them over an average advance of 800 yd down the slope of the Roozebeek valley, where they were exposed to possible enfilade fire from the Oosttaverne Line. None came, and the enemy surrendered in droves, with 289 Germans and six 77mm field guns being taken, as well as over a score of machine-guns.

Action – IX Corps (Centre)

In the centre, 57th Brigade confirmed the wisdom of the change in orders for IX Corps plan of attack. Despite the fact that the platoon commanders and their men had been given scant and hurriedly delivered orders to 'follow the

barrage and take the Oosttaverne Line' (a scenario familiar to anyone who has served in the Infantry across the years), the advance was outstandingly successful. The 57th, sandwiched between 17th and 73rd Brigades of 24th Division on its left and 4th Australian Division on its right, advanced steadily within 50–60 yd of the creeping barrage. Within 20 minutes, the leading battalions had captured their part of the Oosttaverne Line, including the village itself, with very few casualties. They soon established contact with the Australians at Polka Estaminet and then began the task of consolidation.

Action – II Anzac Corps (Right)

The right-hand sector of Second Army's front was a different matter for the 4th Australian Division. Despite the barrage, the German line held firm and the 12th Australian Brigade troops exposed to the earlier enemy artillery fire forward of the Messines Ridge had seen the German line reinforced. The planned tank support was disappointing, as the four tanks expected to move up with 13th Australian Brigade failed to arrive, although three of the four tasked to assist 12th Australian Brigade did marry up and press on with the infantry.

The Australian reservations about the opposition was well-founded. Those troops of *1st Guards Reserve Division* who had survived the abortive counter-attack operations earlier, had withdrawn to the Oosttaverne Line as we have already seen. Also, the three reserve battalions of *3rd Bavarian Division* had been occupying this area at zero hour, shortly after taking over from *40th (Saxon) Division*'s reserve battalions. The Bavarians had attempted a local counter-attack to regain the second defensive line around Messines, but had been driven back by both the New Zealanders and machine-guns from the Cheshires and Worcesters of 25th Division. These depleted German battalions were then reinforced by two battalions from the *4th Bavarian Division (Gruppe Lille)* sector, namely *1st Battalions* of the *9th Bavarian Regiment* and *5th Bavarian Reserve Regiment*. This opposition was about to cause particular problems for the right, 12th Australian Brigade.

On the left of 4th Australian Division's advance, 13th Australian Brigade's axis was distorted by the non-appearance of 33rd Brigade of 11th Division (IX Corps). Consequently, the left battalion of 13th Australian Brigade started to veer off to the left instead of moving almost due east down the slope along the Wambeke spur. A gap began to appear in the assault line and, although the Oosttaverne Line was reached easily enough, the right was by now 1,000 yd north of its planned position. The gap had to be filled, so for a few hours, the Australian brigade ensured that the Oosttaverne Line was occupied between Wambeke village to Polka Estaminet. At last, around 4.30 p.m., 33rd Brigade made its late appearance and soon reinforced the line, then captured the German garrisons of Joye and Van Hove Farms with the help of three tanks supporting IX Corps.

On the right, Brig Robertson's 12th Australian Brigade had been reinforced by the 37th Battalion of 3rd Australian Division. The objective was the rear trenches of the Oosttaverne Line between the River Douve and

Blauwepoortbeek, an attack frontage of 2,000 yd. Three tanks ('Our Emma', 'Rumblebelly' and 'HMS Lucifer') led the assault, and the Queenslanders of 45th and 47th Australian Battalions would not be denied, despite heavy enemy artillery and machine-gun fire. The tanks were valuable in suppressing the defences in a position known as Oxygen Trench and the Aussies captured it with a bag of 120 Germans. As they advanced on the objective through the enemy protective barrage, some of the New Zealand sappers were watching the attack. The account of Sapper Edward Leslie Hughes, watching 4th Australian Division's attack, underlined the uncompromising attitude of these hardened troops, fresh out of Bullecourt:

NZ Sapper Edward Leslie ('Les') Hughes before the battle.

Whilst I was on a crawl around looking for my party, the Australians launched another attack at 3 p.m. It was a magnificent, though dreadful sight to witness. Firstly, up came lumbering tanks, then the infantry in artillery formation and again more tanks. [The tanks] were a failure here, except that they drew fire which otherwise would have been directed onto the masses of men. As the 'Ossies' advanced, they were literally smothered with shells. At times one felt that a whole section of men was blown out, but when the dust settled there they were still wandering on in their leisurely way, with rifles slung, and whilst going through the 'Hun' barrage not a man was scratched. . . . As usual the 'Ossies' made a clean sweep. . . . To watch the Huns run out of their trenches towards us – and to see the way the 'Ossies' harpooned [bayoneted] them one after another, it was a sight that I shall always recall.[5]

It is hardly surprising that the men of 4th Australian Division were in no mood to give quarter: they had seen this all before and knew that in the main, the Germans would continue firing and inflicting casualties until the last possible moment before surrendering. They had witnessed incidents of German machine-gunners concealed by their colleagues surrendering in front of them lying in wait for the Aussie troops to move on before opening fire once more. This time there was to be no compromise at least until they were certain that their enemy were totally beaten men.

Throughout the war, the Germans were generally well-treated by the British and Empire troops once they were taken prisoner and vice versa. Naturally, there were a number of exceptions and, in the heat of battle, men on both sides were killed as they were about to surrender. However, these episodes were by no means exclusive to the First World War.

The main problem thereafter was dealing with the widely-spaced pillboxes behind the forward part of the Oosttaverne Line approximately 300 yd ahead.

Capture of the Oosttaverne Line, p.m. 7 June: looking east from Wytschaete to Oosttaverne Wood.

Capture of the Oosttaverne Line, p.m. 7 June: looking east from Messines towards the Oosttaverne Line.

45th Australian Battalion was held up by both machine-gun fire and the shrapnel bursts from German field guns which were sited in concrete gun emplacements. South of the Messines–Warneton road, 37th and 47th Australian Battalions moved skilfully through the obscuring smoke and debris of their barrage and closed with the enemy pillboxes. The fight that followed across their front was intense. It was gruesome close-quarter stuff, as the assault companies broke down into outflanking and fire-support groups to take the pillboxes. The inexorable drive to capture these positions involved a number of individual acts of courage and determination.

The most notable achievement was that of Capt Bob Grieve, commanding 'A' Company of 37th Australian Battalion. Already 47th Australian Battalion had taken two of these

Capt Bob Grieve VC, 37th Battalion, 3rd Australian Division.

strongpoints, the second being outflanked, rushed and bombed from the rear. Then 37th Australian Battalion came under intense machine-gun fire from several German machine-gun posts. Fire from one of these pillboxes was concentrated in a narrow gap in the wire which 'A' Company was attempting to breach and attack through. Within minutes, half of the company, including most of the officers, had become casualties. Capt Bob Grieve ordered the remaining men to take cover in shell-holes while Lt Fraser of the 10th MG Company tried to suppress the enemy position with Vickers machine-gun fire. However, Fraser's gun was soon put out of action.

Grieve knew that the situation was deadly serious and that his company was doomed if nothing could be done. Once it was clear that he was going to be without either Stokes Mortar or Vickers machine-gun support, he decided that that he would have to deal with the offending pillbox himself. He took a bag of Mills bombs and, throwing as he advanced, rushed from shell-hole to shell-hole under cover of the dust and debris from each grenade burst.

He was able to cut through the pillbox's arc of fire using this technique and dropped into the trench leading towards it. Here he encountered part of the German garrison who were sheltering from the British artillery barrage. He threw one bomb close to the pillbox, momentarily stopping the machine-gunner's fire, and immediately rolled two more grenades through the firing slit, killing or severely wounding all the occupants. Having come through the actual event unscathed, he then became the victim of a sniper

as he stood on the parapet calling his men up and encouraging them to push forward on one side of the pillbox's flank. He was severely wounded. The sniper was soon located in a tree and shot down. Grieve was sent rapidly through the medical chain, survived and was later awarded the VC, much to his surprise![6]

As with the New Zealanders, the Australian method of infiltration and outflanking the German positions often caused panic among the defenders.

> The enemy, who has grown up in the Australian bush, wriggles to our posts with great dexterity from flank and rear in the high crops in order to overwhelm them. It has often happened that complete pickets [OP Positions] have disappeared from the forward line without a trace.[7]

This was no exception. The combination of these tactics and the severe hammering which troops of *3rd Bavarian* and *1st Guards Reserve Divisions* had already experienced led to abject surrender. Many behaved in the way their comrades had done after the mine explosions that morning. Those who did not attempt to escape were found crying like babies and imploring for mercy. It was obvious to the Aussies that the Germans were thoroughly beaten men. They were exhausted, shell-shocked and utterly humiliated. The ones who ran away were either shot down or caught in first their own 'protective' barrage, then by the British barrage which had swept on to the secondary defences of the Oosttaverne Line.

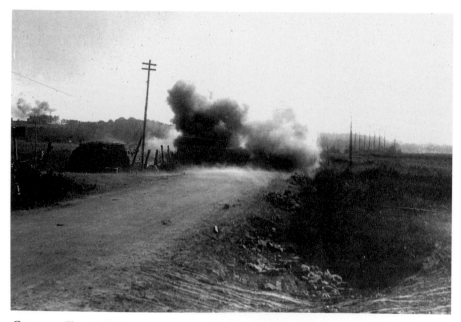

German artillery shells hit the road near Red Lodge (Hill 63 area).

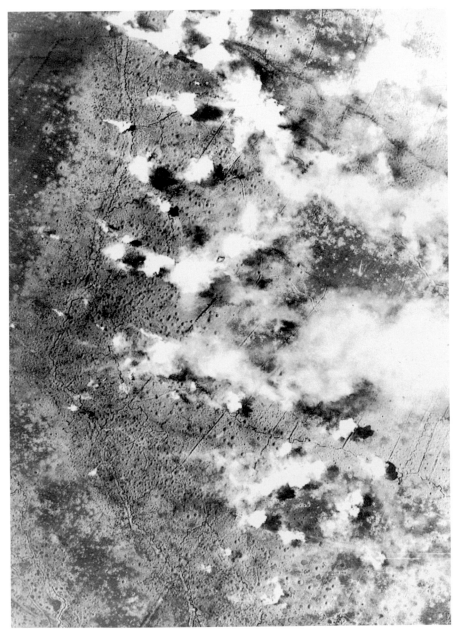

A British barrage seen from the air on 7 June.

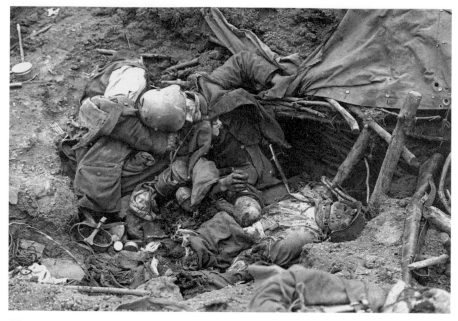

The terrible effects of a heavy artillery bombardment.

Situation at 6 p.m.

The fate of the Germans withdrawing from the Australian attacks and the surrender of the remainder at this stage are a suitable testimony to the general situation by 6 p.m. across the whole of Second Army front. With the exception of the stubborn resistance of *61st Regiment* at the Spoil Bank in X Corps area and the 1,000 yd of the Oosttaverne Line still held by pockets of enemy between the II Anzac and IX Corps boundaries, all objectives had been taken.

Haig's Qualified Delight

Before this at about 4 p.m., Haig visited Gen Plumer at his operational HQ at Cassel. He wrote:

> [I] congratulated him on his success. The old man deserves the highest praise for he has patiently defended the Ypres Salient for two and a half years and he well knows that pressure has been brought to bear on me in order to remove him from command of Second Army. Before I came away he had received news of the capture of the Oosttaverne Line. The operations today are probably the most successful I have yet undertaken.[8]

The 'qualification' was a curious one in the light of the discernible success, and that on his return to GHQ Haig declared to Brig-Gen John Charteris, his Intelligence Chief, that Plumer was his 'most reliable Army Commander'.

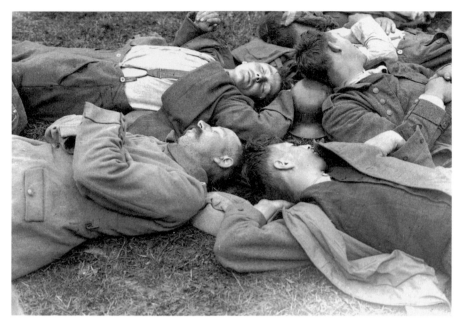

German prisoners sleep after their ordeal.

Von Laffert's Unqualified Misery

Across the wire, Plumer's opponent, *Gen von Laffert* had conceded that any operation to regain the *Wytschaete-Bogen* position was doomed, once the counter-attacks by *7th* and *1st Guards Reserve Divisions* had failed earlier that afternoon. At around 6 p.m., he ordered a night withdrawal to the east of both the Ypres–Comines canal and the River Lys. Thus he was about to effect the withdrawal which had been recommended by *Lt-Gen von Kuhl* and *Crown Prince Rupprecht* weeks before, a withdrawal which he had at that time dismissed as tactically unsound and bad for morale.

Despite the fact that this order was later modified, so that only the artillery was to be withdrawn, there was no denying the scale of *Gruppe Wytschaete*'s failure. *Von Laffert*'s arrogant disregard of reliable intelligence which suggested that the Messines Ridge was to be more than a diversionary attack and his dismissal of the mine threat had cost thousands of his men much more than a dip in their morale. Nevertheless, German morale was shattered as surely as the forward defences had been by the mines. An impregnable position had become untenable and *von Laffert* had nowhere to look but to himself for the reasons behind this disaster. In a little over a week he would be removed from command, his confidence and will destroyed.[9]

The Final Hours of Zero Day

The time had come for *Gen Sixt von Armin* and *Fourth Army HQ* to grip the situation. *Gen von Laffert* had modified his withdrawal orders in response to the news that the British had halted along the Oosttaverne Line. The artillery was then concentrated close to the canal and on the western edge of Commines. *Gen Sixt von Armin* ordered the existing forward line to be held, and reinforced the second line of defence behind the Oosttaverne Line (*Sehnen Stellung*). At dusk at around 8.30 p.m., the remnants of *7th Division*, withdrawn from the abortive attempt to cross the canal in the north to carry out the counter-attack towards Wytschaete, attempted to retake the Oosttaverne Line. Once again, their efforts were denied and each of the assault battalions took heavy casualties. They finally formed a defence zone behind the Oosttaverne Line, occupying shell holes in the area where the field artillery had been.

For Second Army, the remainder of zero day was spent attempting to wrest the Spoil Bank and the gap in the Oosttaverne Line from the enemy. In the north, 47th (2nd London) Division had pounded Spoil Bank with heavy artillery for almost four and a half hours before sending in the 1/20 London (Blackheath and Woolwich) Battalion of 142nd Brigade astride the canal. The assault companies made a desperate attempt to force the German garrison to capitulate, but they were dogged with bad luck from the start. The enemy artillery laid a heavy barrage on the Londons' companies as they formed up for the attack. Half of the left company lost direction and the German machine-gunners were able to sweep them with fire. It was a similar story for the right-flank company and only the centre company was able to make any significant advance. It managed to strike across the forward edge of the mound before realising that it was unsupported by the other companies. Their position became untenable when enemy reinforcements arrived under cover of the canal-cutting. The attack had failed. The battalion had taken nearly 100 casualties out of the 300 involved. Maj-Gen Sir George Gorringe, 47th Division's commander, decided to call a halt, at least until the next day.[10]

Commanders and Gunners: New Lessons for Old

Perhaps the most unfortunate oversight in the overall plan for Messines was that of the later control of the artillery by the troops of divisions consolidating their hold on the Messines–Wytschaete Ridge and those in the reserve divisions responsible for capturing the Oosttaverne Line. A major lesson was learned and perhaps the problem should have been foreseen. The second-phase divisions were by now taking control of the Oosttaverne Line. Therefore, 24th, 11th and 4th Australian Divisions were controlled separately from those now holding the Messines–Wytschaete Ridge. To make matters worse, the artillery observers (FOOs) of the ridge-line divisions were out of contact with the divisions forward. The potential for misunderstanding would grow as daylight began to give way to dusk.

Sure enough, as evening approached many of the FOOs providing sweeping observation posts (OPs) along the ridge, brought fire down on 'friendly' units and their troops in front of them. Perhaps it was inevitable because of two unfortunate factors: the fear of a German counter-attack against the ridge in the gathering gloom, and the more sketchy knowledge by the ridge-holding divisions of the phase two operations by the reserve divisions. The problem would take almost forty-eight hours to resolve.

In the southern sector, the Australian divisions suffered more than most. The situation here was already more confused. In the heat of battle this led to a number of desperately unfortunate errors. The principal source of the problem lay with the abortive attempts of *7th Eingreif Division* and elements of *11th Division* to regain the Oosttaverne Line. Soon after this final objective had been taken, an SOS barrage was called for close to Steignast Farm, just south of Gapaard, to neutralise an advance by elements of *7th Division*.

The barrage fell as planned at 5.30 p.m., but caught the leading battalions of 12th Australian Brigade. They were digging in – 250 yd ahead of their objective, as it had been almost impossible to identify their objective due to the destruction caused here already by the artillery. The *7th Division* counter-attack faltered and melted away as the Australians cut them up with Vickers and Lewis gun fire as well individual rifle fire. However, the barrage continued and the Australian battalions' casualties mounted.[11]

Somewhere along the line, an order was given to fall back towards the observation line. It heralded a period of almost total confusion on the southern flank. Forward companies fell back through the observation line and reorganised on the Messines Ridge. Others stayed in the line, or retired only as far as the observation line. At dusk (between 8 and 9 p.m.) the Kiwi battalion commanders responsible for the defence of the first-phase objective ('Black Line') just east of Messines requested that the barrage be shortened to the observation line. The request was approved on the understanding that there was an imminent threat from further counter-attack and that all the Australian battalions had been withdrawn beyond this line.

The barrage therefore hit men from 47th, 45th and 37th Australian Battalions as they were attempting to consolidate the gains of the afternoon, or trying to withdraw out of the 'friendly' barrage. By 9 p.m., this part of the Oosttaverne Line had been abandoned. However, at 10.45 p.m., General Godley ordered 3rd and 4th Australian Divisions to retake the line, which they did in the early hours of 8 June. The German garrison occupying the shell holes behind the Oosttaverne Line had reoccupied it in only a few places and their resistance was easily crushed.

Along the northern and central sectors of the Oosttaverne Line, *7th Eingreif Division* inadvertently caused further problems. The subsequent SOS barrage was effective in dispersing the enemy advance, utilising both guns and heavy machine-guns. However, the 18-pounders brought up to support the advance, and now firing from the ridge, dropped short, causing casualties among the infantry battalions who were holding the Oosttaverne

Line. As with the Australians, many of the most vulnerable companies fell back, suffering further casualties on their withdrawal. Once again, order was restored at Corps level and the IX Corps troops responsible for holding the final objective had re-occupied it by the early hours of 8 June.

Summary of 7 June

Despite these problems, the final British objective had been won along practically the whole battle front before dusk on the first day of the battle. As Bean pointed out in the Australian Official History: 'The plan had been fulfilled with a swift completeness far beyond that of any major achievement of the British Army in France and Belgium until that day'. (See map 21)

The most significant achievement was that the *main* German counter-attack attempts had already been defeated and the German commander-in-the-field, *Gen von Laffert*, had already conceded that his battle was lost. In short, 7 June had been a tangible and outstanding triumph. The German garrison, which had held this part of the Ypres Salient since the heroic failure of the London Scottish and the cavalry at Hallowe'en 1914, had been blown away by a combination of artillery, mines and an absolute superiority in fighting power both on the ground and in the air. In less than eighteen hours, the British had

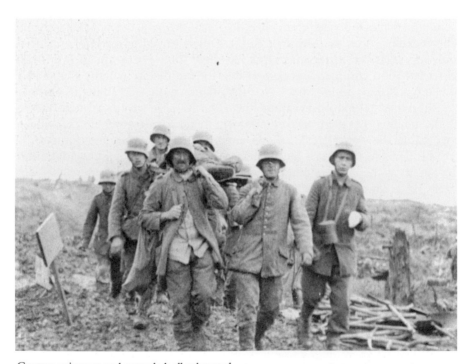

German prisoners and wounded: all exhausted.

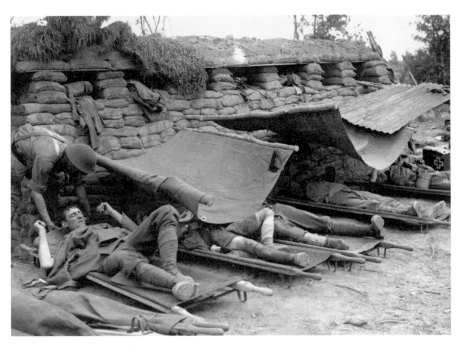

British wounded: p.m. 7 June.

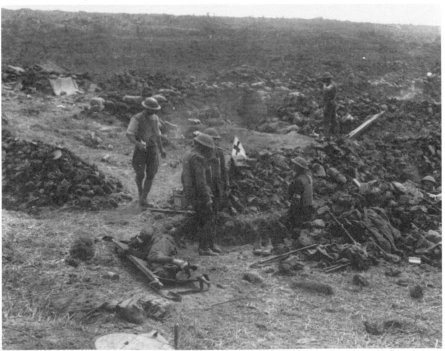

NZ Division Advanced Dressing Station (ADS) near Messines, a position occupied by Capt William Aitken, an RMO during the battle on 7 June.

proved that the German domination of the high ground overlooking Ypres could not only be challenged, but also comprehensively beaten.

In the opening assault, the barrage deluged the German defences to a depth of 700 yd, as well as neutralising much of the German artillery with accurate CB fire, assisted by the RFC. The infantry assault of 80,000 men was so swift that the forward defence was captured within minutes of zero hour. The crest of the ridge fell soon after and by 5.30 p.m., less than sixteen hours after the battle began, virtually the whole of the *Wytschaete-Bogen* was lost by *Gruppe Wytschaete*. Most importantly, the Messines–Wytschaete Ridge was firmly in British hands. The 'Bite' was effectively over and the 'Hold' was about to begin.

By the end of 7 June, Second Army had taken 5,650 prisoners and the estimated German losses were almost 20,000, of whom half were missing, presumed dead. Second Army casualties for 7 June were fewer than 11,000 in total (killed, wounded and missing). Ironically, many of the casualties had been caused by the crowding on Messines Ridge precisely because casualties in the first phase of the battle had been so light.[12]

It is important to note that the remarkable success had been possible not just because of the mines, but also because of the overpowering ratio of 3:1 in artillery in Second Army's favour. *Crown Prince Rupprecht*'s insistence on the reinforcement of *Gruppe Wytschaete*'s artillery assets gave it a total of just over 700 guns, but almost 50 per cent of these were to be put out of action or withdrawn. Although the artillery of *Gruppe Lille* to the south was to affect the Australian Divisions, it could not alter the course of the battle overall. This superiority in guns and their excellent support from the RFC were perhaps the deciding factors overall.

Outpost fighting was to continue for a week, but all the German counter-attacks were destined to fail. Plumer knew that the fight here was not over, but he was prepared to exploit his success.

Notes

1 Second Army Revised Operation Order for Messines, dated 19 May 1917. See Edmonds, *BOH*, 1917, vol. II, App. IX, p. 418.
2 Gen Glasgow was a veteran of Gallipoli and the famous 'Light Horse'. Glasgow would command 1st Australian Division in 1918.
3 For a more detailed narrative of 4th Australian Division's experiences from the afternoon of 7 June, see 4th Australian Division War Diary, and C.E.W. Bean, *Australian Official History*, vol. IV: *The AIF in France*, 1917 (Sydney, Angus & Robertson, 1933), pp. 638–41; 643–5.
4 IWM SS568, Extract no. 8. Letter taken from a prisoner of war after the battle, written by his section corporal. IWM SS Section, GHQ BEF, Extracts from captured letters and documents, issue June/July 1917.
5 Sapper Edward Leslie Hughes, NZ Engineers (Field Squadron), NZ Div: Private papers and recollections. Courtesy of Mrs Y. Fitzmaurice.
6 Grieve was sent back to Blighty, where he remained for six months. His recommendation for the VC was most unusual, if not unique. As there had been no officers of the company remaining to initiate the recommendation, several eyewitnesses from the other ranks provided the details and the draft recommendation. This was an even greater accolade for

Bob Grieve. During his stay in hospital, he received a letter signed by the NCOs and men of his company congratulating him on the award of the VC. The 37th Bn History records the content of this letter:

'We, the men of your Company, will cherish with pride your deeds of heroism and devotion which stimulated us to go forward in the face of all danger, and at critical moments, to give the right guidance, that won the day, and added to the banner of Australia a name which time will not obliterate. We trust that your recovery will be a speedy one, and we can assure you that there awaits you on your return to the boys a very hearty welcome.'

He was presented with his VC by King George V at Buckingham Palace on 20 October 1917.

7 Commander of German 41st Division, Extract from *The Times*, 19 August 1918.
8 Haig's Diary. Copy held at PRO (Kew). Ref: PRO/WO256/19, vol. XVII, June 1917, p. 18.
9 Von Laffert was removed on 16 June and replaced by Gen Dieffenbach. *GOH, Band 12* (1917), pp. 472–6.
10 Maude, Alan H. (ed.), *History of the 47th (2nd London) Division, 1914–1919* (London, Amalgamated Press, 1922), pp. 99–101.
11. Bean, *Australian Official History*, vol. IV, pp. 645–53.
12. PRO/WO 256/19: GHQ BEF Summary from Second Army on the evening of 7 June 1917; quoted in Haig's diaries, vol. XVII (June 1917), p. 18.

Third Movement: 'Not a retreat, merely a withdrawal', 8–14 June

Once you engage in battle it is inexcusable to display any lethargy or hesitation; you must breakfast on the enemy before he dines on you.
Kai Ka'aus ibn Iskander, Tenth Century Prince of Persia, translated by Reuben Levy from *A Mirror for Princes*, The Qabas Nama, 1082.

The Battle Continues

At 4 a.m., Maj-Gen William Holmes, commander 4th Australian Division, went forward to Messines with two of his brigade commanders to solve the problems which had become apparent in taking a firm grip on the previously vacated sector of the Oosttaverne Line. It was agreed that 33rd Brigade of 11th Division (IX Corps reserve) would relieve 52nd Battalion of 13th Australian Brigade, 4th Australian Division, at dusk that night. Then 52nd Battalion would move round to support the planned advance of 49th Battalion, 13th Australian Brigade, into the Blauwepoortbeek gap.

Following this, the morning and early afternoon of 8 June were relatively quiet. However, it was during this period that Brig E.H.B. Brown, commanding 1st NZ Brigade, was killed by a German artillery shell as he went forward to discuss further plans with his battalion commanders. He was replaced by Brig C.W. Melvill on the same day.[1]

At dusk, similar problems occurred as on 7 June with the artillery barrages. When the relief of 52nd Battalion by 33rd Brigade began, FOOs of the original forward assault division, now on the ridge, believed the movement of troops in the valley ahead of them to be a German counter-attack towards their positions. SOS barrages were called for and 13th Australian and 33rd Brigades, the forward units, suffered heavy casualties. Their situation was made worse when the enemy observed the same movement and brought down their own protective artillery barrage. The unfortunate troops caught in this deadly rain of shrapnel had to endure it for two hours. The confusion and loss of life forced a delay on the planned attack.

This was a flaw in the plan which had not been foreseen by Second Army, or its Corps HQs. These incidents had been a tragic and perhaps avoidable

lapse in the achievements of Second Army Command and the artillery as a whole throughout the battle. Two independent defence organisations had been formed, one behind the other. Each had its own artillery support, and this inevitably led to uncoordinated action against any perceived threat.[2]

At this stage, handover/takeover or relief operations were taking place across the front. Pte Leslie Jungwirth was about to come to the end of a typically exhausting battle for the men who had been in action since zero hour on 7 June, revealing also the opinions of the men at the sharp end of the battle as a whole:

> We were relieved on the 9th of June by the 11th Australian Brigade that had been in reserve. Our casualties were light; out of 130 in our Company, 85 were wounded, but only 5 deaths. On the 10th June we were addressed by General Plumer ['Plummer' to Jungwirth] . . . In the course of his speech he said: 'I want to particularly thank 10th Brigade for their good work. By showing such determination and coolness and sticking it under trying conditions the enemy . . . failed to drive you from the position won. And all through that great determination, the enemy this morning is in full retreat towards Warneton.'

Rest, reinforcement and reorganisation were to follow:

> We then went back for a few weeks to get reinforced. No. 1 Section only had 4 men left and 6 of our guns were out of action. The men had their clothing in rags, some also minus equipment, rifles, hats, putties etc. We went to a camp at Kemmel Hill. It was the highest point in Belgium and by climbing up there we could see the battle going on and look right across to the German trenches into the towns beyond. While we were there we got 90 reinforcements. About one week later, the King came and looked down on the Messines battlefield from Kemmel Hill . . .[3]

Returning to the more immediate battle, by the end of 9 June each Corps had prepared its own operation to secure the captured ground. Gen Plumer's concept was to form an overlapping forward defence along the Oosttaverne Line, with the main defensive position back on the Messines–Wytschaete Ridge. Each corps allocated a brigade as a reserve, to be held behind the ridge for counter-attack action as required. At 10 p.m. on 10 June, Brig Glasgow's 13th Australian Brigade attacked down the Blauwepoortbeek, supported by an outflanking bombing assault north along captured part of the Oosttaverne Line, but it was only partially successful. The gap in the line, lightly held by the enemy on 7 and early 8 June, had been reinforced by *11th Division*, a reserve unit of the northern *Gruppe Ypern*, on the evening of 8 June.

In the south, 3rd Australian Division made excellent progress across 600 yd of ground on either side of the River Douve soon after 11 p.m. The right flank of the Second Army front was then consolidated south of the river. The planned withdrawal of the remaining German forces to the Warneton line (*III Stellung*) was confirmed by the prisoners taken by 3rd Division. By 8 a.m. on 11 June, 12th Australian Brigade's G2 branch had informed Second Army HQ via Divisional and II Anzac Corps HQs that the German withdrawal had been scheduled to occur across the whole Messines–Wytschaete front at

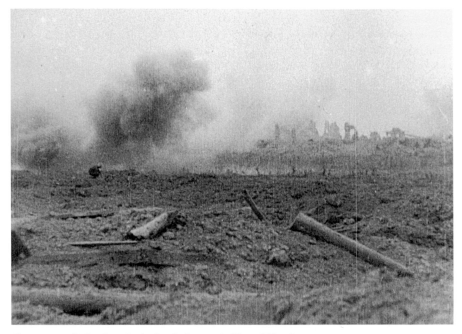

German retaliation later in the battle: heavy shelling of Messines.

1.30 a.m. that morning, but that the Aussies' advance, supported by a heavy artillery bombardment on the German positions, had caught them out here. Withdrawal was impossible, so the majority of the Germans were happy enough to go into the prisoner of war bag.

As dawn broke, any retreating enemy were spotted and shot down by the leading Australian platoons' Lewis gunners. Patrols of the 12th Australian Brigade were sent forward to the Blauwepoortbeek sector (which had been reinforced by *11th Division* of *Gruppe Ypern* late on 8 June), but all outposts and pillboxes were empty. Therefore, by mid-morning on 11 June the gap in the Oosttaverne Line had been closed. Only the remnants of *61st Regiment* (*35th (Prussian) Division*) and *7th Division* remained defiant at Spoil Bank.

After the occupation of the main part of the Oosttaverne Line on 7 June, it had become clear that the observation to the east from it was poorer than expected. Therefore, Plumer planned to extend this final objective, and this additional operation was carried out on the whole front on the night of 11/12 June. The original plan was to effect this on 14 June, but by the evening of 10 and throughout 11 June it became increasingly obvious that the enemy divisions had been withdrawn to the Warneton Line. The final eastern line was to run from Spoil Bank and White Château park in X Corps sector, through Joye Farm and Wambeke village in IX Corps', to the 'Birdcage'/Hill 20 advance line for II Anzac Corps on the right flank. (See map 22)

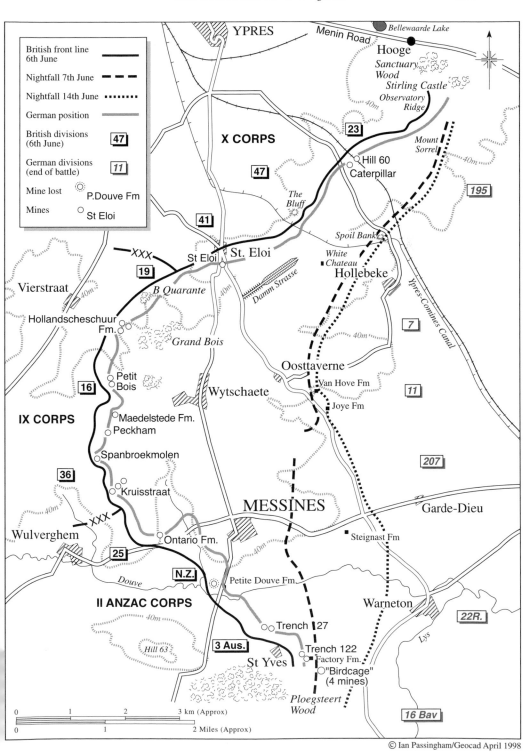

Map 22: Messines, June 1917: the end of the battle.

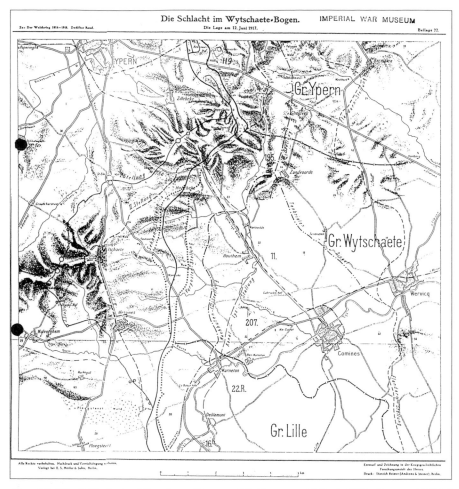

Map 23: Die Schlacht im Wytschaete-Bogen – Die Lage am 12 Juni 1917. German Official History map of the battle, showing the situation on 12 June, from German intelligence and operational reports.

Intelligence reports pieced together the fact that all the original defensive divisions had been replaced and that the new line was occupied by the German *195th, 7th, 11th, 207th and 22nd Divisions* and *16th Bavarian Divisions* from north to south replacing *204th, 35th, 2nd Divisions,* and *3rd* and *4th Bavarian Divisions* respectively. (See map 23) The new British line in advance of the Oosttaverne line was occupied swiftly and practically unopposed; Spoil Bank was finally vacated as the courageous garrison finally capitulated.

At the eleventh hour, supreme courage was acknowledged for the fourth time in the battle. Once again, it was within II Anzac Corps, only

Pte William Ratcliffe VC, 2nd Battalion the South Lancashire Regiment (Prince of Wales's Own), 25th Division.

this time in 25th Division. As a stretcher-bearer, Pte William Ratcliffe of the 2nd Battalion The South Lancashire Regiment (75th Brigade) had been in action for the best part of the battle. He had already distinguished himself, like John Carroll on day one, for his aggressive spirit and tireless effort. On 14 June he had occupied a trench in the forward line when he and his platoon came under fire from an enemy machine-gun. Ratcliffe spotted it and on his own initiative rushed it and bayoneted the machine-gun crew. He then brought the gun back into action in the front line and used it to cover his own men and against any opportunity enemy targets thereafter. He was awarded the VC.[4]

By the early morning of Thursday 14 June, a week since the mines had rocked the Messines–Wytschaete Ridge and the artillery had engulfed it, the battle was officially over. All objectives had been taken, in the main on 7 June. Despite the misunderstanding which had caused additional casualties by the British artillery and those caused by the unforeseen crowding of men on the ridge on the morning of 7 June, this had been a comprehensive and significant victory.

Across the wire, it had been a disaster which looked briefly as though it would have wider, perhaps fatal, implications.

Reaction – at the Kaiser's Court

As the battle of Messines progressed, it had become all too clear that the shattering of German morale was becoming all-pervasive. *Admiral Georg Müller* was unequivocal on 8 June: 'This evening at Kreuznach a few details of the English attack at Wytschaete Ridge came through. We have been pushed back about three kilometres on a broad front and lost more than 5,000 prisoners. Depression at Headquarters.'

By 9 June, *Admiral Müller* reflected the general feeling that the battle was already over and with far-reaching implications from His Majesty's point of view: 'It has been announced that at Wytschaete [Ridge] we lost several thousand prisoners. [The English announced 6,000] The Kaiser was nearly out of his mind and said: "Then the U-boat war has been of no earthly use to us".'[5]

At the other end of the spectrum, 2/Lt Firstbrooke Clarke, 8th Bn. N. Staffords summed up his experience in a letter to his brother on 12 June:

> Our turn came and we went forward. The ground was very cut up . . . but we got up close to our barrage and passed the troops in front, who had got their final objective. <u>Our</u> first objective was a trench just this side of a wood ¼ km square in area. We then had to clear the wood and dig in the other side. . . . [We] went in. The Germans had a lot of strong dug-outs and shelters in the woods, but their men were frightened by our bombardment and made no resistance. I felt sorry for them . . . I didn't have to fire a shot. . . . We consolidated the new trench that night and the next day. [On the] 8th the Germans strafed us and tried to counter-attack, but we put up too good a barrage for them. I [then] got a small splinter from a 5.9 in my backside. . . . [On the 9th] I saw our MO, got my 'behind' painted with iodine and some gauze stuck on and an anti-tetanus injection and went back to my platoon. . . . I am still desperately tired and rather stiff and lame. . . . I [do] hope they give us a rest soon: we need it.[6]

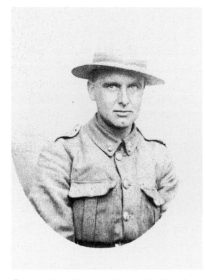

Sapper Les Hughes after the battle – just to let everyone back home that he was still OK.

The Cost of Victory . . . and Defeat

The time had come to take stock and consider the success first by the casualty figures and the respective states of morale in the British and German troops involved. As always, it is difficult to be able to give figures down to the last man because of the different methods by which the opposing sides accounted for their casualties. Nevertheless, in terms of other offensives on this scale, the British casualties were lower than had been anticipated.

The total casualties for the period 1 to 12 June within Second Army were 24,562, of which 3,538 were killed. However, for the period of the main

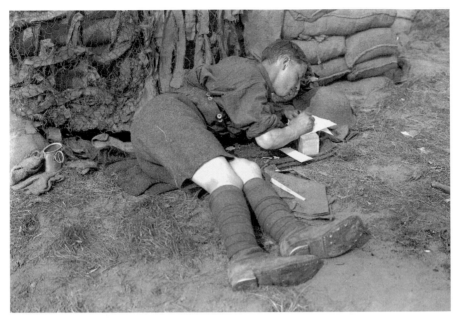

Writing home from Oosttaverne Wood.

Pte Walter Humphrys (second row, second from left) and his platoon at St Omer 'at rest' after the battle, 17 June 1917.

'And Irish eyes are smiling': the Royal Dublin Fusiliers clowning around with their trophies.

battle from 7 to 12 June, the total casualties recorded were 20,940: that is, killed, wounded and missing. This figure, which includes the casualties within the RFA brigades, RGA batteries, Infantry, Machine-Gun Coys and all other troops, is out of a total figure of the troops involved of 287,091: a total of less than 10 per cent.

This is all the more remarkable given the unfortunate ridge-crowding and artillery incidents on day one and until 9 June respectively. The latter had inflicted unnecessarily high comparative casualties on II Anzac Corps. For the period 1 to 12 June, it sustained 12,391 casualties, of which 1,785 were killed, representing around 50 per cent of both totals within Second Army as a whole.[7] GHQ BEF summary noted that for the period 7–10 June inclusive, Second Army had taken 18,500 casualties. This compared with the first four days of the Arras Offensive, 9–12 April 1917 (35,000) and the Somme Offensive, 1–4 July 1916 (69,000). The extent of the ground gained at Messines was about twice that taken across the whole front during the first four days of the Somme Offensive.[8]

On the German side, 144 officers and 7,210 other ranks (7,354) had been taken prisoner – many so dazed that they hardly knew who or where they were. It was estimated that 23,000–27,000 casualties were suffered by them between 21 May and 10 June. Of this figure, over 10,000 were officially

reported missing, many of whom were undoubtedly vapourised or blown apart by the effects of the mines.[9]

Despite the fact that some historians have suggested that the German front line was virtually unoccupied at the beginning of this offensive, the facts as presented here simply do not support such a view.[10]

Sources of Victory . . . and Defeat

Despite the mistakes made, there was no question that the battle was a quantifiable British success. Second Army produced a post-battle report which highlighted what is termed here as: Success by Design. The design for battle was simple and its aim was understood by all. It was a vindication of the importance of Plumer's maxim of the Three 'T's: Trust, Training and Thoroughness.

The summary of the battle attributed the success of the operations to the following factors:

a Use of indirect fire: the exceptionally good counter-battery (CB) work, trench-bombardment, wire-cutting, and barrage work by the artillery;

b Good morale and confidence in the plan: the determination and courage of the assaulting infantry, who were motivated with an excellent fighting spirit;

c Air superiority and vertical envelopment: the fine work of the RFC, who allowed nothing to deter them from the effective execution of tasks allotted to them;

d Good Staff work: not only in the previous preparations, but also in the co-ordination of the work of the various arms-of-service during the operations;

e Training, rehearsals and 'the knowledge': the systematic training of all the troops beforehand, so that all ranks were aware of the tasks which they had to carry out and the ground over which they had to fight;

f Administration and logistics: the careful preparation of the administrative arrangements for the railways, roads, water supply, ammunition resupply, etc.;

g Surprise and siege tactics: the successful explosion of the mines and exploitation of the opportunity thereafter.

On the other hand, Second Army's assessment of the causes which led to the German defeat were summarised as follows:

a Surprise: the actual date and hour of the attack appeared not to have been anticipated, although the enemy were well aware of the impending attack and approximately the front on which it would be expected. The potential threat of the mines across the defensive front had been effectively dismissed prior to the battle and therefore the effect was even more devastating than anticipated by the attacking force;

b Exhaustion and poor morale: the German divisions in line were

exhausted and suffered considerable casualties as a result of the preparatory bombardment, leading to a significant lowering of morale. This was exacerbated by the virtually impossible task of bringing forward rations, water, ammunition and other essential materiel, particularly in the final days before 7 June;

c The destructive effects of the British CB fire: This was most relevant in the systematic destruction of the German artillery batteries within the Oosttaverne Group, preventing effective enemy artillery support for both the defending troops in the front line when the attack was launched, and later attempts to use counter-attack forces;

d The use of gas and flame: Enormous strain was imposed on the German defenders attempting to carry out their tasks under the extreme pressure of constant artillery barrage; successful completion of tasks was made virtually impossible by the need to wear gas masks throughout the week or so prior to the attack;

e The trauma imposed by the mines and the loss of the ridge: Second Army specifically cites the enemy troops in the front and second defensive lines, although the effect of the mines, artillery and subsequent loss of the Messines–Wytschaete Ridge equally shattered the confidence of both the German Army on the Western Front and its High Command.[11]

Artillery

The artillery's overall success was due to the artillery fire plan. Since September 1916 the creeping barrage had brought a new confidence to most of the infantry whom it was to support. The battle had underlined the need for accurate CB fire, and interdiction showed that massive artillery fire in support of attacks with limited objectives could work. SOS barrages by aerial observers was an innovation which worked well. The use of protective barrages which utilised the heavy howitzers in advance of the 18-pounders was also an imaginative and effective method to increase ranges at which enemy counter-attacks could be neutralised.

Failure by Design – the Other Side of the Wire

The German inquiry following the battle concluded that there were five principal factors which had led to their failure at Messines:

1 Concentration of effort: Second Army's thorough planning, preparation and conduct of the battle, including the swift passing through of the second phase Divisions (24th, 11th and 4th Australian); the British superiority in the number of infantry, artillery, aircraft (noting British air-superiority) and tanks;

2 The unprecedented scale, siting and devastating effect of the nineteen mines: Surprise was total, as *OHL* had dismissed this potential threat by early May;

3 The unfavourable position of the German front line on a forward slope;
4 The cramped defensive deployment area; the vulnerability of the German artillery and the disastrous consequences of the *40th (Saxon) Division* and *3rd Bavarian Division* undergoing a relief-in-place in both the front and second line defences at the time of the British assault;
5 The late arrival and subsequent vulnerability of the counter-attack (*Eingreif*) Divisions: *7th* and *1st Guards Reserve Divisions* suffered in excess of 70 per cent casualties.[12]

The summaries from both sides of the wire bear out the reasons for success and disaster plainly enough and no further comment is necessary here. However, with the German defences in turmoil, there had appeared a significant opportunity to be exploited. The question now was whether it would be.

Notes

1 Brig E.H.B. Brown was with Maj-Gen Russell at the time. Brig Brown was revered by his men, an unassuming though professional officer. See Stewart, Col. H., *Official History of the N.Z. Effort in the Great War*, vol. II: *France* (Auckland, Whitcombe & Tombs, 1921), p. 207.
2 The experiences of the 3rd and 4th Australian Divisions through much of this time was grim indeed. Even 4th Division Australian officers, like Albert Jacka VC, who had been at Pozières, were to report it as one of the most trying periods endured on the Western Front. (See Bean, *Australian Official History*, pp. 638–41, 658–68.)
3 AWM PR89/63 Private Papers of Pte L.M. Jungwirth, 10th MG Coy AIF.
4 No. 2251 Pte William Ratcliffe, 2nd Bn South Lancashire Regiment (The Prince of Wales's Volunteers). The VC citation also noted that 'This very gallant soldier has displayed great resource on previous occasions and has set an exceptionally fine example of devotion to duty.' Ratcliffe was awarded his VC by King George V on the same day as Samuel Frickleton. He was honoured by the National Union of Dock Labourers, of which he was a member, in Liverpool on 14 October 1917. Lord Derby attended and replied to the toast. The Union had proposed a financial reward for William, to acknowledge his achievement. Lord Derby reminded those present that this brave man could not receive monetary reward for doing his duty, but to general agreement suggested that the money was held until he returned to civilian life. He emphasised that the VC was recognised as a soldier's honour world-wide as one which carries real merit, and if he could do anything by granting extra leave to enable Private Ratcliffe to earn the suggested 'Bar' to his VC by matrimony, he would be pleased to do so!
5 Müller, Admiral Georg von, *The Kaiser and his Court: The First World War Diaries of Admiral Georg von Müller*, Görlitz, W. (ed.) and Savill, M. (trans.) (Frankfurt, Musterschmidt-Verlag, 1959). (Extracts courtesy of the Liddle Collection, University of Leeds.)
6 Private collection of 2/Lt (later Capt) Firstbrooke Clarke, 8th Bn. N. Staffords, 57th Brigade, 19th (Western) Division, Western Front 1917–1918. (Courtesy of the Liddle Collection, University of Leeds.)
7 Edmonds, *BOH*, 1917, vol. II, pp. 87–8.
8 PRO WO256/19 vol. XVII (June 1917): Summary of the military situation in the various theatres of war for the seven days ending 14 June 1917; GHQ BEF (Marked V. Secret, Ministers only), 14 June 1917, p. 3.
9 *GOH, Band 12*, (1917), pp. 471–2.
10 Winter, D., *Haig's Command, A Reassessment* (London, Viking, 1991). On p. 96, Winter claims that a week before the battle of Messines, the Germans had pulled back. He implies that the battle was more a masterly deception by the Germans and that the mines were wasted on almost empty positions. The battle was 'little more than the capture of a few scattered pillboxes'. The facts discussed in this book do not bear this out.
11 Harington, *Plumer of Messines*, pp. 94–6; and *Second Army Report on Recent Operations on the Second Army Front*, dated July 1917 (IWM: SS172/AWM: B519/3/49).
12 *GOH, Band 12* (1917), p. 471.

Fourth Movement: 'Opportunity Gained . . . and Lost'

The Bigger Picture

The wider events which had been unfolding throughout the Battle of Messines will now be reviewed. The period 7 to 21 June proved to be a fateful fortnight. It was characterised by unfortunate indecision by Haig and growing confidence by *Crown Prince Rupprecht*, *Ludendorff* and *Hindenburg* that the British would not exploit their success at Messines.

The German High Command was already certain that the *Wytschaete-Bogen* was a lost cause on 8 June. Messines and Wytschaete were already beyond the reach of German counter-attack forces. The British divisions were consolidating beyond the Oosttaverne Line which more or less conformed with the *Sehnen Stellung*, the defensive cord which had bound the German Messines–Wytschaete sector together.

It was reluctantly agreed that beyond 8 June the German response would be in the form of a damage-limitation operation. The sheer weight and accuracy of the British firepower would preclude any other option. *Ludendorff* was unequivocal: 'The 7th of June cost us dear, and owing to the success of the enemy the drain on our resources was very heavy. Here too, it was many days before the front was again secure. The British Army did not press its advantage; apparently it only intended to improve its position for the launching of the great Flanders offensive.'[1]

Haig was delighted at the success and eager to press on with the offensive. Both the 1916 and 1917 plans had underscored the importance of taking the Gheluvelt area as well as the southern shoulder of the German-held high ground of the salient. The opportunity existed to drive a wedge towards the northern part of the salient via Mount Sorrel before the Germans had time to reinforce and repair the damage done. The C-in-C appeared confident enough to exploit it and grab the subsequent prize of the Gheluvelt plateau.

It will be recalled that this contingency had been examined as an option by Plumer and the Second Army staff in early spring as a direct result of Haig's encouragement. As recently as 24 May, Haig had written to

Plumer explicitly charging him with the responsibility, as: 'the capture of the Messines Ridge might be the beginning of the capture of the Passchendaele-Staden Ridge [and] in the event of the situation developing in our favour, reserves will be placed at the disposal of General Gough, GOC Fifth Army, in order to enable him to co-operate in an effort to gain that Ridge'.[2]

Plumer's response to the possibilities being offered came on 3 June. He pointed out to Haig that: 'It is essential that the opportunity for exploiting a success should be taken advantage of at the earliest possible moment'.[3]

Although Haig had previously warned Gough that he would probably be responsible for any exploitation operation which might occur, it appears that Haig did fleetingly see an opportunity to use the proven commander on the ground. Haig asked Plumer how long it would take before he would be ready to take on this subsequent exploitation operation. Plumer had already planned to use II and VIII Corps to attack north and south of Bellewaarde lake, around Hooge and the Menin Road. The first objective was to be Stirling Castle, an advance of 1,200 yd. (See maps 22 and 24) This would open up the Gheluvelt plateau and provide the essential launching pad for later operations north of the Menin Road. Sixty heavy and medium guns were to be transferred from the Messines front to support this advance. The troops were ready and expecting the call. Plumer calculated that the necessary re-tasking and move of artillery and infantry and the supporting arms would be complete within 72 hours.

By 11 June, Plumer would have secured the southern flank along the Messines Ridge and simultaneously prepared for the next 'Bite and Hold' operation against the Gheluvelt plateau. Gheluvelt was vital for the launch of a developing offensive in the north towards the Passchendaele Ridge. Plumer was expecting the principal responsibility for the exploitation phase. Messines had confirmed his methods and his resolve. Many of Haig's staff were convinced that Plumer would have the leading role in the subsequent operations, particularly in the light of Gough's indifferent performance at Bullecourt. It was the logical and most expedient thing to do. For some unknown reason, this was a time that Haig was to prove neither logical nor expedient.

After conferring with Gough on 6 June, the day before Messines, Haig warned him that there was an excellent prospect for pushing on as Plumer had recommended.[4] Plumer had, in fact, anticipated the enemy's worst fears. *Crown Prince Rupprecht* wrote that he saw the victory at Messines as only the first step to the capture of the Belgian ports via a Flanders offensive. He envisaged Gheluvelt-Zandvoorde as the next British step, establishing a firm right flank here and using it for the foundation from which to launch the wider offensive. From 9 June onwards he expected the blow to fall, but doubted whether the German defences as they stood would be able to resist this next thrust. However, in contrast to both Plumer and Haig's apparent optimism, Gough was ambivalent, preferring either to go for an operation which would put him in command of II and VIII Corps, or to hold back this attempt to capture it as part of a later and more deliberate wider offensive in the north.

Even as late as 19 June, *Crown Prince Rupprecht* remained convinced that the British would attack in this same area and continue to wear down the German resistance through a series of operations like Messines, which would attack on a narrow front, but with a massive artillery concentration, to force German reserves to be committed and drive a number of wedges into the defensive line. He concluded that: 'an improvement in the defence situation can only come about by moving back to *the Flanders line*'.[5]

On 8 June, when Plumer told Haig that he would be ready to carry out the exploitation operation on 11 June, Haig, who had been informed that the Germans were beginning to reinforce the Gheluvelt area, appeared to lose his resolve. The first stage had been achieved beyond even Haig's expectations, Plumer was ready to develop this victory and the much sought-after Gheluvelt prize was almost certainly within his grasp. The time was now, as it was clear to all that the Germans were still in disarray. It was equally clear from past, bitter experience that the German High Command would not allow such a situation to persist.

Every day lost from 8 June on would be another day of respite and reorganisation for the German defences around the Ypres Salient, where it had become clear to the enemy that the main Allied blow would fall.

Yet, Haig somehow allowed the opportunity slip from his grasp. The real tragedy of this period was rooted in Haig's decision-making. Plumer, now a proven winner in the offensive as well as in defence, and preparing to exploit this over the ground he knew intimately, was not permitted the requested three days to regroup his forces for this next bite out of the salient. At this time it was a brittle crust on the German defensive pie. On the other hand, Gough, who knew nothing of the area, was given six days, then six weeks to consider, then plan the next move.

Haig's questionable will to continue to harass and then destroy the German resistance when it appeared at its most vulnerable was most unfortunate. However, two factors may have outweighed Haig's immediate desire to exploit his success. The first was that he and his intelligence staff were well aware that the rear lines of the Gheluvelt plateau contained German heavy artillery pieces which could have been used to disrupt any exploitation operation. For this reason, it is conceivable that he was unwilling to risk losing the psychological advantage of the Messines victory. To be fair, he had to consider the political as well as military implications of failing in a bold attempt to continue to harass the enemy. Second, regardless of the obvious advantages of Plumer's knowledge of the ground and now-proven offensive command ability, Haig continued to prefer Gough for the forthcoming Ypres campaign. However, for hundreds of thousands of men on either side of the wire, it was to prove a costly mistake. Haig had already spelled out that in his opinion the enemy should never be given a complete rest by day or night, so that he would be inexorably worn out and worn down until his defences collapsed. There were precious few opportunities that Haig had experienced until June 1917 to really grind the German

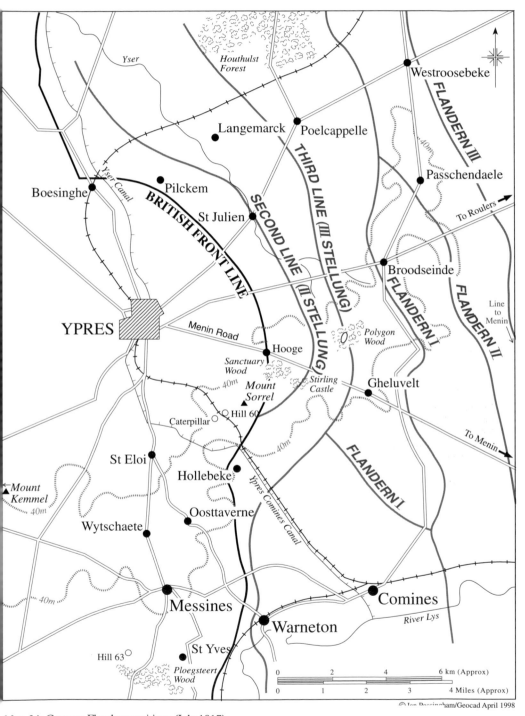

Map 24: German Flanders positions (July 1917).

defences down while they struggled to recover from such a potentially devastating blow, yet he did not take it. On balance, it remains as one of his important errors as Commander-in-Chief.

Evidence to support such views on what might have been can be gleaned from the attitude of those across the wire. *Crown Prince Rupprecht* and *Gen Sixt von Armin* were the catalysts for the German decision to withdraw following the dreadful events of 7 June. They met on 9 June and agreed from the reports received that the British were already able to observe the Warneton Line (*III Stellung*) and therefore their artillery could sweep it with heavy fire at will. The worst feature of the Warneton line was its continuous trench line which was obsolete and thus more vulnerable, particularly as it was easily seen from the air.

Gen Sixt von Armin advocated the use of the next line back, namely the *Flandern Stellung* or Flanders Line, joined to the existing front line by the *Tenbrielen Riegel* (Switch Line) and which was to be improved. *Crown Prince Rupprecht* agreed and two weeks would be spent constructing a new position in depth in front of this position, with a bridgehead position known as the *Kanal-Lys Stellung* (Canal-Lys Line) which established a series of outposts between Houthem and Warneton and advanced posts forward of the Warneton line. After the obvious disaster at Messines, the Germans were to demonstrate their characteristic ability to recover quickly.

Notes

1 Ludendorff, Gen Erich von, *My War Memories*, vol. II (London, Hutchinson, 1919) p. 429.
2 Edmonds, *BOH*, 1917, vol. II, p. 88.
3 Ibid.
4 Ibid, p. 89 and PRO WO256/19 (June 1917) vol. XVII (Haig diaries/records), entry for 6 June, pp. 14–15.
5 Crown Prince Rupprecht (Kronprinz Rupprecht von Bayern) *War Diary* (*Mein Kriegstagebuch*) vol. II (Munich, Deutsche National Verlag, 1920); entries for 7 and 19 June 1917.

Finale: Repercussions – Third Ypres, Cambrai and Crisis

We lived united, as men always are who are daily staring death in the face on the same side and who, caring little about it, look upon each new day added to their lives as one more to rejoice in.
John Kincaid, British Infantryman, 1811 (during the Peninsular War), quoted in
Random Shots from a Rifleman, published 1835.

Beyond Messines

By early July the revised Flanders plan still envisaged a general breakout, with Ypres as the fulcrum for the main sweep towards the Belgian coast. However, Haig's optimism concerning the method to defeat the German army in the west was by now declining. The opportunity to keep the German army on the rack, advocated by the British PM in May, had passed with Haig's decision not to exploit the success at Messines. Furthermore, it was becoming clear that the German U-boat threat would not be stopped by the plan, as the submarines were operating principally from home ports rather than the Channel ports.

Doubts were expressed by Lloyd-George and the War Cabinet, as well as Haig's French counterparts. Marshal Foch regarded the concept as a futile one; Pétain considered it to be doomed to failure. However, the French situation remained precarious. It was argued that this was a valid reason to go ahead. A Flanders offensive would at least keep the enemy occupied and tie his reserves down for the following weeks, taking pressure off the French line. In Haig's defence, and despite the reservations of the French, this did prove to be an important factor.

As the British troops enjoyed the summer weather and started to train for the new offensive, the plan for the Third Ypres campaign was debated and mulled over at a series of conferences which involved all of the main political and military players. Doubts on the wisdom to continue as Haig had planned took time to resolve, particularly as Haig had to convince Lloyd-George on most of the issues. Full sanction for the offensive did not come until days before it was due to begin on 31 July. By then, caution about the size of the task and the probable deterioration in the weather had been thrown to the wind.

As this drama unfolded, *Gen Ludendorff, Crown Prince Rupprecht, Gen Sixt von Armin* and the German field commanders were preparing to meet the expected Ypres offensive with vengeance. (See map 24) As June wore on, one man appeared on the scene to mastermind the German response: *Col Fritz von Lossberg*. He had become Germany's defensive expert. The lessons of the Somme had not been lost by him. *Lossberg* had been instrumental in the development of the revised German defensive doctrine, manifest in the withdrawal to the Hindenburg line. Now he was given free rein to improve the brittle defences around Ypres. He had six weeks. Not a day was wasted.

The trench and pillbox system was increased to six lines in places, with the underlying principle of reverse strength. This meant simply drawing the attacker deeper into zones of increasing defensive strength, while his own fighting power in the attack diminished. In principle, the German method was designed to lead the attacker into a 'killing zone' where his forces would be cut off and destroyed, or forced to surrender.

This underlined the doctrine of flexible, or elastic, defence. This time the forward zone *would* be lightly held and the elite machine-gun crews would occupy prepared positions or even shell holes on the crests and forward slopes of each defensive position. The concept emphasised the use of well-sited strongpoints, rather than a system of tightly packed and more linear trenches, such as the Warneton line (*III Stellung*) abandoned for this reason in the latter stages of Messines.

On the reverse slopes, the defence lines would be covered by a series of machine-gun and field gun strongpoints, mutually supporting each other and therefore providing protective fire. Each line would, in turn, be supported by artillery and increasingly strong bodies of counter-attack (*Eingreif*) units. As an example, one line might be supported by a counter-attack battalion, the next by a counter-attack regiment and the third by a division. Concrete emplacements were built while the weather held good not only for the strongpoint garrisons but also as shelter for HQs, medical units and for the counter-attack troops. Not all the troops would be afforded such relative luxury, as will be seen, but by the end of July, the brittle crust of the German defences in the Ypres Salient had been considerably hardened.[1]

Gen Sixt von Armin would not be caught out by the virtual no-contest in the artillery battle which his men had endured at Messines. Opposing 3,100 British guns, 1,556 German guns of all calibres were concentrated in the Ypres area, a ratio of 1:2. The interlude of six weeks had allowed the German infantry units time to reinforce, retrain and deploy, so that by 31 July, there were three corps (*Gruppe Dixmude, Ypern* and *Wytschaete*) consisting of a total of nine divisions as the front line units. Six reserve divisions were deployed behind these, and a further five mobile divisions in two echelons behind these reserve divisions. Therefore nine German front line divisions and eleven in depth (twenty) faced seventeen British assault divisions, with a further seventeen in reserve (thirty-four).[2]

Into Battle

The time for waiting was over once more. At 3.50 a.m. on 31 July, twelve British infantry divisions advanced under cover of their creeping barrage into a thick mist and the rain which had started almost on cue the previous evening. (See map 25) The rain became progressively heavier as the day wore on. The left and right flanks of the offensive were to meet their objectives, but the area of the main attack astride the Menin Road was soon in difficulties. It was indeed a day of mixed fortunes. Over 6,000 prisoners were taken, including over 130 officers, but although the German defences were badly damaged or destroyed in places, the main line held.

The period from 31 July to 5 August was grim for the troops on both sides of the wire. As in the dreadful conditions on the Somme after mid-September 1916, the rain just kept on coming. It stopped briefly on 5 August, but even then there followed days of dark skies, wet mists and unrelentingly depressing conditions.

Though the Germans were holding their ground in the main, their situation was equally depressing. *Georg Bucher*, an infantry officer facing the British assaults on 31 July wrote:

> There was an absolute downpour of earth and shell splinters. . . . Three men were plastered on the walls of the trench or lying in fragments on the ground. . . . By evening the parapets had disappeared. . . . Forty-one dead [now]. . . . All through the night the soil of Flanders was lacerated by the most furious shellfire. . . . On the fourth day, one young soldier had had enough. He climbed out of the trench with two grenades . . . and told his comrades what he thought of the war. He was going to run towards the British rifle fire and hurl his grenades at them, but he would throw them at his comrades if they tried to stop him. [They let him go.][3]

Further progress became impossible throughout this first fortnight. The tanks and infantry were unable to move, just as had been predicted. By the end of the first week Gen Sir Hubert Gough was a worried man, not at all like the confident man who had planned to break through the German third line within three days. To be fair, he expressed his reservations to Haig, but the C-in-C was determined to continue. He had a resolute faith in a successful outcome.

He was well aware of the conditions in which the new campaign was being fought. He knew that when it rained in Flanders the landscape was transformed into long stretches of bog, impassable except by a few well-defined tracks, which were ideal targets for the enemy's artillery. Many men on both sides of the wire, weighed down by their weapons and equipment, were destined to drown.

As August ticked by, Haig noted and complained about the unavoidable delay as a result of the weather, which was losing valuable time for developing the offensive. It seems a pity that this sense of urgency had not been part of his character in early June.

The next phase opened with an attack on 16 August when Fifth Army battered itself against the Gheluvelt-Langemarck line, attempting to swing

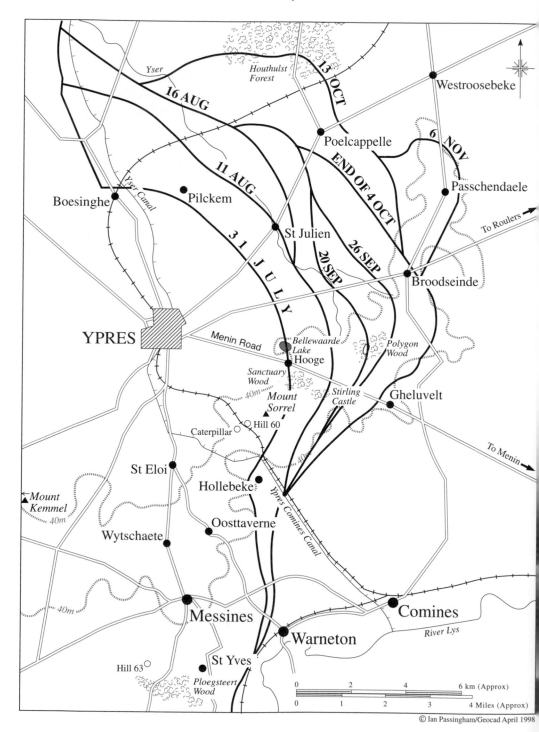

Map 25: Third Ypres campaign: 31 July to 6 November 1917.

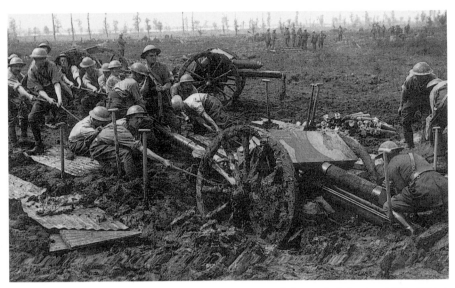

British gunners struggling to haul an 18-pounder out of the mud, 9 August 1917. (Third Ypres).

north from the Menin Road. Although some gains were made on the left flank, no significant progress was made, and conditions became grimmer still. Even the soldiers' enduring humour reflected the blackest sort. The *Wipers Times* ran a 'spoof' advert announcing:

Coming to a Cinema very near to you;
(and even closer than that for some):

Now showing nightly at the Menin gate cinema – this week's great sensation: '***The Road to Ruin***'. 15,000 feet long and every foot a thrill. Book at once! People have been so overcome when the final stages are reached as to necessitate help being given to enable them to reach home. . . . Our new consignment of highly decorated cars are now placed at the convenience of the public. They are handsomely appointed throughout and can be easily known by the red cross painted on each side. Telegraphic address: 'R.I.P.-P.E.D. Ypres'.[4]

Gen Gough's credibility was at a low ebb. He had been dealt a bad hand with the weather, sure enough. However, the flaws in Fifth Army HQ's preparation for Third Ypres was by now exposed to all, not least of which was their poor knowledge of the ground over which they were expecting the troops to fight.

The front-line officers and men were beginning to mutter that the impressive resolve of their enemy and the mud were not the only reasons for their suffering and frustrating lack of progress. It was reported that

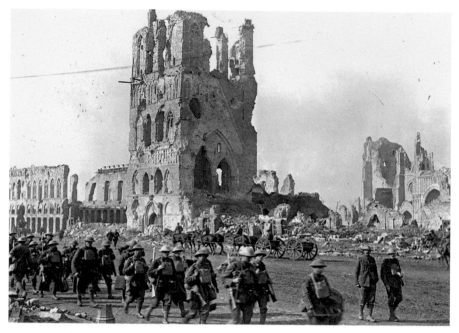

Australian troops march through the ruins of Ypres, September 1917.

'Complaints against the direction and staff work in Gough's Fifth Army were general and bitter.'[5]

The fundamental flaw lay in the design for battle. The vision of sweeping offensives, swift exploitation and the use of cavalry for the breakout was already consigned to history, but Haig and Gough had still to be informed of this. The next phase was to prove the point. 'Bite and hold' operations were the future for practical purposes in these conditions, in a modern war and against the main enemy.

Even Haig's faith in Gough was growing thin. On 25 August, the C-in-C reluctantly acknowledged his error and decided to hand the main responsibility for the stalled campaign to Plumer. Haig's ambitious experiment had failed and now he had to rely once again on his 'most reliable Army Commander'.[6]

Second Army's operational area was extended north to include the Menin Road and the principal objective: the Gheluvelt Plateau. The irony was not lost on Maj-Gen Tim Harrington, Plumer's Chief of Staff. It was a question of 'Here we are again', only two and a half months late. Plumer would not be rushed into further pointless attacks in the conditions which prevailed at the end of August. He assured Haig that he would be ready to strike again in three weeks. The date set was 20 September.

In typical style, he determined to take the principal objective in a series of meticulously planned operations, each one limited and achievable, and designed to absorb the inevitable German counter-moves before pressing on with the next attack: 'bite, hold and exploit'. Once again he would focus on the guiding principle of concentration of force, in particular the use of artillery aided by the RFC and strong reserves. The attack was launched at 5.40 a.m. on 20 September, astride the Menin Road. The first objectives were taken in less than an hour and by midday, 23rd Division, who had done so well at Messines, were within half a mile of Gheluvelt village. By the end of the day, all objectives had been taken by a combined British and Anzac force.

German counter-attacks were crushed by massive artillery and machine-gun barrages. The German defence was brittle once more. Their experience was chilling. A soldier wrote hurriedly to his brother in the line further south:

> Flanders, 20/9/17: I hope you are getting on better down there than I am here. I had up to now never been in anything like it. Before Arras it was very bad. You may not believe me, but here it is the devil let loose. What is happening here is incredible. This is the seventh day I have been in the open fields. I must stop for the enemy is bombarding our position vigorously, and I must take shelter.[7]

The letter was never posted.

The next phase, the Battle for Polygon Wood, began on 26 September and the pattern was repeated. Once again, the British and Anzac troops

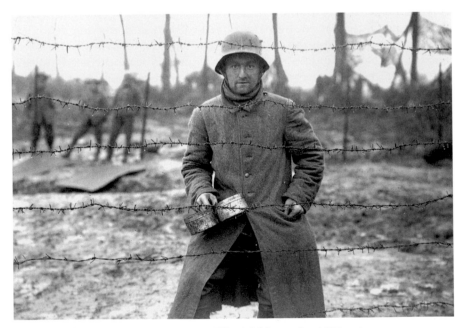

German prisoner 'in the bag' after Polygon Wood, 26 September 1917.

carried all before them, achieved their objectives and held them. Then they destroyed the German counter-attacks as they had done a few days before.

On 4 October, at Broodseinde, the Gheluvelt plateau was finally in British hands and the German line was almost broken. Since the rejection of the proposed operation to secure it in the wake of the victory at Messines, it had taken four months, almost to the day.

Into an Unknown Place

Broodseinde was described by the German High Command as a 'Black Day' in their army's fortunes. *Crown Prince Rupprecht* was expecting the German defensive dam to burst. Then the rains came again and it was certain that nothing more significant could be achieved. *Rupprecht* was reported to say on 5 October that the rain was 'Germany's greatest ally'.[8] Even if Passchendaele were now seized, Haig could not possibly contemplate an advance beyond it. Gens Plumer and Gough were no doubt sceptical and were reported to have counselled Haig to hold the line as it now stood and draw the campaign to a close. Other evidence, more recently cited, would suggest that regardless of any natural misgivings, the Army Commanders endorsed the C-in-C's desire to continue the campaign.[9]

Haig's judgement was now coloured by three factors which appeared to him to be pressing reasons to continue the offensive. First, after the French successes at Verdun and Chemin des Dames in August and September, a further major offensive was planned in the Aisne sector. Pétain wished to consolidate the revival of French morale before the year's end. Given their desperate situation after the Nivelle fiasco and ensuing mutinies, it seemed a compelling reason. Secondly, another British offensive was planned at Cambrai in late-November, and another was scheduled to begin in Italy. Secrecy surrounding these preparations was paramount. German eyes had therefore to remain fixed on Flanders. Thirdly, the Russians were effectively out of the war. The October Revolution had led to the ousting of the Tsar and the new regime was suing for peace with Germany. Therefore, victorious and hardened German divisions were being diverted to the Western Front. Haig wanted a decision in his sector before they could arrive in significant numbers. Haig was allowed to continue, albeit reluctantly, though the scale of the offensive was to be significantly reduced. The final month which gradually pushed the enemy beyond Passchendaele village was to become the apotheosis of 'The Slough of Despond'.

On 16 October, Sapper John McCreesh and part of his section were returning from the usual grinding day close to the front line. The tunnellers were already part of Sapper folklore, but only that. The tunnellers' days were over and the majority of the men who had been part of their triumph at Messines had been employed in the more routine RE tasks: repairing roads and track-ways, digging dug-outs and communication trenches, providing water points, the list was almost endless. As the four men trudged

on back via St Eloi towards their billets, a stray German shell landed close to the crossroads north of the village. John and his friend Sapper Henry James Gibson were killed instantly, one man was wounded, but the other was amazingly unscathed. It was a cruel end to a man who had given so much to the effort of mining beneath the German defences since the tunnelling companies had been formed by Norton-Griffiths two long years before. Ironic too, that he had volunteered to train as a mine rescue specialist, saved so many other lives and instructed the younger men in the same skills, only to become a victim of a random shot from a German gun crew. Gibson, a Scot from Tarbolton in Ayrshire, was 23 years old. John McCreesh, the proud Irishman 'adopted by Tyneside', and a genuine father-figure for Gibson and many other men in 250 Tunnelling Company, was 41.[10]

Kiwi Sapper Les Hughes, who had witnessed the awesome attack of the Australian 4th Division on the afternoon of 7 June beyond Messines, went down at the same time with trench fever and nephritis and was sent to England for treatment. Months of continual work in often appalling conditions made him one of the many thousands of casualties who were victims of the other enemy which afflicted both sides. He would not return to France or Belgium again.[11]

Plumer and his staff would be sent to assist in limiting the growing crisis on the Italian Front, together with divisions which had fought at Messines and during this campaign. He would return to the Ypres Salient in March 1918, just in time to prevent a final enemy attempt to secure Ypres, and ultimately push them out of the salient for good.

A Terrifying Vision of Suffering on Both Sides of the Wire

Across the wire, the German assessment of Third Ypres was well documented by *Gen von Kuhl*. He noted that the most significant success of the British and Empire forces in the campaign was the tying-down and drastic weakening of the remaining experienced and well-led German fighting troops. The offensive had protected the weakened French army against German attacks (as FM Haig had advocated) and given them time to pull their shattered army together. The campaign from June to November had made it necessary for *OHL* to limit severely any troop movements to other theatres of operation. 'But', *von Kuhl* wrote, 'above everything else the battle had led to a vast consumption of German strength. Losses had been so high that they could no longer be replaced.'[12] Regardless of the widely-held image of British troops struggling vainly against impossible conditions as October wore on into November, the final effort damaged the German Flanders soldier more.

Gen von Kuhl reminds us all that the terrain and climate across the wire did not change dramatically in their favour:

That the enemy . . . had been able to achieve less than had been planned was partly due to adverse weather conditions. But water and mud were no less a disadvantage to the defenders. The British were able to withdraw their troops during the operations to better billets to rest

them. The Germans, on the other hand, who did not know when the next attack was to come, were under duress to keep their troops in a state of permanent readiness. In many cases, as the combined effects of massive artillery attacks and the adverse weather reduced the ground and the trench lines to a slime-filled moonscape, the maintenance of continuous trench systems and building of dug-outs proved impossible. . . . There were insufficient concrete positions to counter this. And it was impossible to create new ones in these conditions anyway. The result was that the bulk of the defenders could only find the most primitive shelter from the enemy artillery fire in water-filled shell holes. These horrendous 'living spaces' more than the incessant bloody fighting, led to a rapid wearing out of the troops. . . . The bald truth is that there were simply not enough divisions. . . . The 73 divisions which fought in Flanders over the 4 months from August to November could only be brought together by replacing the 'fought-out' divisions of Fourth Army by fresh troops from other armies. There were no reserves, and the German artillery ultimately lost the artillery duel, unable to match the numbers, types and quantities of ammunition available to the British [Gunner] units.[13]

Retrospect – Third Ypres

From 9 October to the end of the first week in November, the British and German troops continued to slug it out, like two punch-drunk boxers resolved to fight themselves to a bloody and damaging draw. The evidence would suggest that the most enduring damage was meted out to the German fighter. The really low point in British morale had been reached and passed in the week following the dreadful events of 16 August. Thereafter, it became clear to the British, Anzac and Canadian troops that the German defenders were suffering a terrible ordeal.

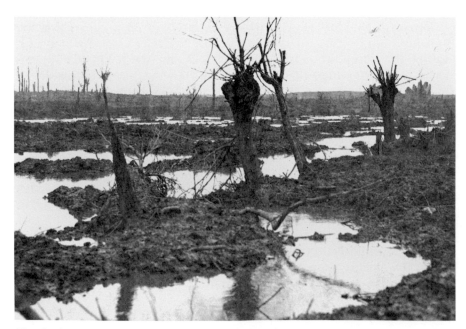

Slugging it out on both sides of the wire, mid-October 1917.

Once the British troops were under a unified command and knew that they were pushing the German defenders to the limit, they responded with great courage, resolved to wear them down until the cracks finally appeared in the German defence. Most importantly, such casualties were those that the German army could least afford to lose.

The 'Plumer battles' of September and early October had shown that the German defences could be breached, that the German response was predictable and that their much-vaunted counter-attack (*Eingreif*) units could be equally predictably smashed on the anvil of a multi-layered, pre-targeted 'killing zone'. This meant that the hapless German *Eingreif* units were spotted miles from their destination by the RFC, targeted by RFC aircraft and the long-range artillery, then hit by medium- and later field-artillery and mortars, and finally machine-guns, Lewis guns and individual infantry rifle-fire. Time and time again the same sorry tale evolved and counter-attack divisions were effectively annihilated. This method was so effective that the German defensive doctrine was revised, leading to a disastrous return to the old practice of packing the front line and bringing counter-attack forces closer to the forward zone of defence.

This regressive German tactic played directly into Plumer's hands, as it put the bulk of the German defensive battalions, regiments and divisions well within the range of the British artillery. The artillery then duly inflicted huge casualties on the enemy before our infantry were obliged to slog through the usual mud onto the German positions. Perhaps more than the Somme, the Third Ypres campaign was regarded by many of the German soldiers and commanders who experienced it as the supreme martyrdom of the war so far. Despite the impending influx of experienced German units from the Eastern Front, it is probably fair to say that the stoic and hard-bitten courage of the British and Commonwealth troops during this campaign fatally reduced the all too small reserve of the battle-hardened German junior leaders and manpower that would become the core of the forces engaged in the German offensive of 1918.

False Hopes Raised – and Dashed – at Cambrai

On 20 November, attention was drawn away from Ypres and south to Cambrai. (See map 26) A British offensive, using Third Army, commanded by General Sir Julian Byng (who had orchestrated the successful assault at Vimy Ridge in April), was to break through the Hindenburg Line and capture Cambrai itself. Success would create opportunities for further advances to be made, but these would be directed by GHQ. The British attack was to use three particularly innovative methods: the first massed use of tanks as the main assaulting 'punch', or 'mailed fist',[14] an evolutionary development of infantry-tank co-operation, and the surprise use of artillery employing 'predicted' fire, which meant that no preliminary bombardment occurred.

Operating in 'troops' or platoons of three and therefore using early armoured

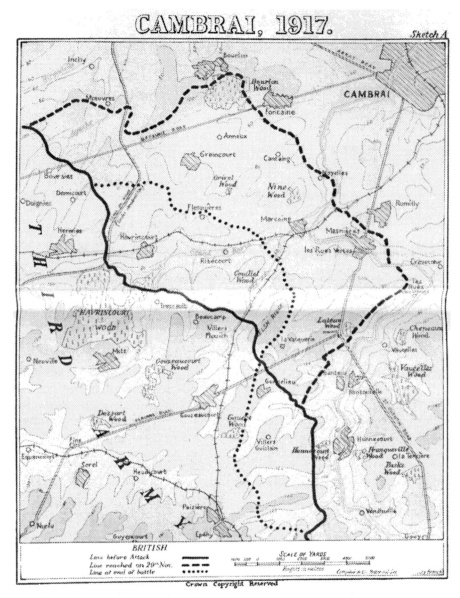

Map 26: Cambrai: 20 November to 6 December 1917.

tactics, 378 Mk IV 'fighting' tanks swept through the stunned German defences. They were supported by 6 of the 19 designated infantry divisions, the RFC, artillery and a further 98 Mk I and II 'supply' tanks (as used also at Messines). The initial results were outstanding, as German resistance appeared to crumble and the Hindenburg Line was penetrated as planned.

However, as usual, the German resistance soon hardened and many of the British tanks were put out of action by German gunners firing field guns over open sights. By 23 November, the 'fighting' tank strength had been reduced to 92 and, realistically, the British offensive could not be sustained, because of lack of reserves. A final opportunity was about to slip out of the BEF's grasp. On 30 November, the German Second Army, commanded by General von der Marwitz, delivered a stunning series of counter-attacks, using short, concentrated artillery fire (which included smoke and gas shells ass well as high explosive) and infiltration tactics by swift-moving storm troops. Both sides had by now begun to test methods by which the deadlock might be broken in 1918. Cambrai had been at a cost of 40,000 casualties on each side of the wire. Breaking the deadlock was not considered to be a serious option to most of the officers and men in the field.

Walter Humphrys had moved up the line at the end of the first week with 1/15 London (Civil Service Rifles) Battalion of 47th (London) Division. The Division was then severely tested by the subsequent German counter-attacks on Bourlon Wood, a major feature of the Cambrai sector. 'At first, we all thought that we were about to have the same success as we did at Messines, but this time, Jerry was ready to have a go back at us: And he did, good and proper.'[15] Walter, by now a senior member of the Lewis machine-gun team in his platoon, saw the rest of his crew wounded or killed as his battalion held onto the remaining part of Bourlon Wood against major enemy assaults. Eventually, 47th Division was forced to withdraw. By the end of the first week in December, the Germans had restored the original front line. Walter had survived by the skin of his teeth, or rather, the tin of bully beef which he had not had time to eat. After the battle, he discovered a 'brace' of shrapnel-pieces lodged in his back pack, the larger one stuck fast into the neglected tin of 'bully'. He could not recall when it had happened, but he was delighted that his rations had been of use after all.

Franz Benöhr, an *Obergefreiter* (Corporal) in the intelligence branch of the German GHQ, had been attempting to predict British and French moves. His department's successes in anticipating the Arras and Third Ypres were overshadowed by their failure to predict Messines and now Cambrai. *Benöhr*'s recollections of the latter summed up the promise, but ultimate disappointment of the British ambition:

I shall never forget that night 20/21 November 1917 at my desk at Spa! There had not been any hint whatever of any preparation of attack; no indications from radio traffic, no troop movements, nothing extraordinary on a seemingly thin, quiet front. – Only on the evening of the 20th, the British divisions [who were to attack] had exchanged the troops in the [trenches]. Tanks in units of brigades had advanced, camouflaged by machine-gun fire. Late in the evening, the attack started and also of course a use of radio messages. Only then did we [the Germans] learn what was going to happen. The British forces, strengthened by hundreds of tanks, could move freely and overthrew our thin [defences] . . . they moved so quickly that they often got lost. . . . Having arrived at the outskirts of Cambrai the [British] had to stop for a day or two for reorganisation etc. Then it was too late for them to move on: Strong German reinforcements arrived and stopped the British attack. Within 7 days German counter-attacks had won back all that had been lost![16]

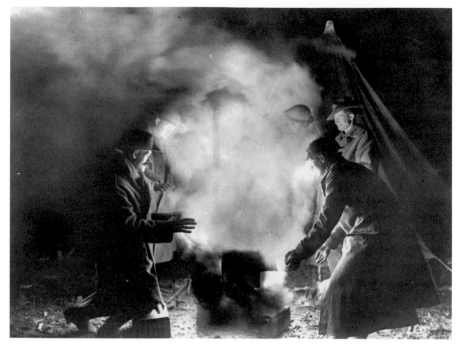

'We will not be beat.' Keeping warm through another perishing winter.

Despite the early promise of the massed tank offensive at Cambrai, which was forced back onto its starting line after a well-orchestrated German counter-attack, between 20 November and 5 December, Haig's vision of victory remained as elusive as ever. The Third Ypres campaign had led to a discernible dip in the Allies' morale. The British and Dominion troops had suffered around 250,000 casualties, the Germans about the same.[17] But 'bean counting' was not the point. Both sides had often suffered almost beyond endurance. The German defences had been badly dented, in parts almost irreparably so, but they had not been broken. Once again, winter came. Once again, the fitful hibernation began. Once again, the end of this war seemed out of sight.

On 11 November 1917, at Mons, the German High Command met to consider their plans for 1918. The date and place were unwittingly chosen for a conference which was convened to force a decision in the main theatre of war before the Americans could arrive in sufficient numbers to tip the balance against Germany. An operation was devised for the following year, a massive offensive to split the British and French forces in two. It was code-named *Kaiserschlacht*, The Kaiser's battle. It was a huge gamble, but one which had to be taken. Exactly one year later, at Mons, the Armistice was signed. The German gamble was destined to fail.

Retrospect – the Lost Opportunity of Messines

We recall that in the heady days of early June, Haig briefly saw an opportunity which would have allowed him to keep on battering at the German stockade after its foundations had been rocked by Messines. Plumer had a plan and asked for three days to effect the necessary movement and adjustments to his existing line. Haig somehow considered this too long and passed the responsibility to Gough. Gough was then given six days, then six weeks to consider and plan the next move.

In mid-August, when Haig realised that an error had been made in his decision on the overall command of Third Ypres, he handed the reins back to Plumer. Three weeks were then necessary to realign the whole front before the battle of the Menin Road (20 September) which finally achieved an objective which had been lined up over three months before.

It cannot be denied that mistakes were made at Messines. Casualties, though comparatively low, would have been even lower if divisional, corps and Second Army HQs had realised and acted quickly on the overcrowding along the ridge on the morning of 7 June and the artillery problems thereafter. Neither is it argued here that the battle was more than one with limited objectives, and one that was able to use the concentrated use of both mines and artillery. However, the possibility of exploiting this success, crucially as far as Gheluvelt, had been considered in both the 1916 and 1917 plans. Messines was an undeniable victory and it had a numbing effect on German morale.

This was a lost opportunity. But an opportunity for what? The answer is plain enough. The prize was Gheluvelt plateau and then beyond towards Passchendaele in a further set of 'bite and hold' operations against a demoralised and disorganised enemy while the weather remained almost ideal for a continued offensive. It is conceivable that the German hold on the higher ground which formed the main curve of the Ypres Salient would have been lost *before* 31 July.

Then, if the rains came, as they did, the Germans would have been obliged to attack to regain the lost ground and at enormous cost. Worse still, the only other option was a wholesale withdrawal to the *Flandern* defensive positions in depth. The Ypres Salient would have been extended to a wider and more defensible British line than the one which would exist by November. It would have made the German defences across such a front a great deal more vulnerable.

Such a scenario is speculative, but equally compulsive. Consider what the British and Dominion troops *were* able to achieve from 31 July to 6 November against a greatly strengthened enemy, reorganised defensively by the skilful *Col Fritz von Lossberg*, in often diabolical weather and poor visibility, and under General Gough and Fifth Army HQ for the first month of the offensive. It is not difficult to imagine what might have been achieved in June and July against a weakened and dispirited enemy, in generally excellent

weather and visibility and under the command of General Plumer and Second Army staff. Third Ypres was to give a frustrating yet tantalising glimpse of what might have been with the 'Plumer' battles in September and early October.

Notes

1 Edmonds, *BOH*, 1917, vol. II, pp. 141–5.
2 Ibid, pp. 145–6.
3 Bucher's experiences: Hammerton, J. *The Great War: I Was There*, pp. 1240–2.
4 *Wipers Times*, 1917.
5 Liddell Hart, Capt B.H., *History of The First World War* (London, Cassell, 1970).
6 Haig's description to Charteris at GHQ on the evening of 7 June.
7 IWM SS712: BEF GHQ November 1917: Extracts No. 12 from German documents and correspondence: *Conditions at the Front and Military Morale* (25 November 1917).
8 Edmonds, *BOH*, 1917, vol. II, p. 325.
9 See Prior, Robin, and Wilson, Trevor, *Passchendaele, the Untold Story* (New Haven and London, Yale University Press, 1996), pp. 160–1; there is some debate as to whether the Army Commanders did meet formally with FM Haig on 9 October and expressed their doubts as recorded by Edmonds.
10 Sapper John McCreesh, 250 Tunnelling Company, private collection, Mr Terry Middleton OBE.
11 Sapper Leslie Edward Hughes, NZ Division Engineers; private collection of Mrs Y. Fitzmaurice.
12 Kuhl, *Reflections (Erinnerungen)*: Flanders 1917. (Courtesy of the Liddle Collection, German Archives, University of Leeds.) See also Kuhl, *Der Weltkrieg 1914–1918*.
13 Ibid.
14 Simkins, Peter, *Chronicles of the Great War, The Western Front 1914–1918* (Godalming, Bramley, 1997) pp. 168–70.
15 Humphrys, Walter, *Recollections*.
16 Franz Benöhr, who was a Corporal in *OHL*, German General Supreme HQ, Intelligence Branch between 1917 and November 1918 at Kreuznach, Charleville-Mézières and Spa, Belgium early 1918. Enlisted spring 1915; demobilised in November 1918 as a corporal. (Courtesy of the Liddle Collection, German Archives, University of Leeds.)
17 Edmonds, *BOH*, 1917, vol. II, pp. 360–5.

Coda: the Legacy of Messines

A Myth or Two Exposed

The Battle of Messines remains an example of what was possible against a well-organised, resolute enemy in the First World War. Contrary to the popular myth of disaster in the wake of poor planning by incompetent generals and their staff, this operation proved the very real value of strong leadership, assiduous planning and preparation and the confidence with which each soldier went forward knowing his task and his part in the 'big picture'.

Once the mines were sprung, victory was assured by accurate, concentrated use of artillery, air superiority, good communications, outstanding logistic support and the timely concentrated use of the infantry to take and then hold the ground wrested from that enemy.

Its unique quality is that it was planned at the outset as an operation of classic siege warfare and thus its key elements were those of the artillery and engineers to break the back of the Messines–Wytschaete defence. The triumph of arms became the triumph over the will of the enemy. Messines proved the point that 'It is not big armies that win battles, it is the good ones'.[1]

On the other hand, it was one of the low points of German morale between 1914 and 1918. If Gen Plumer and his staff were a model of planning, cooperation and firm control, then *Gen von Laffert* and his staff represented none of these qualities. The troops of *Gruppe Wytschaete* had good reason to feel abandoned to their fates by inept leadership, but there was much more behind their humiliation on 7 June and beyond. The British mines were an integral factor, but it was the combination of their effects with those of the enormous power, flexibility and accuracy of the artillery which really shattered the former German defensive 'ring of unbreakable steel' around the Messines Ridge.

Hindenburg was forced to concede that,

Violent attempts on our part to restore the situation by counter-attacks failed under the murderous, hostile artillery fire which from all sides converted the rear area of the lost position into a genuine inferno. [Although] we succeeded in bringing the enemy to a halt before he had achieved a complete breach in our lines, our losses in men and equipment were heavy.

FM the Viscount Plumer 'of Messines', 1919.

Hindenburg's final comment on the battle underlined the consequence of failing to act in the way advocated by *von Kuhl* and *Crown Prince Rupprecht*. He wrote that: 'It would have been better to have evacuated the ground voluntarily.'[2]

Plumer

Plumer's record of success throughout the war has stood the test of time. He was a truly 'modern' General, who viewed the military horizon beyond the dreadful limitations imposed by the scale and technology of the First World War, and whose vision inspired the concept and use of the all-arms war-fighting doctrine. He was regarded as 'the most consistently reliable and successful British Army Commander of the First World War: a very great soldier, whose title stems from an outstanding feat of arms: [but] now an almost unknown name'.[3] John Terraine's assessment in 1964 rings as true today as it was then.

Achievement

Messines had first a psychological achievement, one of morale. It lifted that of the Allies and destroyed, albeit temporarily, that of the German army. It was undoubtedly a tactical success in a relatively local operation with limited objectives, but one that could and should have been exploited immediately.

The Legacy of Messines

The planning and conduct of the battle of Messines was a model for modern warfare and the principal root from which the BEF grew in 1918. Its legacy lay in the maturing of the BEF into one of the best led and resourced all-arms formations that had taken the field and won against the main enemy in the main theatre of war.

Perhaps the most appropriate post-script should come from Basil Liddell Hart:

> On the 7th June 1917, took place a battle which on the morrow was hailed as a brilliant military achievement, and which today, unlike so many historically tarnished 'masterpieces' of 1914–1918 stands out in even higher relief. For we appreciate now that the capture of Messines Ridge by General Plumer's Second Army was almost the only true siege-warfare attack made throughout a siege war. It was also one of the few attacks until late 1918 in which the methods employed by the command completely fitted the facts of the situation.[4]

The Legacy for Final Victory

Perhaps Haig's greatest contribution to the success of the British and Commonwealth armed forces of late 1918 was devolved command. The concept of breakthrough by bullish sweeping methods had been firmly replaced by the application of meticulously planned, limited but locally overwhelming 'bite and hold' operations. This ethos was understood and practised not only at all levels of command within the British army but also across nationalities. It had evolved through the assiduous learning from lessons of previous battles and tactics of the French and British experience of the Western Front, and then applied to improve Allied methods to check, then defeat the enemy threat. Pétain and Plumer were only too ready to learn from each other: their successes remain as testament to this enlightened attitude. Furthermore, generals such as Rawlinson, Plumer, Horne, Byng, Monash (Australian Corps) and Currie (Canadian Corps) had learned their trade, and their staffs had learned from the example of HQs such as Second Army. When Haig did attempt to intervene and urge more speed, such as immediately after the victory at Amiens on 8 August 1918, his field commanders had the confidence to just say no. This hands-off approach was vindicated by the steady yet inexorable advance to ultimate victory.

Haig demonstrated in 1918 that he may well have finally learned the lesson that it was, after all, possible to keep the German army off balance as Arras/Vimy, Messines and Cambrai in 1917 had suggested he could. He was, ultimately, the victorious commander, overseeing a highly potent fighting force which won against the main enemy precisely because the BEF gave the Germans little or no time to recover after each stunning blow. It proved to be a sound principle. It is a great pity that such a sound principle seems to have deserted him when he had the opportunity to make this clear and sensible choice in June 1917.

Notes

1 de Saxe, Marshal Maurice, *Mes Rêveries* (1757).
2 Hindenburg, Field-Marshal Paul von, *Out of my Life* (London, Cassell, 1920), p. 267.
3 Terraine, John, *The Great War, 1914–1918* (London, Hutchinson, 1965).
4 Liddell Hart, *History of the First World War*, p. 417.

Postscript: 'To my chum'

No more we'll share the same old barn,
The same old dug-out, same old yarn,
No more a tin of bully' share,
Nor split our rum by a star-shell's flare,
So long old lad.

What times we had, both good and bad,
We've shared what shelter could be had,
The same crump-hole when the whizz-bangs shrieked,
The same old billet that always leaked,
And now – you've stopped one.

We'd weathered the storm two winters long,
We'd managed to grin when all went wrong,
because together we fought and fed,
Our hearts were light; but now – you're dead
And I am Mateless.

Well old lad, here's peace to you,
And for me, well, there's a job to do,
For you and the others who lie at rest,
Assured may be that we'll do our best,
In vengeance.

Just one more cross by a strafed roadside,
With its G.R.C.[1] and a name for a guide,
But it's only myself who has lost a friend,
and though I may fight through to the end,
No dug-out or billet will be the same,
All pals can only be pals in name,
But we'll carry on till the end of the game;
Because, you lie there.

Wipers Times

[1] G.R.C. : Graves' Registration Cross

Messines Ridge today: facing Messines church, looking from Messines Ridge Commonwealth War Graves Commission (CWGC) Cemetery.

'One of the most tragic features of the Great War was the number of casualties reported "missing, believed killed". . . . and it was resolved that here at Ypres, where so many of the missing are known to have fallen, there should be erected a memorial worthy of them which should give expression to the nation's gratitude for their sacrifice and their sympathy with those who mourned them . . . and now it can be said of each one in whose honour we are assembled . . . "he is not missing; he is here".'

FM Viscount Plumer of Messines
at the unveiling of the Menin Gate, 1927.

Appendix 1

SECOND ARMY ORDER OF BATTLE (ORBAT)
BATTLE FOR MESSINES-WYTSCHAETE RIDGE: 7 -14 JUNE 1917

Operational Command: Gen Sir Hubert C O Plumer GCMG, KCB, ADC,
Commanding Second Army;

Corps Commanders: X CORPS - Lt Gen Sir Thomas Morland;
(North to South) **IX CORPS -** Lt-Gen Sir Alexander Hamilton-Gordon;
II ANZAC CORPS - Lt-Gen Sir Alexander Godley.

**Command/Staff: (*See Photograph, Chapter Two, HQ Second Army, June 1917,*
left to right looking at photograph):**
(Front Row): Col A B R Hildebrand, DSO, Deputy Director (DD) Signals; Lt Col C H
Mitchell, CMG, DSO, General Staff (Grade 1) - Intelligence; Lt Col W Robertson, DSO,
General Staff (Grade 1) - Operations; Maj-Gen F M Glubb, CB DSO, Chief Engineer; Maj-
Gen C H ("Tim") Harington, CB, DSO, Maj-Gen General Staff (Chief of Staff, (COS) Second
Army); Gen Sir Hubert C O Plumer GCMG, KCB, ADC; Maj-Gen A A Chichester, CB,
DSO, Deputy Adjt Gen & QMG; Maj-Gen G McK Franks, CB, GOC Royal Artillery (Comd
RA); Surgeon-Gen R Porter, CB, Director Medical Services; Lt Col E S Burden, CMG, Asst
Adjt Gen; Col T W Hale, CMG, DD Ordnance Services;
(Second Row): Maj F. St. J. Hughes, CMG, Camp Commandant; Lt Col A G Stevenson,
CMG, DSO, Controller of Mines; Rev G Standing, MC, Asst Principal Chaplain; Lt Col B B
Crozier, DSO, Staff Officer to GOC, RA; Lt F D L Green, ADC; Comdt. Comte de
Malleissey-Melun, MC, French Liaison Officer; Maj W Heyn, Belgian Liaison Officer; Maj J
Knowles, Asst. Military Secretary; Lt Col H W Jackson, Asst. QMG.; Comdt M Claude,
French Mission; Capt F C Bedwell, General Staff (Grade 3); Maj G M Darrell, MC,
DAQMG; Rev. I M Anderson, CMG, Asst. Chaplain-General; Capt A C P Butler, ADC; Capt
P de Fonblanque, Staff Officer RE;
(Back Row): Capt C K Phillips, Staff Capt AAG, Maj R S Abbott, MC, General Staff (Grade
2); Lt Col W H Trevor, Provost Marshal; Capt L H Hawes, MC, Staff Captain, RA; Maj N L
Craig, DAD Supplies; Capt P E Longmore, DAAG; Capt W Gould, Staff Captain
Reconnaissance, RA; Capt M B Heywood, DSO, General Staff (Grade 3); Capt H P Sparks,
MC, General Staff (Grade 3).

ARTILLERY

See Divisional Artillery ORBATS (Divisional Troops)
2,266 Guns of all Calibres;
78 Brigades, Royal Field Artillery (RFA);
187 Batteries, Royal Garrison Artillery (RGA).

ROYAL ENGINEERS

1 - The Tunnelling Companies

1st Australian Tunnelling Company (Woodward):
Hill 60 and Caterpillar;
1st Canadian Tunnelling Company (Thorne and O'Reilly):
St. Eloi;
250 Tunnelling Company (Cropper, Rees)
Hollandscheschuur Farm, Petit Bois, Maedelstede Farm, Peckham;
171 Tunnelling Company: (Hudspeth)
Spanbroekmolen, Kruisstraat, Ontario Farm;

3rd Canadian Tunnelling Company (Davis, Garner, Hall/Beer)
(Petit Douve Farm - lost to the Germans on 24th August 1916), Trench 127, Trench 122,/
Factory Farm, ("The Birdcage").

ROYAL ENGINEERS
2 Army Field Engineers - See ORBAT Table following Infantry ORBAT.
3 Signals Service - See ORBAT Table following Infantry ORBAT.

TANK CORPS
2nd Brigade (A and B Battalions), Commanded by Brigadier Courage:
76 Mk IV Tanks and 12 Mk II "supply" Tanks (38 and 6 respectively per battalion)

CAVALRY
Army, Corps and Divisional Cavalry Squadrons

INFANTRY -
158 Battalions, 41 Machine Gun Companies:

CORPS, INFANTRY DIVISIONS, BRIGADES AND BATTALIONS
(ORBAT Shows Formations and Units from North to South).

Corps/Division/Brigade (Bde)	Mines (by Divisions)

X CORPS (Lt Gen Sir Thomas Morland)

23RD DIVISION
(Maj Gen J M Babington)

Hill 60 and Caterpillar

68 Bde: (Brig-Gen G N Colville)
10 and 11/Northumberland Fusiliers; 12 and 13 DLI.
69 Bde: (Brig-Gen T S Lambert)* (* = Asslt Bdes at "Zero": 03.10 hours 7 June).
11/W Yorks; 8 and 9/ Green Howards; 10/DWR.
70 Bde: (Brig-Gen H Gordon)*
11/Sherwood Foresters; 8/KOYLI; 8 and 9 Yorks and Lancs.
Pioneers: 9/S. Staffords.
(23rd)Divisional Troops: Artillery:
102nd Bde (A B, C and D Batteries) and 103rd Bde (A B, C and D Batteries) RFA ;
V 23 Heavy and X 23, Y 23 and Z 23 Trench Mortar Batteries RA.

47TH (2nd LONDON) DIVISION (Territorial Force (TF))
(Maj Gen Sir George Gorringe)
140 Bde: (Brig-Gen H P B L Kennedy)*
1/6 London (City of London), 1/7 (City of London), 1/8 London (Post Office Rifles), 1/15
London (Civil Service Rifles) Battalions of the London Regiment.
141 Bde: (Brig-Gen R McDougall)
1/17 London (Poplar and Stepney Rifles); 1/18 London (London Irish Rifles);
1/19 London (St. Pancras); 1/20 London (Blackheath and Woolwich) Battalions of the London
Regiment.
142 Bde: (Brig-Gen V T Bailey)*
1/21 London (1st Surrey Rifles); 1/22 London (The Queen's); 1/23 London (The Queen's);
1/24 London (The Queen's) Battalions of the London Regiment.
Pioneers: 1/4 RWF.
(47th)Divisional Troops: Artillery:

235th (London) Bde (A B, C and D Batteries) and 236th (London) Bde (A B, C and D Batteries) RFA ; V 47 Heavy and X 47, Y 47 and Z 47 Trench Mortar Batteries RA.

41ST DIVISION (SOUTHERN AND HOME COUNTIES) St. Eloi
(Maj Gen S T B Lawford)
122 Bde: (Brig-Gen F W Towsey)
12/E. Surreys; 15 Hampshire, 11/RW Kents; 18/ KRRC.
123 Bde: (Brig-Gen C W E Gordon)*
11/Queens; 10/RW Kents; 23/Middlesex; 20/DLI.
124 Bde: (Brig-Gen W F Clemson)*
10/Queens, 26/Royal Fusiliers; 32/Royal Fusiliers; 21/KRRC.
Pioneers: 19/Middlesex.
(41st)Divisional Troops: Artillery:
187th Bde (A B, C and D Batteries) and 190th Bde (A B, C and D Batteries) RFA ;
V 41 Heavy and X 41, Y 41 and Z 41 Trench Mortar Batteries RA.

24TH DIVISION (Reserve; Assault Division Main Phase Two)
(Maj-Gen L J Bols)
17 Bde: (Brig-Gen P V P Stone)
8/Buffs; 1 and 12/Royal Fusiliers; 3/Rifle Bde.
72 Bde: (Brig-Gen W F Sweny)
8/Queens; 9/E. Surreys; 8/RW Kents; 1/N Staffords.
73 Bde: (Brig-Gen W J Dugan)
9/R Sussex; 7/Northamptons; 13/Middlesex; 2/Leinster.
Pioneers: 12/Sherwood Foresters.
(24th)Divisional Troops: Artillery:
106th Bde (A B, C and D Batteries) and 107th Bde (A B, C and D Batteries) RFA ;
V 24 Heavy and X 24, Y 24 and Z 24 Trench Mortar Batteries RA.

IX CORPS (Lt-Gen Sir Alexander Hamilton-Gordon)

19TH (WESTERN) DIVISION Hollandscheschuur
(Maj-Gen C D Shute; to 19 June)
56 Bde: (Brig-Gen E Craig-Brown)*
7/King's Own; 7/E Lancs; 7/S Lancs; 7/N Lancs.
57 Bde: (Brig-Gen T A Cubitt)
10/R Warwicks; 8/Gloster; 10/Worcs; 8/N Staffords.
58 Bde: (Brig-Gen A E Glasgow)*
9/Cheshire; 9/RWF; 9/Welsh; 6/Wiltshire.
Pioneers: 5/SWB.
(19th)Divisional Troops: Artillery:
87th Bde (A B, C and D Batteries) and 88th Bde (A B, C and D Batteries) RFA ;
V 19 Heavy and X 19, Y 19 and Z 19 Trench Mortar Batteries RA.

16TH (IRISH) DIVISION Petit Bois
(Maj-Gen W B Hickie) Maedelstede Farm
47 Bde: (Brig-Gen G E Pereira)*
6/R Irish; 6/Connaught Rangers; 7/Leinsters; 8/R Munster Fusiliers (RMF).
48 Bde: (Brig-Gen F W Ramsey)
7/R Irish Rifles; 1/RMF; 8 and 9/R Dublin Fusiliers.
49 Bde: (Brig-Gen P Leveson-Gower)*
7 and 8/R Inniskilling Fusiliers (R Inn F); 7 and 8/R Irish Fusiliers.

Pioneers: 11/Hampshire.
(16th)Divisional Troops: Artillery:
177th Bde (A B, C and D Batteries) and 180th Bde (A B, C and D Batteries) RFA ;
V 16 Heavy and X 16, Y 16 and Z 16 Trench Mortar Batteries RA.

36TH (ULSTER) DIVISION **Peckham House**
(Maj-Gen O S W Nugent) **Spanbroekmolen**
107 Bde: (Brig-Gen W M Withycombe)* **Kruisstraat**
8/R Irish Rifles (East Belfast Volunteers), 9/R Irish Rifles
(West Belfast Volunteers), 10/R Irish Rifles (South Belfast Volunteers)
and 15/R Irish Rifles (North Belfast Volunteers).
108 Bde: (Brig-Gen C R J Griffith)
11/R Irish Rifles (South Antrim Volunteers), 12/R Irish Rifles
(Mid Antrim Volunteers), 13/R Irish Rifles (1st County Down Volunteers)
and 9/ R Irish Fusiliers (Armagh, Monaghan and Cavan Volunteers).
109 Bde: (Brig-Gen A St. Q Ricardo)*
9/Royal Inniskilling Fusiliers (R Inn F) (Tyrone Volunteers), 10/R Inn F
(Derry Volunteers), 11/R Inn F (Donegal and Fermanagh Volunteers) and
14/R Irish Rifles (Young Citizen Volunteers of Belfast).
Pioneers: 16/R Irish Rifles (2nd County Down Volunteers).
(36th)Divisional Troops: Artillery:
153rd Bde (A B, C and D Batteries) and 173rd Bde (A B, C and D Batteries) RFA ;
V 36 Heavy and X 36, Y 36 and Z 36 Trench Mortar Batteries RA.

11TH (NORTHERN) DIVISION ((Reserve; Assault Division Main Phase Two)
(Maj-Gen H R Davies)
32 Bde: (Brig-Gen T H F Price)
9/W. Yorks; 6/Green Howards; 8/DWR; 6/Yorks and Lancs.
33 Bde: (Brig-Gen A C Daly)
6/Lincolns, 6/Border, 7/S.Staffords, 9/Sherwood Foresters.
34 Bde: (Brig-Gen S H Pedley)
8/Northumberland Fusiliers, 9/Lancashire Fusiliers, 5/Dorsets, 11/Manchesters.
Pioneers: 6/E.Yorks.
(11th)Divisional Troops: Artillery:
58th Bde (A B, C and D Batteries) and 59th Bde (A B, C and D Batteries) RFA ;
V 11 Heavy and X 11, Y 11 and Z 11 Trench Mortar Batteries RA.

II ANZAC CORPS (Lt-Gen Sir Alexander Godley)
25TH DIVISION **Ontario Farm**
(Maj-Gen E G T Bainbridge)
7 Bde: (Brig-Gen C C Onslow)*
10/Cheshire; 3/Worcesters; 8/N Lancs; 1/Wiltshires.
74 Bde: (Brig-Gen H K Bethell)*
11/Lancashire Fusiliers; 13/Cheshire; 9/N Lancs; 2/R Irish Rifles.
75 Bde: (Brig-Gen H B D Baird)
11/Cheshire; 8/Border Regt; 2 and 8/S Lancs.
Pioneers: 6/SWB.
(25th)Divisional Troops: Artillery:
110th Bde (A B, C and D Batteries) and 112th Bde (A B, C and D Batteries) RFA ;
V 25 Heavy and X 25, Y 25 and Z 25 Trench Mortar Batteries RA.

NEW ZEALAND DIVISION
(Maj-Gen Sir Andrew Russell) (Petit Douve Fm)
1st **NZ Bde:** (Brig-Gen E H B Brown, *KIA 8th June*
and replaced on the same day by Brig-Gen C W Melvill)
1/Auckland, 1/Canterbury, 1/Otago, 1/Wellington.
2nd **NZ Bde:** (Brig-Gen W G Braithwaite)*
2/Auckland, 2/Canterbury, 2/Otago, 2/Wellington.
3rd **NZ Rifle Bde:** (Brig-Gen H T Fulton)*
1/NZ Rifle Bn, 2/NZ Rifle Bn, 3/NZ Rifle Bn, 4/NZ Rifle Bn.
Pioneers: NZ Pioneer Bn.
(NZ) Divisional Troops: Artillery:
1st Bde NZ Field Artillery (NZFA) (1st, 3rd, 7th and 15th Batteries), and
3rd Bde NZ Field Artillery, (11th, 12th, 13th and 4th Batteries);
V NZ Heavy and X NZ, Y NZ and Z NZ Trench Mortar Batteries NZFA.

3RD AUSTRALIAN DIVISION Trench 127
(Maj-Gen Sir John Monash) Trench 122/
9th **Aus Bde:** (Brig-Gen A Jobson)* **Factory Farm**
33rd Bn, 34th Bn, 35th Bn, 36th Bn. (All Bns raised from NSW). **("Birdcage")**
10th **Aus Bde:** (Brig-Gen W R McNicoll)*
37th Bn, 38th Bn, 39th Bn, 40th Bn. (All Bns raised from Victoria).
11th **Aus Bde:** (Brig-Gen A Cannan)
41st Bn, 42nd Bn, 43rd Bn, 44th Bn. (Bns raised from Outer States;
i.e. Queensland, S. & W. Australia and Tasmania).
Pioneers: 3rd Aus Div Pioneer Bn.
(3rd Australian) Divisional Troops: Artillery:
7th Bde Australian Field Artillery (AFA) (25th, 26th, 27th and 107th Batteries)
and 8th Bde AFA (29th, 30th, 31st and 108th Batteries);
V 3A Heavy and X 3A, Y 3A and Z 3A Trench Mortar Batteries AFA.

4TH AUSTRALIAN DIVISION (Reserve; Assault Division Main Phase Two)
(Maj-Gen William Holmes, KIA 2nd July)
4th **Aus Bde:** (Brig Gen C H Brand, WIA 6th July)
13th (NSW) Bn, 14th (Victoria) Bn, 15th (Queensland and Tasmania) Bn, 16th (S. and W.
Australia) Bn.
12th **Aus Bde:** (Brig Gen J C Robertson)
45th (NSW) Bn, 46th (Victoria) Bn, 47th (Queensland and Tasmania) Bn,
48th (S. and W. Australia) Bn.
13th **Aus Bde:** (Brig Gen T W Glasgow)
49th (Queensland) Bn, 50th (S. Australia) Bn, 51st (W. Australia) Bn, 52nd
(S. and W., Tasmania) Bn.
Pioneers: 4th Aus Div Pioneer Bn.
(4th Australian) Divisional Troops: Artillery:
10th Bde Australian Field Artillery (AFA) (37th, 38th, 39th and 110th Batteries)
and 11th Bde AFA (41st, 42nd, 43rd and 111th Batteries)
31st and 108th Batteries);
V 4A Heavy and X 4A, Y 4A and Z 4A Trench Mortar Batteries AFA.

ROYAL ENGINEERS

2 - The Army Field Engineers:
Second Army - Special Units
A, K, L, O and Z Special (Cylinder) Coy Special Bdes
Z Special (Projector)Coy
No.2 and No.3 Special (Mortar) Coys
136th Army Troops Coy

X Corps

101st, 102nd, 128th Field (Fd) Coys	23rd Division
517th, 518th, 520th "	47th (2nd London) Division
228th, 233rd, 237th "	41st Division
103rd, 104th, 129th "	24th Division (Reserve)

IX Corps

81st, 82nd, 94th	Field Coys	19th (Western) Division
155th, 156th, 157th	"	16th (Irish)Division
121st, 122nd, 150th	"	36th (Ulster) Division
67th, 68th, 86th	"	11th Division (Reserve)

II ANZAC Corps

105th, 106th, 130th Fd Coys	25th Division
9th, 10th 11th Aus Fd Coys	3rd Aus Division
1st, 2nd, 3rd, 4th NZ Fd Coys	NZ Division
4th, 12th, 13th Aus Fd Coys	4th Aus Division (Reserve)

Army and Corps Reserve, Territorial and Miscellaneous Units
Second Army
2nd Fd. Survey Coy
No.2 Pontoon Park
No.5 Labour Bn R.E.
No.7 Labour Bn R.E.
No.4 Army Tramway Coy R.E. - (Attached temporarily to II ANZAC Corps)
No.8 Army Tramway Coy R.E.
No.4 Siege Coy (Royal Monmouth)
X Corps
236th Coy, 567th (Devon), 568th (Devon)
and 573rd (Cornwall) (Territorial) Coys
IX Corps
285th Coy
II ANZAC Corps
216th, 290th Coys
and 554th (Dundee) Army Troops Coy
(**Source:** Institution of the Royal Engineers (RE): RE Journal, Vol XL, Chatham, V Mar - Dec 1926).
3 Signals Service
Second Army Signal Coy
X Corps Signal Coy
23rd Div Signal Coy
24th Div Signal Coy
41st Div Signal Coy
47th Div Signal Coy
IX Corps Signal Coy
11th Div Signal Coy

16th Div Signal Coy
19th Div Signal Coy
36th Div Signal Coy
II ANZAC Corps Signal Coy
25th Div Signal Coy
3rd Aus Div Signal Coy
4th Aus Div Signal Coy
NZ Div Signal Coy
(**Reference:** Priestly, R.E.; *The Signals Service 1914-1918;* Mackays Co Ltd, 1921).

ORDER OF BATTLE (ORBAT) GLOSSARY

Aus - Australian
Bde/bde - Brigade
Bn/bn - Battalion
Div - Division
DWR - Duke of Wellington's Regiment (West Riding)
KIA - Killed in Action
KOYLI- King's Own Yorkshire Light Infantry
KRRC - King's Royal Rifle Corps
NSW - New South Wales
R Inn F- Royal Inniskilling Fusiliers
RMF - Royal Munster Fusiliers
RWF - Royal Welsh Fusiliers
SWB - South Wales Borderers
TF - Territorial Force
WIA - Wounded (In Action)
Worcs. - Worcestershire Regiment

Appendix 2

Commander *Fourth Army*: *General Sixt von Armin*
Commander *XIX Korps (Gruppe Wytschaete)*: *General der Kavallerie von Laffert.*

Division	Main Location	Deployment
	(GRUPPE YPERN)	
(119th Div. Gen-Maj Grünert		
Bellewarde/Hooge)*		
Replaced 195th Div in the line 4/5 June:		
195th Div in reserve.		
195th Div would relieve 204th Div by 12 June in Zandvoorde area		

--------------------------------------- XXX --------------(*Gruppe,* or Corps Boundary)--------

	GRUPPE WYTSCHAETE	
204th Div (Wurttemberg).	**Hill 60**	Mt Sorrel,
(Gen-Maj von Stein)		
413th Regt.		Hill 60,
120th Res. Regt.		Caterpillar.
414th Regt.	*414th Regt. In Reserve at **MENIN** a.m. 7 June*	

------------------------------------- XX -----------------------(**Divisional Boundary**)---------

35th Div (Prussian).	**St Eloi**	St Eloi,
(Gen-Lt von Hahn)		
176th Regt.		Dammstrasse,
141st Regt.		White Chateau
61st Regt		Hollebeke.
(Remnants of 61st Regt were relieved		
by two Coys of 26th Regt, 7th Division,		
early a.m. 8 June).		

--- XX ---

2nd Div (E. Prussian).	**Wytschaete**	St Eloi (W),
(Gen-Maj Reiser)		
44th Regt		Hollandscheschuur,
33rd Regt		Grand Bois,
4th Grenadier Regt.		Petit Bois,
		Maedelstede Fm,
		Peckham House.

--------------------------------------- XX --------------------------------------

40th Div (Saxon)./	**Messines**	Spanbroekmolen,
(Gen-Maj Meister)		
104th Regt.		Kruisstraat,
134th Regt.		Ontario Fm,
181st Regt.		Messines.
3rd Bav. Div (Bavarian).		
(Gen-Lt von Wenninger)		
23rd Bav. Regt.		
18th Bav. Regt.(Two Coys as garrison of Messines).		
17th Bav. Regt.		

--------------------------------------- XXX ------------------------------------

GRUPPE LILLE

4ᵗʰ Bav. Div (Bavarian).	**River Douve**	St. Yves,
(Gen-Maj Prinz Franz von Bayern)		
5ᵗʰ Bav. Regt.	**St. Yves**	Trench 127/122
9ᵗʰ Bav. Regt.		Factory Farm,
5ᵗʰ Bav. Res. Regt.		"Birdcage".

DIVISIONS IN RESERVE
[OR COUNTER-ATTACK *(EINGREIF)* DIVISIONS]

7ᵗʰ Div. *(Had replaced 35ᵗʰ Division, which had in turn relieved 24ᵗʰ Division*
(Gen-Maj von der Eich) *St. Eloi/Dammstrasse defensive sector).*
26ᵗʰ Regt.
163ʳᵈ Regt.
393ʳᵈ Regt.

1ˢᵗ Guards Res. Div. *(Had replaced 3ʳᵈ Bav. Division, a specialist counter-attack*
(Gen-Maj von Tiede) *unit, who had been obliged to relieve 40ᵗʰ (Saxon) Division*
 in the line in the Messines defensive sector).
1ˢᵗ Gds. Res. Regt.
2ⁿᵈ Gds. Res. Regt.
64ᵗʰ Res. Regt.

24ᵗʰ Div (Saxon). *(See above).*
Elements of:
 a. *3ʳᵈ Bav. Div (Bavarian).*

 b. 16ᵗʰ (Bavarian) Div.

Deployment of remaining Divisions referred to in Second Army Assessment of 4ᵗʰ June:

11ᵗʰ Div (Silesian).

23ʳᵈ Res. Div (Saxon).

Notes on Deployments, Unit Boundaries and Responsibilities
as at 6 June 1917

On average one German Regiment (three battalions in defensive echelon) faced the assault frontage of each British division (two brigades up, each with a minimum of two battalions in the main assault phase).

35ᵗʰ and *204ᵗʰ Divisions* faced the 6,000 yard frontage of X Corps.

2ⁿᵈ Division covered a frontage of 6,000 yards facing IX Corps.

The 4,800 yard frontage opposite II ANZAC Corps was held by only one division, namely *3ʳᵈ Bavarian Division,* although it was in the process of relieving *40ᵗʰ (Saxon) Division* in place at Zero Hour. Nevertheless, as the battle progressed, 3ʳᵈ and 4ᵗʰ Australian Divisions became more and more involved with *4ᵗʰ Bavarian Division of Gruppe Lille.*

ENEMY DISPOSITIONS SECOND ARMY FRONT
(NORTH TO SOUTH)
TOWARDS THE END OF THE BATTLE
12TH JUNE 1917
(Source: Map 22 from *Der Weltkrieg 1914 - 1918. Zwölfter Band*)

GRUPPE YPERN

Division	Location
119th Div.	Bellewaarde/Hooge

GRUPPE WYTSCHAETE

195th Div.	Zandvoorde (N)
7th Div.	Zandvoorde (S) - Hollebeke
11th Div.	Houthem
207th Div.	Comines to East of Messines to Warneton Triangle

GRUPPE LILLE

22nd Res. Div.	Warneton - Deûlemont
16th Bav. Div. (Bavarian).	Deûlemont (S) to Armentières (N)

Second Army Intelligence Assessment of Enemy Dispositions by Divisions and Regiments:
June 4th 1917
(Source: Map 1:40,000 2FSC, o/p red 2118 4-6-17, 2nd Army Intelligence, Enemy
Dispositions Second Army Front 4-6-17 SECRET).

DIVISIONS IN LINE
(North to South)

195th Div (Prussian).	Good troops. Two regiments of Jägers. Division arrived from Galicia end of April, when they came into line; has not had much experience of hard fighting.
204th Div (Württemberg).	Fair troops. Only the 120th Res. Regiment has had much fighting experience. Division formed in June 1916, and has remained in the Ypres salient since October 1916.
35th Div (Prussian).	Moderate division. Contains some Poles. Lost heavily on the Somme. Fought near Arras in April. Into line end of May.
2nd Div (E. Prussian).	Division in Russia until February 1917 and came into line in April. Was in many successful engagements [in the east], but has shown little spirit or enterprise on the Western Front.; its morale, although improved lately, is not high.
40th Div (Saxon).	Good Division when fighting on the defensive, but passive in attitude like all Saxon Corps. Losses on Somme estimated 70% of establishment. Has been on Messines front since Nov 1916.
4th Bav. Div (Bavarian).	A good division. Seen considerable amount of fighting, including the Somme. Opposite this Army front since Sept 1916.

DIVISIONS IN RESERVE AS AT 4 JUNE
[OR COUNTER-ATTACK DIVISIONS]

11th Div (Silesian).	Not a good division. Suffered very heavily on the Somme, and on the Scarpe in April. Contains number of Poles who desert frequently. Came middle of May.
23rd Res. Div (Saxon).	Had good reputation early in the war but not distinguished itself since. Was engaged in the Somme and came here from Arras Battle in April.
3rd Bav. Div (Bavarian).	The remarks ref. *4th Bavarian Division* also apply to this division. Also engaged heavily at Arras and returned end of May.
24th Div (Saxon).	Sister division to the *40th Division (XIX Saxon Corps)*. Same remarks also apply.

Select Bibliography

Imperial War Museum

Private Records: Department of Documents

Angus, Captain Alan, 8/Northumberland Fusiliers (34th Bde, 11th Division), Reference: 88/65/1.

Ashley, Lt C.A. (RA), Reference: 85/22/1.

Blackadder, Lt R.J., 151st Siege Battery RGA (99th Howitzer Bde, RGA), Reference: 88/11/1.

Cardew, Lt-Col G.A., 190th Bde RFA (41st Division), Reference: 86/92/1.

Clark, Capt Sir George, 1/8th London (Post Office Rifles) Bn (140th Bde), Reference: 88/52/1.

Cotton, Maj V.E., Trench Mortar Officer (TMO), 23rd Division, Reference: 93/25/1.

Craig-Brown, Brig Ernest, GOC 56th Bde, 19th (Western Division), Reference: 92/23/2 (& Con. Shelf).

de Caux, E.G., 1/8 London (City of London) Bn (140th Bde, 47th (2nd London) Division), Reference: 88/46/1.

Ebsworth, Cpl W.P., 1st Bn Royal Fusiliers (17th Bde, 24th Division), Reference: 93/23/1.

Hemsley, Lt-Col A. (Lt: 1917); 12/E Surrey Regiment ('Black Hand Gang'/'Bermondsey Boys') 122nd Bde, 41st Division, Reference: 87/26/1.

Lambert, Brig T.S., GOC 69th Bde, 23rd Division, Reference: 80/10/5.

Lyne, Lt-Col C.E.L. (RA), (64th Army Fd Arty Bde(?)), Reference: 80/14/1.

Lyon, Lt-Col W.A., 7/Leinster Regiment (47th Bde, 16th (Irish) Division), Reference: 80/25/1.

May, Lt A.G., 49th MG Coy (49th Bde, 16th (Irish) Division), Reference: 88/46/1.

McElwaine, Sir Percy, 9/R Irish Rifles, 107th Bde, 36th (Ulster) Division, Reference: 92/35/1.

Norton-Griffiths, Sir John; Miscellaneous Documents; Reference: 85/7/1.

Plint, Cpl R.G., MM, 26/Royal Fusiliers (124th Bde, 41st Division); Reference: 80/19/1.

Sambrook, A., 216 Army Troops Company, RE; May 1915–September 1918; Reference: 95/16/1.

Saunders, Maj C.J., attached 142nd Bde, 47th (2nd London) Division, Reference: 94/3/1.

Schweder, Maj R.P. (RFA), Reference: 86/65/1.

Tickle, E., 13/Middlesex Regiment (73rd Bde, 24th Division), Reference: 88/65/1.

Military Documents

No. 6 Sqn RFC; Record of Action and Associated Aerial Photographs covering Messines and Third Ypres; May to November 1917. Reference: Dept of Docs Miscellaneous 2013.

SS 135	Instructions for the Training of (Infantry) Divisions for Offensive Action; August 1917/Revised April 1918.
SS 135	The Division in the Attack; November 1918.
SS 143	Platoon Training (Evolving Tactics); 1916–1918.
SS 151	Notes and Information from Captured Enemy (German) Documents; March 1917 to August 1918.
SS 152	Notes on Army Training; 1917 and 1918.
SS 155	Notes on Dealing with Machine Guns in the Advance; April 1917.
SS 161	Instructions for Battle; May 1917.
SS 164	Notes on the Use of Tanks; Mark IV Tank: May 1917.
SS 171	Notes on Inventions and New Stores; November 1917 – January 1918.
SS 172	Preliminary Notes on Recent Operations of Second Army; July 1917.
SS 174	Communications in Second Army; July 1917.
SS 191	Communications in the Field.
SS 192	Tactical Employment of Machine Guns: Part One – Tactical Considerations;
SS 192	Part Two – Organization and Direction of Fire.
SS 197	Tactical Employment of the Lewis (Light) Machine Gun (and Amendment).
SS 204	Infantry and Tank Co-operation and Training; March 1918.
SS 356	Handbook of the German Army in War: January 1917.
SS 356	Handbook of the German Army in War: April 1918.
SS 356	Handbook of the German Army in War: November 1918.
SS 467	Periodical Index of German Divisions; No. 11: At 1 July 1917, (Brig-Gen J. Charteris).
SS 537	Summary of Recent Information Regarding the German Army and its Methods; January 1917 (March 1917 Publication).
SS 540	Instructions for Mine Warfare (German) – 1917.
SS 551	Extracts from Captured German Documents and Correspondence – 1917.
	Other References: SS556; SS564; SS568; SS573–SS712.

SS 567 Diagram Showing Organization of German Regimental
 Defensive Sector; 18 July 1918.
SS 574 The Construction of Defensive Positions: General Sixt von
 Arnim; 18 August 1917.
SS 582 Weekly Intelligence Summary of the German Fourth Army; 17
 July 1917.
SS 600 Organization of the Infantry Battalion and Normal Formation for
 the Attack; April 1917.
SS 703 Manual of Position Warfare for All Arms, Special Part: The
 Experience Gained During the English and French Offensives in
 Spring to October 1917.
SS 707 The Employment of Machine Guns in Trench Warfare.

Sound Archive
Archer, Private George, Durham Light Infantry (DLI).
 Reference: 8949/3.
Bowyer-Green, Private/Signaller Edward, 25th Bn London Regiment and
 15th Bn Royal Irish Regiment.
 Reference: 9547/4.
Chapman, Corporal William (originally a miner): RAMC, 1915–1916; Lt
 DLI, 1917–1919.
 Reference: 7309/12.
Clayton, Sapper George, Royal Engineers, 175 Tunnelling Company.
 Reference: 10012/12.
Cole, Private/Gunner/Signaller, Royal Artillery: 250/252 and 253 Bdes, RFA.
 Reference: 9535/18.
Fagence, Private Victor Edgar, Lewis machine-gunner, 11th Bn Royal West
 Kent Regiment.
 Reference: 0000327/08.
Frayling, Lt Bryan E., Royal Engineers; 171 Tunnelling Company.
 Reference: 4105/D/B.
Greener, Captain Martin, Durham Light Infantry (DLI) and 175
 Tunnelling Company.
 Reference: 8945/11.
Hunt, Private/Signaller Francis Henry, Middlesex Regiment and 8th Bn
 London Regiment.
 Reference: 13117/2.
Jourdain, Captain Seymour, 6th Bn Connaught Rangers, 16th (Irish)
 Division.
 Reference: 11214/12.
Neame, Lt-Col Philip, VC; Royal Engineers and Staff Officer.
 Reference: 000048/15.
Terrell, Private John William, 1/8 Bn, London Regiment (140 Bde, 47th
 (2nd London) Division).
 Reference: 11044/8.

Film and Video Archive

IWM 158 (Australia, 1917), Fighting in Flanders: With the AIF on the Western Front.

IWM 197 (GB, 7/1917), The Capture of Messines.

IWM 212 (GB(?), 1918), With the North and South Irish at the Front – Official Pictures of the British Army in France, Fourth Series.

Printed Books and Articles

Imperial War Museum Reference Library/General Printed Book Sources

Atkinson, C.T., *The Queen's Own Royal West Kent Regiment 1914–1919* (London, Hamilton, Kent & Co, 1924).

Barrie, Alexander, *War Underground* (London, Frederick Muller Ltd, 1961).

Becke, Maj A.F., *History of the Great War: Order of Battle (ORBAT) of Divisions*. 6 vols (London, HMSO, 1938).

Blake, Robert (ed.), *The Private Papers of Douglas Haig, 1914–1919* (London, Eyre & Spottiswoode, 1952).

Blaxland, G., *Amiens: 1918* (London, Frederick Muller Ltd, 1968).

Brophy, J. and Partridge, E., *Songs and Slang of the British Soldier 1914–1918* (London, Eric Partridge, 1930).

Cecil, Hugh and Liddle, Peter (eds), *Facing Armageddon: The First World War Experienced* (London, Leo Cooper, 1996).

Charteris, Brig-Gen John, *At GHQ* (London, Cassell, 1921).

——, *Field Marshal Earl Haig* (London, Cassell, 1929).

Chasseaud, Peter, *Topography of Armageddon: A British Trench Map Atlas of the Western Front, 1914–1918* (London, Mapbooks, 1991).

Churchill, Winston S., *The World Crisis* (London, Butterworth, 1927).

Cooper, Alfred Duff, *Haig*, 2 vols (London, Faber & Faber, 1936).

Crookenden, A., *The History of the Cheshire Regiment in the Great War* (Chester, Crookenden, 1939).

Crutwell, C.R.M.F., *A History of the Great War 1914–1918* (Oxford, Clarendon Press, 1934).

Davidson, Maj-Gen Sir John, *Haig: Master of the Field* (London, Peter Nevill, 1953).

Denman, Dr Terence, *Ireland's Unknown Soldiers: The 16th (Irish) Division in the Great War. 1917 – Triumph and Disaster* (Black Rock, Co. Dublin, Irish Academic Press, 1992).

Dennis, Rifleman Gerald V., *A Kitchener Man's Bit: An Account of the Great War 1914–1918* (London, Merh Books, 1994).

Doyle, Sir Arthur Conan, *The British Campaign in France and Flanders*: vol. IV: *1917* (London, Hodder & Stoughton, 1924).

Edmonds, Brig-Gen Sir James E., *Military Operations in France and Belgium, 1916 and 1917*, vols I and II (London, HMSO, 1932–1948).

Falls, Cyril, *The History of the 36th (Ulster) Division in the War 1914–1918* (London, McCaw Stevenson & Orr, 1922).

Farrar-Hockley, Gen Sir Anthony H., *Goughie: The Life of General Sir Hubert Gough* (London, Hart-Davis/McGibbon, 1975).

Fisher, J.J., *History of the Duke of Wellington's Regiment (DWR) (West Riding): August 1914 to December 1917* (1919).

Fuller, J.F.C., *Tanks in the Great War* (London, John Murray, 1920).

Fussell, P., *The Great War and Modern Memory* (Oxford University Press, 1976).

Gibbs, Philip, *From Bapaume to Passchendaele* (London, Wm Heinemann, 1918).

——, *Realities of War* (London, Wm Heinemann, 1920).

Giddings, R., *The War Poets* (London, Bloomsbury, 1988).

Giles, John, *Flanders Then and Now: The Ypres Salient and Passchendaele* (London, Leo Cooper, 1970).

Glubb, Lt-Gen Sir John, *Into Battle: a Soldier's Diary of the Great War* (London, Cassell, 1977).

Godfrey, E.G., *The Cast Iron Sixth: A History of the Sixth Battalion, London Regiment* (London, Old Comrades Association, 1938).

Gough, Gen Sir Hubert, *The Fifth Army* (London, Hodder & Stoughton, 1931).

Grieve, Capt W. Grant and Newman, Bernard, *The Tunnellers* (London, Herbert Jenkins, 1936).

Griffith, Paddy, *Battle Tactics of the Western Front: The British Army's Art of Attack, 1916–1918* (New Haven and London, Yale University Press, 1994).

Hammerton, J., *The Great War: I Was There: Undying Memories of 1914–1918* (London, 1939).

Harington, Gen Sir Charles (Tim), *Plumer of Messines* (London, John Murray, 1935).

Haste, C., *Keep the Home Fires Burning: Propaganda in the First World War* (London, 1977).

Haythornthwaite, Philip J., *The World War One Source Book* (London, Arms & Armour Press, 1992).

Hogg, Ian V., *The Guns, 1914–1918* (London, Pan Books, 1973).

Jones, H.A., *The War in the Air: Official History of the Great War (1914–1918),* vol. II (London, HMSO/Hamish Hamilton, 1928/1969 (Reprint)).

Historical Branch (Royal Air Force), *The Royal Air Force in the Great War* (originally released in 1936 as: *A Short History of the Royal Air Force*) (London/Nashville, Imperial War Museum/Battery Press).

Holt, Tonie and Valmai, *Battlefields of the First World War* (London, Pavilion Books Ltd, 1993).

Lampaert, Roger, *De Mijnenoorlog in Vlaanderen, (1914–1918) (The Mining/Underground War in Flanders)* (Roesbrugge, Belgium, Drukkerij Schoonaert, 1989).

Liddell Hart, Basil H., *History of the First World War* (London, Cassell, 1970).

——, *The Tanks, Volume I: 1914–1939* (London, Cassell, 1959).

——, 'The Basic Truths of Passchendaele', *Journal of the Royal United Services Institution (RUSI)*, vol. 104, 1959.

Liddle, Peter (ed.), *Passchendaele in Perspective: The Third Battle of Ypres* (London, Leo Cooper, 1997).

Lloyd George, David, *War Memoirs*, vol. II *(1917 to Armistice and Reflections)* (London, Oldhams Press Ltd, 1936).

Macdonald, Lyn, *They Called it Passchendaele* (London, Michael Joseph, 1978).

Maude, A.H., *History of the 47th (2nd London) Division, 1914–1919* (London, Amalgamated Press, 1922).

Messenger, Charles, *Trench Fighting, 1914–1918* (London, Pan/Ballantine, 1973).

Miles, Capt Wilfred, *The Durham Forces in the Field, 1914–1918* (London, Cassell & Co, 1920).

Moreland, A., *The History of the Hun* (120 Cartoons) (London, Cecil Palmer & Hayward, 1917).

Neame, Lt-Col Philip, *German Strategy in the Great War* (London, Edward Arnold & Co, 1923).

Oldham, Peter, *The Hindenburg Line* (London, Leo Cooper (Pen & Sword Books), 1995).

——, *Messines Ridge, 1914–1918* (London, Leo Cooper (Pen & Sword Books), 1998).

Pitt, B., *1918 – The Last Act* (London, Cassell, 1962).

Playne, Caroline, *Britain Holds On* (London, Allen & Unwin, 1933).

Powell, Geoffrey, *Plumer: The Soldier's General* (London, Leo Cooper, 1990).

——, *The History of the Green Howards* (London, Arms & Armour Press, 1992).

Priestley, R.E., *The Signal Service 1914–1918* (London, Mackay & Co, 1921).

Roberts, Lt-Col F.J. MC (ed.) *The Wipers Times* (London, Eveleigh Nash & Grayson Ltd, 1930).

Sandilands, Lt-Col H.R., *The Twenty-Third Division, 1914–1919* (Edinburgh, William Blackwood & Sons, 1925).

Scott, Michael, *The Ypres Salient: A Guide to the Cemeteries and Memorials of the Salient* (Norwich, Gliddon Books, 1992).

Simkins, Peter, *Chronicles of The Great War, The Western Front, 1914–1918* (Godalming, Bramley Books, CLB International, 1991/1997).

Sixsmith, E.K.G., *Douglas Haig* (London, Weidenfeld & Nicolson, 1976).

Spagnoly, Tony and Smith, Ted, *Salient Points: Cameos of the Western Front; Ypres 1914–1918* (London, Leo Cooper, 1993).

——, *A Walk Round Plugstreet: Cameos of the Western Front; South Ypres Sector 1914–1918* (London, Leo Cooper, 1997).

Spears, Sir Edward, *Prelude to Victory* (London, Cape, 1939).

Steel, Harwood, *The Canadians in France (and Belgium), 1915–1918* (T. Fisher Unwin, 1920).

Steel, Nigel and Hart, Peter, *Tumult in the Clouds: The British Experience of the War in the Air, 1914–1918* (London, Hodder and Stoughton, 1997).

Terraine, John, *Douglas Haig: The Educated Soldier* (London, Hutchinson, 1963).

——, *The Great War, 1914–1918* (London, Hutchinson, 1965).

——, *The Road to Passchendaele: The Flanders Offensive of 1917: A Study in Inevitability* (London, Leo Cooper, 1977).

——, *The Smoke and the Fire: Myths and Anti-Myths of War, 1861–1945* (London, Sidgwick & Jackson, 1980).

——, *The Western Front, 1914–1918* (London, Arrow Books, 1970).

——, *To Win a War: 1918, The Year of Victory* (London, Sidgwick & Jackson, 1978).

——, *White Heat: The New Warfare, 1914–1918* (London, Sidgwick & Jackson, 1982).

——, 'Monash, Australian Commander' *History Today*, vol. 16, 1966.

The Sphere Illustrated Newspaper, *The Capture of the Messines Ridge by Mine and Shell: A Diagrammatic Vision of the Attack in the Ypres Sector, June 7, 1917*; 16 June 1917 edition (London, Eyre & Spottiswoode).

The Times (Illustrated) History of the War, vols 15 and 16 (London, 1917/1918).

Winter, Denis, *Haig's Command; A Reassessment* (Harmondsworth, Viking Publications, 1991).

Wolff, Leon, *In Flanders Field: The 1917 Campaign* (London/New York, Penguin Books, 1958).

Wrigley, Chris, *Lloyd George* (Oxford, Historical Association Studies, Blackwell Publishers, 1992).

Wynne, G.C., 'The Development of the German Defensive Battle in 1917 and its Influence on British Defensive Tactics', *Army Quarterly*, vol. 34, April 1937.

Wyrall, E., *History of the 19th (Western) Division, 1914–1918* (London, Arnold, 1932).

Public Record Office, Kew

CAB 23	War Cabinet Minutes.
WO 95	Operational War Diaries.
WO 95/275	Second Army: January–October 1917.
WO 95/1032	II Anzac Corps: March 1916–December 1917.
WO 95/852	X Corps: January–June 1917.
WO 95/853	X Corps: July–December 1917.
WO 95/835	IX Corps: June 1916–November 1917.
WO 106	Directorate of Military Operations Files.
WO 106/387	Harvey, Maj-Gen R.N. (Late Inspector of Mines), *Mining in France, 1914–1918*.
WO 153	Artillery Operational Maps.

WO 153/234–41 Second Army and Corps Plans (Mapped operation orders) for the Battle of Messines, June 1917: Operations, intelligence and logistics.

WO 153/234/235 IX Corps.

WO 153/236 X Corps.

WO 153/237 II Anzac Corps.
 Second Army.

WO 153/238 Enemy Trenches/ Intelligence estimates.

WO 153/239 Second Army railheads and ammunition supplies.

WO 153/240 Messines – German Orders of battle (ORBATs), May/June 1917.

WO 153/241 German positions from Bois Quarante to Ypres–Comines canal – from war diary of XXXIX Bde RFA (41st Division), June 1917.

WO 157 Directorate of Military Intelligence Files.

WO 158 Operations.

WO 161/86 Logan, Lt-Col Dale, RAMC, *Mine Rescue Work on the Western Front.*

WO 256 Field Marshal Sir Douglas Haig: Diaries/Records (WO 256/19, vol. XVII for June 1917).

RE Library and Museum, Chatham

Institution of the Royal Engineers, *The History of the Corps of Royal Engineers*, vol. V: *The Home Front, France, Flanders and Italy in the First World War* (Chatham, 1952).

——, 'RE Order of Battle for Messines, June 1917', *RE Journal*, vol. XL (Chatham, December 1926).

Macleod, Maj-Gen M.N., 'A Sapper: Secret Weapon of World War I', *Royal Engineers Journal*, vol. 68, 1954.

War Diaries and Operational Records: selective list:

81 Field Company (Fd Coy)

82 Fd Coy – (19th Division)

94 Fd Coy – (19th Division)

103 Fd Coy – (24th Division)

105 Fd Coy – (25th Division)

106 Fd Coy – (25th Division)

104 Fd Coy – (41st Division)

520 Fd Coy – (47th Division)

Royal Artillery Institution Library and Museum, Woolwich

Becke, Maj A.F., 'The Coming of the Creeping Barrage', *Journal of the Royal Artillery*, vol. 58, 1931–1932.

Farndale, Gen Sir Martin, *History of the Royal Regiment of Artillery, Western Front, 1914–1918* (Woolwich, Royal Artillery Institution, 1986).

Kirke, Col R.M. St G., 'Some Aspects of Artillery Development during the

First World War on the Western Front', *Journal of the Royal Artillery*, vol. 101, September, 1974.

Pemberton, Brig A.L., *The Development of Artillery Tactics and Equipment*, (London, War Office, 1950).

Penrose, Maj John, 'Survey for Batteries', *Journal of the Royal Artillery*, vol. 49, 1922/3.

Wade, A., *The War of the Guns* (London, Batsford, 1936).

Liddle Collection, Brotherton Library, University of Leeds

Benöhr, Obergefreiter Franz, *Recollections*, Memoirs of Service with Intelligence Branch of the Imperial German GHQ, 1917–1918.

Firstbrooke Clarke, Lt, 8th Bn. N. Staffords.

Hall, Capt B.C., 3rd Canadian Tunnelling Company.

Lyons, CSgt (CQMS) EM, ASC.

Lyons, Cpl J.L., 171 Tunnelling Company.

Smith, A.E., 47th (2nd London) Division.

Stokes, Brig R.S.

Townley, C.E.

Wellingham, H.T.

Wilson, A.

Australian War Memorial, Canberra Research Centre

Private Records

C.E.W. Bean: AWM 38.

Gen Sir John Monash: AWM 3DRL 2316 (Items 24, 25, 79/3, 79/2, 42 & 43).

Aitken, Capt William, MC, 1st NZ Div Field Ambulance: AWM 3DRL/2422.

Gallway, Wilfred Denver, 47th Bn, 12th Australian Bde, 4th Australian Division: AWM MSS1355.

Grieve, Capt Robert C., VC; 37th Bn, 10th Australian Bde, 3rd Australian Division: AWM PR83/015.

Jungwirth, Pte Leslie Montus, 10th MG Coy, 3rd Australian Division: AWM PR89/063.

MacIntosh, Pte Alexander Keith, 7th Field Arty Bde, AFA: AWM PR00092.

McCaskill, Rifleman, NZ Rifle Bde, NZ Division: AWM PR00229.

Woodward, Capt Oliver H., MC & 2 bars, 1st Australian Tunnelling Coy: AWM MSS0717.

Operational Records

AWM 26 – Operational Files, 1914–1918 War (Period 6, Boxes 185–205)

II Anzac Corps

3rd Australian Division

4th Australian Division

AWM 1/13 Reel 763 Second Army War Diaries; AWM 1/32, reel 790 & 1/33, reel 791: II Anzac Corps.

AWM 45 – Copies of British Unit War Diaries and Operational Records:
Second Army
25th Division (II Anzac Corps)
AWM 1/46, reel 826, 3rd Australian Division War Diaries; AWM 1/48, reel
831, 4th Australian Division War Diaries.

Secondary Sources/Printed Books

Bean, C.E.W., *Official History of Australia in the War*, vols I and II: *The
Story of Anzac*; vol. III: *The AIF in France, 1916*; vol. IV: *The AIF in
France, 1917*; vol. V and VI: *The AIF in France, 1918* (Sydney, Angus
and Robertson, 1938–1942).

——, *Anzac to Amiens: a Shorter History of the Australian Fighting Services in
the First World War* (Canberra, Australian War Memorial, 1946).

Brahms, V., *The Spirit of 42nd: Narrative of the 42nd Battalion, 11th Infantry
Brigade, 3rd Australian Division of the Australian Imperial Forces, During
the Great War* (Brisbane, 42nd Bn AIF Association, 1938).

Cutlack, F.M., *The Australians: Their Final Campaign, 1918* (London,
Sampson Low, Marston, 1918).

——, Official History of Australia in the War, vol. VIII: *The Australian
Flying Corps* (Sydney, Angus and Robertson, 1939).

Dennis, Peter, Grey, Jeffrey, Morris, Ewan and Prior, Robin, *The Oxford
Companion to Australian Military History* (Melbourne, Oxford University
Press, 1995/1997).

Gammage, B., *The Broken Years: Australian Soldiers in the Great War*
(Canberra, Australian National University Press, 1974).

Horner, D.M. (ed.), *The Commanders: Australian Military Leadership in the
Twentieth Century* (Sydney, Allen & Unwin, 1984).

Laffin, John, *Western Front, 1916–1917: The Price of Honour* (Sydney,
Time-Life Books Australia, 1987).

Monash, Gen Sir John, *The Australian Victories in France in 1918*, 2nd edn (London,
Hutchinson, National University Press, 1974, originally published 1920).

Pedersen, Peter A., *Monash as a Military Commander* (Melbourne,
Melbourne University Press, 1985).

Prior, Robin and Wilson, Trevor, *Command on the Western Front: The
Military Career of Sir Henry Rawlinson, 1914–1918* (Oxford/Cambridge,
Mass., Blackwell, 1992).

——, *Passchendaele, the Untold Story* (New Haven & London, Yale
University Press, 1996).

Smith, P. Adam, *The Anzacs* (London, Hamish Hamilton, 1978).

The New Zealand Armed Forces
(Principal Sources from Imperial War Museum and Australian War Memorial)

Austin, W.S., *The Official History of the New Zealand Rifle Brigade (The Earl
of Liverpool's Own) Covering the Period of Service with the New Zealand*

Expeditionary Force in the Great War from 1915–1919 (Wellington, Watkins, 1924).

Burton, O.E., *The Auckland Regiment* (Auckland, Whitcombe & Tombs, 1922).

——, *The Silent Division, New Zealanders at the Front: 1914–1918* (Sydney, Angus & Robertson, 1935).

Byrne, A.E., *Official History of the Otago Regiment, N.Z.E.F., in the Great War, 1914–1918* (Dunedin, Wilkie, no date).

Byrne, J.R., *New Zealand Field Artillery in the Field, 1914–1918* (Auckland, Whitcombe & Tombs, 1922).

——, *Sketches of the N.Z.F.A. by an Artillery Digger. Dial sights* (N.Z. War Records, 1919).

Carberry, A.D., *The New Zealand Medical Service in the Great War, 1914–1918, based on Official Documents* (Auckland, Whitcombe & Tombs, 1924).

Cowan, J., *The Maoris in the Great War: A History of the New Zealand Native Contingent and Pioneer Battalion. Gallipoli, 1915. France & Flanders, 1916–1918* (Wellington, Whitcombe & Tombs, 1922).

Cunningham, W.H., Treadwell C.A.L. and Hanna J.S., *The Wellington Regiment, N.Z.E.F., 1914–1919* (Wellington, Ferguson & Osborn, 1928).

Cyclist Corps, *Regimental History of New Zealand Cyclist Corps in the Great War, 1914–1918* (Auckland, Whitcombe & Tombs, 1922).

Drew, H.T.B., *The Silent Division, The Pride of New Zealand* (Reprint from *The Sphere*, dated 18 January 1919) (London, Eyre & Spottiswoode, 1919).

——, *The War Effort of New Zealand* (Auckland, Whitcombe & Tombs, 1924).

Ferguson, D., *History of the Canterbury Regiment, N.Z.E.F. 1914–1919* (Auckland, Whitcombe & Tombs, 1921).

Luxford, J.H., *With the Machine Gunners in France and Palestine, The Official History of the New Zealand Machine Gun Corps in the Great World War, 1914–1918* (Auckland, Whitcombe & Tombs, 1923).

Neill, J.C., (ed.), *The New Zealand Tunnelling Company, 1915–1919* (Wellington, Whitcombe & Tombs, 1922).

New Zealand, *The Official History of New Zealand's Effort in the Great War*, vol. II: *The New Zealanders in France* (Auckland, Whitcombe & Tombs, 1921/1923).

——, vol. IV: *The War Effort of New Zealand* (Auckland, Whitcombe & Tombs, 1921/1923).

New Zealand, *Official History of the New Zealand Engineers during the Great War, 1914–1919* (Wanganui, Evans, Cobb & Sharpe, 1927).

Steeple, W.J., *The Wellington Regiment (City of Wellington's Own) N.Z.M.F.* (typescript, 1957).

Stewart, Col H., *The New Zealand Division 1916–1918: A Popular History based on Official Records* (Wellington, Whitcombe & Tombs, 1921).

Bundesarchiv and German Archive Sources on the Imperial German Army, 1914–1918

American Expeditionary Force (AEF), General Staff, Intelligence Section, *Histories of the 251 Divisions of the German Army which Participated in the War (1914–1918)* (Washington, USAF HQ, 1919).

Berger, G., *Die 204e Infanterie Division im Weltkrieg, 1914–1918* (Stuttgart, Belser Verlag, 1922).

Beumelburg, W., *Flandern 1917; Schlachten des Weltkrieges* (Oldenburg, Stallung, 1928).

Cron, H., *Geschichte der Deutschen Heeres im Weltkriege, 1914–1918* (Berlin, Sigismund, 1937).

Füsslein, O., *Report to the German HQ (Fourth Army) on the disaster of the black day of Wytschaete 6/7 June 1917*, Paper (London, German Historical Institute, originally published 1917).

General Staff (Intelligence) GHQ: *Historical Notes on German Divisions Engaged on the Western Front up to January 1918*, GHQ BEF (SS642A); May 1918.

——, *Vocabulary of German Military Terms and Abbreviations* (SS555, 1st edn, 1917).

——, *Vocabulary of German Military Terms and Abbreviations* (SS555, 2nd edn, 1918).

German Official History: *Great Battles Fought during the First World War: Flanders 1917*, translated by Lt-Col Roderick Macleod, RA (no date).

Hindenburg, Field Marshal Paul von, *Out of My Life*, vol. 2 (London, Cassell, 1920).

Imperial War Museum: Reference CDS 1–20; *German Military Engineering, Mines and Trench Warfare*, GHQ and Army (Intelligence) Staffs; March 1917–November 1918.

Jünger, Ernst, *In Stahl Gewittern/Storm of Steel: From the Diary of a German Storm-Troop Officer on the Western Front* (London, Chatto & Windus, 1929).

Kuhl, General Hermann von, *Der Weltkrieg, 1914–1918*, vol. II and *Diaries/Memoirs for 1917: Flanders (Messines and Third Ypres)*, Berlin, Kolk, 1928. Translated by Lt-Col Roderick Macleod, RA. (Key references held in the Liddle Collection and Royal Artillery Institution Library, Woolwich.)

Lossberg, Gen Fritz von, *Mein Tätigkeit im Weltkriege, 1914–1918* (Berlin, Mittler, 1922).

Ludendorff, General Erich von, *My War Memories, 1914–1918* (London, Hutchinson, 1919).

Lupfer, Capt Timothy T., *The Dynamics of Doctrine: The Changes in German Tactical Doctrine during the First World War* (USA, Combat Studies Institute, Fort Leavenworth, Kansas, 1981).

Nash, D.B., *German Artillery, 1914–1918* (London, Almark, 1970).

——, *German Infantry, 1914–1918* (London, Almark, 1971).

Oberkommando des Heeres (OKH); *Der Weltkrieg 1914–1918*, Band 12: *Die Kriegsführung im Frühjahr 1917* (*The First World War*, vol. 12: *The Conduct of the War in the early part of 1917*) (Berlin, 1938).

Reichsarchiv, *Der Weltkrieg 1914–1918* 18 vols (Berlin, Mittler, 1925/1944).

Remarque, Erich Maria, *All Quiet on the Western Front* (London, Putnam & Co, 1929).

Rupprecht, Crown Prince, *In Treuefest: Mein Kriegstagebuch*, vol. II (Munich, Deutsche National Verlag, 1920).

Individual Private and Family Acknowledgements
Mrs Yvonne Fitzmaurice
Mr Terry Middleton, OBE
Mr & Mrs John Heritage
Walter Humphrys
FM Viscount Plumer: Mr Freddie Cohen and Mrs Rosemary Lowry-Corry
Jacques Ryckebosch, TocH, Poperinghe, Ypres
Mr Albert Ghekiere, Messines (Mesen)
Mr Ivan van den Burie, Kemmel, Ypres

Index

Note: page numbers in italics indicate illustrations.